MW00908724

THE LIGHTWAVE 7.5 PRIMER

LIMITED WARRANTY AND DISCLAIMER OF LIABILITY

THE CD-ROM WHICH ACCOMPANIES THE BOOK MAY BE USED ON A SINGLE PC ONLY. THE LICENSE DOES NOT PERMIT THE USE ON A NETWORK (OF ANY KIND). YOU FURTHER AGREE THAT THIS LICENSE GRANTS PERMISSION TO USE THE PRODUCTS CONTAINED HEREIN, BUT DOES NOT GIVE YOU RIGHT OF OWNERSHIP TO ANY OF THE CONTENT OR PRODUCT CONTAINED ON THIS CD-ROM. USE OF THIRD PARTY SOFTWARE CONTAINED ON THIS CD-ROM IS LIMITED TO AND SUBJECT TO LICENSING TERMS FOR THE RESPECTIVE PRODUCTS.

CHARLES RIVER MEDIA, INC. ("CRM") AND/OR ANYONE WHO HAS BEEN INVOLVED IN THE WRITING, CREATION, OR PRODUCTION OF THE ACCOMPANYING CODE ("THE SOFTWARE") OR THE THIRD PARTY PRODUCTS CONTAINED ON THE CD-ROM OR TEXTUAL MATERIAL IN THE BOOK, CANNOT AND DO NOT WARRANT THE PERFORMANCE OR RESULTS THAT MAY BE OBTAINED BY USING THE SOFTWARE OR CONTENTS OF THE BOOK. THE AUTHOR AND PUBLISHER HAVE USED THEIR BEST EFFORTS TO ENSURE THE ACCURACY AND FUNCTIONALITY OF THE TEXTUAL MATERIAL AND PROGRAMS CONTAINED HEREIN. WE, HOWEVER, MAKE NO WARRANTY OF ANY KIND, EXPRESS OR IMPLIED, REGARDING THE PERFORMANCE OF THESE PROGRAMS OR CONTENTS. THE SOFTWARE IS SOLD "AS IS " WITHOUT WARRANTY (EXCEPT FOR DEFECTIVE MATERIALS USED IN MANUFACTURING THE DISK OR DUE TO FAULTY WORKMANSHIP).

THE AUTHOR, THE PUBLISHER, DEVELOPERS OF THIRD PARTY SOFTWARE, AND ANYONE INVOLVED IN THE PRODUCTION AND MANUFACTURING OF THIS WORK SHALL NOT BE LIABLE FOR DAMAGES OF ANY KIND ARISING OUT OF THE USE OF (OR THE INABILITY TO USE) THE PROGRAMS, SOURCE CODE, OR TEXTUAL MATERIAL CONTAINED IN THIS PUBLICATION. THIS INCLUDES, BUT IS NOT LIMITED TO, LOSS OF REVENUE OR PROFIT, OR OTHER INCIDENTAL OR CONSEQUENTIAL DAMAGES ARISING OUT OF THE USE OF THE PRODUCT.

THE SOLE REMEDY IN THE EVENT OF A CLAIM OF ANY KIND IS EXPRESSLY LIMITED TO REPLACEMENT OF THE BOOK AND/OR CD-ROM, AND ONLY AT THE DISCRETION OF CRM.

THE USE OF "IMPLIED WARRANTY" AND CERTAIN "EXCLUSIONS" VARY FROM STATE TO STATE, AND MAY NOT APPLY TO THE PURCHASER OF THIS PRODUCT.

THE LIGHTWAVE 7.5 PRIMER

PATRIK BECK

CHARLES RIVER MEDIA, INC.

Hingham, Massachusetts

Copyright 2003 by CHARLES RIVER MEDIA, INC.
All rights reserved.

No part of this publication may be reproduced in any way, stored in a retrieval system of any type, or transmitted by any means or media, electronic or mechanical, including, but not limited to, photocopy, recording, or scanning, without *prior permission in writing* from the publisher.

Publisher: Jenifer Niles
Production: Publishers' Design and Production Services, Inc.
Cover Design: The Printed Image
Cover Image: Patrik Beck

CHARLES RIVER MEDIA, INC.
20 Downer Avenue, Suite 3
Hingham, Massachusetts 02043
781-740-0400
781-740-8816 (FAX)
info@charlesriver.com
www.charlesriver.com

This book is printed on acid-free paper.

Patrik Beck. *The LightWave 7.5 Primer*.
ISBN: 1-58450-222-3

All brand names and product names mentioned in this book are trademarks or service marks of their respective companies. Any omission or misuse (of any kind) of service marks or trademarks should not be regarded as intent to infringe on the property of others. The publisher recognizes and respects all marks used by companies, manufacturers, and developers as a means to distinguish their products.

Library of Congress Cataloging-in-Publication Data

Beck, Patrik.
 The LightWave 7.5 primer / Patrik Beck.— 1st ed.
 p. cm.
 ISBN 1-58450-222-3
 1. Computer animation. 2. Computer graphics. 3. LightWave 3D. I. Title.
 TR897.7 B44 2002
 006.6'96—dc21
 2002012859

Printed in the United States of America
02 7 6 5 4 3 2 First Edition

CHARLES RIVER MEDIA titles are available for site license or bulk purchase by institutions, user groups, corporations, etc. For additional information, please contact the Special Sales Department at 781-740-0400.

Requests for replacement of a defective CD-ROM must be accompanied by the original disc, your mailing address, telephone number, date of purchase and purchase price. Please state the nature of the problem, and send the information to CHARLES RIVER MEDIA, INC., 20 Downer Avenue, Suite 3, Hingham, Massachusetts 02043. CRM's sole obligation to the purchaser is to replace the disc, based on defective materials or faulty workmanship, but not on the operation or functionality of the product.

This book could not have been completed without the help and support of my wife Cathy and the constant reminder of what life is all about from my children, Mariah and Christian.

I would also like to thank my publisher for supporting me through the process of creating this book and for having the courage to sign me up a second time.

Last, to the spirit of my grandfather, Otto Peter Beck, a slightly schooled man who was the greatest teacher I have ever known. His words to me when I was a child remain with me today.

CONTENTS

CHAPTER 5 LIGHTS AND LIGHTING 173

CHAPTER 8 ANIMATION OF OBJECT DEFORMATION 257

CHAPTER 9 COMPOSITING 279

PREFACE

Welcome to *The LightWave 7.5 Primer*.

The LightWave 7.5 Primer is intended to help those just getting started in the field of 3D animation. It is a reference guide to the dozens of little details necessary to learn in order to get comfortable with a software program. While LightWave is fairly straight forward and intuitive in its construction, computer animation by itself can be a very involved process.

The first part of the book covers many of the basics of 3D animation and the way LightWave addresses aspects of computer animation. Learning why and how things operate is important. After you learn which tools are used to create 3D animation, you learn how they work and how to use them.

Mastering any form of artistic expression requires learning the basic mechanical skills of the medium—this is true whether you are using a chisel, a paint brush, or a computer mouse. Although there may seem to be a huge difference between a sphere in a box and a dinosaur in the jungle, the same skills are required to manipulate them.

Working through this book will give you the basic grounding in LightWave necessary to allow you to do some amazing things. You will learn how to construct basic objects and make them move. You will learn to give them textures and render them as animations. You will even be able to composite your LightWave renders into live footage.

As you work through this book and examine the examples on the CD-ROM, keep in mind that you are beginning an art form that has virtually no limit. The things you can do today on your desktop were unthinkable just a few years ago. One of the most exciting things about computer animation is that it is still so very young, and although we have had several outstanding pioneers, there is still room for more.

Perhaps someone like you.

CHAPTER

1

INTRODUCTION TO
LightWave

In This Chapter

- LightWave Concepts

- Objects and Modeler

- Layout

- Rendering Issues

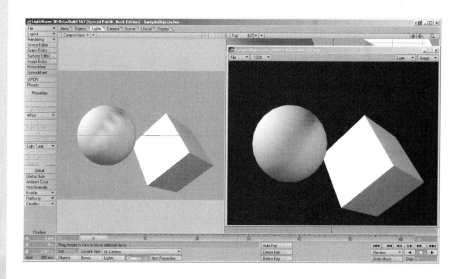

Welcome to the world of 3D animation, a wonderful and magical place in which all things are possible. Computer animation has matured to a level where just about anything that can be imagined can be rendered on a computer screen. From there, the images can be printed or compiled as animations to be displayed anywhere from a low-resolution Web page to an ultra-sized movie screen.

Much in the way that anyone with a typewriter (or a word processor) has the potential to write a great novel, or anyone with a 35mm camera can take beautiful pictures, LightWave puts the tools to accomplish great things in your hands. In order for great things to happen, however, you need to understand the tools you have been given.

Just as in music, art, and dance, it takes study and practice to work at a professional level. As an art form and an industry, 3D computer animation is barely more than a decade old. On the one hand, there are very few grand masters to show us the way, but on the other hand, we have the joy of discovering and pioneering. How often in history do you get to take part in the birth of something new that will be part of the world forever?

While we may not have a hundred years of computer animation history to draw from, we are free to borrow from all the other disciplines that came before us. You will find that many things in LightWave resemble or even take their names from real world things. Be aware that everything you will use is a simulation, a representation of the real world. Software and hardware improves every day by leaps and bounds, but the interface between you and cyberspace is still far from transparent. Until the day we can hook a video card directly into our brains and project our dreams for all to see, we will need our virtual workshop, our LightWave, to set free our imagination. Let us get started on a basic orientation to the world of LightWave.

LIGHTWAVE CONCEPTS

A very important aspect of any piece of software is its user interface. While all the buttons, tabs, and menus may seem a bit daunting at first, LightWave's design has been set up to facilitate work flow.

The Two Faces of LightWave

The 3D aspect of 3D animation means that we are creating 3D geometry and manipulating it in a 3D environment. These are big jobs to handle. To

FIGURE 1.1 Screenshot of Layout.

make things a little easier, LightWave is broken down into two separate but connected interface screens, Layout (see Figure 1.1) and Modeler (see Figure 1.2).

After the LightWave software is installed on your computer, it will list two programs: LightWave and Modeler. Starting the LightWave program will open what is commonly referred to as the *Layout.* Modeler and Layout are two totally separate programs that share some functions and are connected by the *Hub,* which allows them to share information. Not all 3D animation packages come with modeling tools, and those that do, do not necessarily break them into separate applications. Because both Layout and Modeler have so many tools and functions, dividing the software into these two parts helps keep their complexity at a manageable level.

FIGURE 1.2 Screenshots of Modeler.

The Roles of Layout and Modeler

There are a few functions shared by both Layout and Modeler, but on the whole, they each have a specific job to do. If 3D animation was a theatrical play, Layout would be the stage and Modeler would be the workshop and prop department.

A theatrical stage is a good analogy for 3D animation, because on stage as in 3D animation, you are duplicating the outside world, presenting things more in the way they are perceived than the way they actually are. A marble column and a brick wall may look real to an audience member, but in reality they are plaster, paint, and cardboard, likely to not even have a back side, if that back side was never intended to be seen by the audience.

In the LightWave Layout screen, the stage is set. Objects are brought in and positioned. Lights are rigged, filtered, and focused to flatter the

subject or direct the eye. Movements are blocked and characters are choreographed. Every movement is a dance. Every piece of set dressing exists because someone specifically placed it there. The word *animate* means *to give life*, and all of that is done on this stage we call Layout.

The upper-right corner of the LightWave Layout screen contains a button that activates the Modeler program. The Modeler program can also be launched directly without first starting Layout. Modeler is the workshop—the prop department, the costume shop, and the garage. Anything that catches light in Layout begins in Modeler, whether a table, turtleneck, or T-Rex. The process of creating the geometry is an art unto itself.

Layout and Modeler overlap in just a few areas. Some of the texturing tools used to paint subjects have made their way from Layout into Modeler. Likewise, a few of the object deforming tools used in Modeler can now be applied to an animation in Layout. These capabilities were introduced after users told the programmers at Newtek what they need to make their jobs easier and the animation pipeline more streamlined.

What It Means to Be an Object

In 3D animation, an *object* is a very specific thing: it is the set of data that describes the shape and attributes of the item we want to create. The object is sometimes referred to as a *data set, mesh,* or *wire-frame model.* An object is a file in the computer much like a text document; we generally create the object in Modeler, shape it into the form we want, label the specific surfaces, and save it to use in Layout.

If the object in question was a simple box, the object file could be explained as "there are corners at these four locations in space, and the corners are connected by this surface, and the surface is red and shiny." The object file gives the exact numeric positions of each of the four corners and the specific RGB and secularity values of the surface, and it is really nothing more than that.

Any object is simply a list of the positions of each point in the wire-frame model, and the surface attributes of every plane created by stitching those points together. The model may be a three-point triangle, or a 3 million-point starship, but it really is no more complex than that—a larger object just contains a longer list.

The Scene File

If 3D animation is like a stage play, the Scene file is the script. Layout has objects, lights, and cameras, and they all need to be told were they need

to be and what they need to be doing. Even if something is not moving, it still needs to be in the correct position. All this information is contained in the Scene file.

When LightWave is launched and the Layout screen appears, we see the default scene setup, one camera, one light, and no objects. It is an empty stage, but a stage nonetheless. As objects get loaded and put into position, the scene becomes more complex. Every change to every layout item is dutifully accounted for in the Scene file. Once the scene is saved, the position and action of all the items are recorded. If Layout is shut down without saving the Scene file, all is lost; the scene will not be there when LightWave is restarted.

It is important to remember that in 3D animation, nothing comes free. The animator is in charge of the entire universe. There is no light unless directed by you. There is no background, floor, or sky, unless you place it there. The implications of this will become apparent as you start building scenes.

What the Scene file basically contains is "lights, camera, and action." The position of everything that can be moved—its motion—is contained in the Scene file. The settings for the lights—their intensity and color—are recorded in the Scene file. Even the settings for the final rendering—the size of the image, the quality, and even the number of frames—are all recorded in the Scene file.

If anything in a scene gets changed, the Scene file needs to be re-saved so that the new settings are recorded for the next time that scene is loaded. Even very complex scenes are usually fairly small as far as computer files go, allowing you to number your scenes and save new versions often.

There are a number of things, however, that the Scene file does not save. The Scene file does not actually contain the objects specified in the scene or the images that may be used in object surfaces; the Scene file contains the location where those objects and images may be found. The Scene file is a set of directions. A scene may call for a box and a red ball, which would both be loaded from the objects directory. If, during the course of building the scene, the ball surface gets changed from red to blue, that is a change to the attribute of the object, *not* the attribute of the scene. The modified ball needs to be saved as an object to retain the change; saving only the scene will not save changes made to the surface of an object. This is a common stumbling block to many new LightWave users.

Rendering an Image

After the stage is set, the lights are on, and all the objects are positioned and textured, it is time to render the frames. When a scene is set up in

Layout, we work with a low-resolution preview. Real-time displays of the objects, textures, and lights have become amazingly good, but to get the final full quality image, the scene needs to be rendered.

When a frame is *rendered,* it generates an image from all the objects, textures, and lights in the scene. The rendered image is the final output of the scene setup in Layout. Rendering a frame can take from seconds to days to complete, depending on the complexity and resolution of the desired image.

In animation, its many frames are rendered sequentially, one frame at a time, and saved in an image format you choose to a specified directory.

LightWave also has the option of rendering directly to an animation file such as a QuickTime or an AVI. As each frame is rendered, the rendered frame is appended to the animation file containing the previous frames. Although this is convenient, particularly for quick testing and for those with limited resources, you are generally better off rendering the sequence of frames first, then, once all the frames of the animation are rendered, compiling the frames into an animation format. Not only do you prevent the possibility of losing all frames if you abort a render before it finishes writing to the animation file, this method also provides more flexibility, allowing you to start and stop the rendering sequence at your convenience.

Frequently, only a single frame is rendered, usually for an image destined for print. Print generally requires a much higher resolution image than does multimedia, video, or the Web. LightWave is well suited for creating high-resolution images for print because of its high quality rendering engine and its option to render the square pixels that print images require.

OBJECTS AND MODELER

To create images and animation in LightWave, you need *geometry*. By geometry, I mean a LightWave object made up of points and polygons. With the exception of some tricks with lights and background textures, you must have surfaces in the scene that light will bounce from to give us something to see.

The creation and modification of objects all takes place in Light-Wave's Modeler program. This section covers how objects are manipulated in Modeler, how to navigate the Modeler program, and the use and location of some basic Modeler tools. After completing this section, you should have a rough familiarity with Modeler's basic functions.

Start the Modeler program and follow along as we present the various functions of the Modeler interface.

Loading and Saving Objects

There are two ways of getting an object into Modeler: you can create a new object from scratch, or you can load a previously created object. When Modeler is first opened, it presents you with an empty *quad* view of the Modeler environment, the workspace where objects are created and manipulated.

In the top-left corner of the Modeler screen is a button labeled File (see Figure 1.3). Clicking the File button brings up several options for loading and saving objects. Select Load Object.

Selecting Load Object immediately opens a requestor box for selecting the object. Navigate to the Objects directory of the Newtek folder and

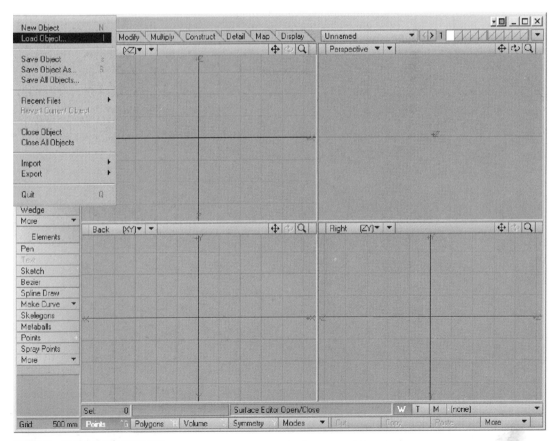

FIGURE 1.3 Modeler's File requester.

locate the directory inside the Objects folder called Animals. Inside the Animals folder is the famous LightWave Cow object. Select and load the Cow object. The Cow object will appear.

As with most software, Modeler provides two save options. You can select Save Object, which will overwrite the original file. Alternatively, you can select Save Object As, which allows you to save the current object as a new file, thus retaining the original.

If you have several objects open at one time and want to save all of them before closing down the program, you can select Save all Objects. All the objects will be saved even if they are not currently in the foreground. If you want to get rid of an open object, select Close Object. Note that closing an object does *not* save it to a file. (Modeler has sets of commands that deal with multi-layered objects, which we will cover later.)

Before we discuss how to manipulate the geometry, let us first cover how to manipulate the view. Along the top of the Modeler screen is a row of tabs (see Figure 1.4).

FIGURE 1.4 Modeler tabs.

Selecting each tab brings up a list of buttons on the left side of the Modeler screen that activate tools and functions that relate in some way to the selected tab. Click on the Display tab to bring up the various display options listed under Viewports in the buttons on the left side of the screen. Most of the options will be self-evident or become obvious after a little experimentation.

Click the Magnify button. The mouse pointer changes into a miniature magnifying glass. By clicking on the screen and holding down the mouse button you can zoom in and out of the view screen. (Please note that you are changing only the view of the object, not the size of the object.)

Next, look at the button labeled Fit All at the upper left of the toolbar under the Display tab. The fit-all function is probably the most used function in Modeler. Clicking Fit All automatically sizes the viewports to fit the currently visible object.

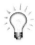

The Fit All topic leads to the topic of hot keys. *Hot keys are keyboard shortcuts that allow you to perform the function listed on the interface by pressing a key or key combination rather than clicking a button. If you look closely at the menu selections on the Modeler interface, you will notice that most of them have a keyboard equivalent posted on the right. The Fit All selection has the letter* a *associated with it. This means that pressing the lowercase* a *on the keyboard performs the same function as clicking Fit All.*

Posting the keyboard shortcuts next to the function buttons is a thoughtful addition to the interface. It is good practice to become accustomed to using keyboard shortcuts, because using the shortcuts can increase productivity by reducing the number of times you must jump between menu tabs in the middle of a project.

The Viewports section of the Display tab allows you to navigate within the viewports, but you also have several viewport options. At the far left of the control bar in each viewport are the View Type options. Clicking on the View Type option will bring up a list of eight views of the object (see Figure 1.5).

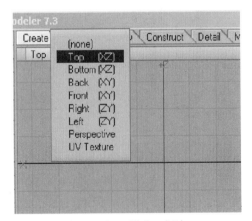

FIGURE 1.5 Viewport bar with list of view types.

Any of the viewports can use any of the view options, whether in the horizontal, vertical, or perspective (see Figure 1.6).

Next to the View Type options button is the Rendering mode button (see Figure 1.7).

Rendering mode determines how the image will look in the viewport. Rendering mode can be changed at any time during the course of the project; it has no effect on the real geometry of the object or its final render, and it is purely for visual reference.

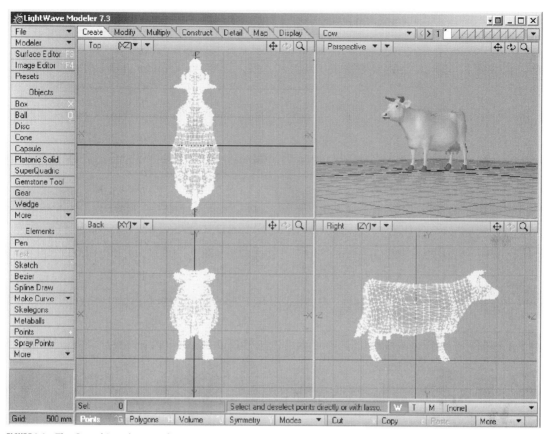

FIGURE 1.6 The Cow object shown in four views.

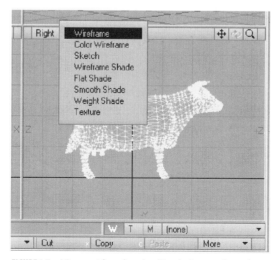

FIGURE 1.7 Viewport bar showing Rendering mode options.

The far right side of the viewport control bar contains three navigation tools. Clicking the tool and holding down the mouse button and dragging operates the tools (see Figure 1.8).

FIGURE 1.8 Viewport control bar navigation controls.

The first button with the four joined arrows moves the current viewport left, right, up, or down. The second button with two arrows in a circle only works when the viewport is in Perspective mode; it allows you to rotate the view. The third button, the magnifying glass, allows you to zoom the viewport in and out.

What an Object Is

Any object that we load into Layout is referred to as *geometry*. Do not let the word *geometry* scare you. Breaking an object down into its geometric structure is the most convenient way to describe the way in which an object is put together.

If you look closely at the Cow object in Wire Frame mode, you can see that it is made up of many points strung together. Each point (often called a *vertex*) has its own "serial number," and specifies a specific location referenced from the center of the object. Think of each point as a pin in the 3D map of an object; each pin specifies its location using X-Y-Z coordinates.

When you set a table for a meal, you are arranging plates and silverware in 3D space. The height of the table is the Y axis, the distance from the floor to the tabletop. If you place the fork on the right of the table, the horizontal distance from the center to the right is the X value; a knife placed on the left of center is still on the X axis, but it is a negative X value. Forward and behind the center is the Z axis. The chair you sit on would be a negative Z value. A chair directly across the center of the table would have a positive Z value. In other words, three things are needed to accurately describe where each object is: how far from the center to the right or left it is (the X value), how high it is (the Y value), and how far ahead or behind the center of the table it is (the Z position).

Points vs. Polygons

An object is made up of a group of points. A *point* is nothing but a num-bered dot that has a name and a location. To give the computer some-thing to render, the object needs to have a surface. A point is a placeholder for location data; we stitch these points together to create a surface that will react to light and can be seen by the camera. The surface created by these points is called a *polygon*.

Joining three or more points to a surface creates a polygon. One- and two-point polygons also exist, which are referred to as *degenerate geometry*, because, strictly speaking, you need at least three points to make a poly-gon. However, one- and two-point polygons can sometimes be very useful.

The polygon is what we actually see in a rendered image. The poly-gon has a surface (sometimes referred to as *face*) that holds all the infor-mation on the polygon's characteristics.

Points do not get rendered and are not seen in the final render; only the surfaces of the polygons are rendered in the final image. The polygon surfaces are given *attributes*. The attribute may instruct the image to ap-pear "shiny and red" or to be "blue, bumpy, and 50% transparent." The way in which a polygon is instructed to appear in the final render is re-ferred to as its *surfaces attributes*.

If you are having trouble mentally picturing how points and poly-gons work together, imagine it this way. Say you had three clothespins, a rubber band, and a bowl of soapy water. Stretch the rubber band around the three clothespins to make a triangle, and then dip the triangle into the soapy water. The bubble film in the middle is the polygon, the clothespins are the vertex points, and the rubber bands represent the edges of the polygon. If you have more hands, or several understanding friends, you can add more clothespins (vertexes) to create a more de-tailed outline of the soap polygon.

Polygons need to be flat, which is why they are often referred to as *planes*. This does not mean "flat on the ground"; rather the term means flat like a sheet of glass. Even the most curvaceous object is made up of many flat-edged, straight-line segments. The polygon is the basic building block of an object, and with it the computer calculates its image render. A smoothing setting in the surface attributes makes the surface appear as a seamless curve rather than a mosaic of flat planes, but the smoothing at-tribute only works properly when it has appropriate geometry to work with.

Virtually all objects are made up of both points and polygons. There can be no polygons without points to give the polygon corners. Modeler

can work in both Point or Polygon modes for modifying objects; a button at the bottom of the Modeler screen activates either Point mode or Polygon mode for work on the models.

Mouse Controls

Nearly everything in LightWave can be adjusted interactively by using the mouse. Most of the numeric controls include up and down arrows to nudge values higher and lower. Most objects in Modeler can be selected and grabbed by clicking and dragging. This brings us to the single biggest issue in LightWave being a truly transparent cross-platform program—the one button mouse that comes with every Mac.

Since its original inception on the Amiga computer over a decade ago, LightWave has been designed to work with a two-button mouse, and the two-button mouse is an integral part of its functionality. Every Mac, on the other hand, is shipped with a single-button mouse. That single button is the equivalent of the left mouse button (LMB) of any PC. To access the function of the right mouse button (RMB), you must hold down the Control (Apple) key on the keyboard prior to clicking the single mouse button. Many people choose to simply purchase a two-button mouse that will work with the Mac.

command key ⌘

Creating Primitives

The first tab at the top of the Modeler screen is the Create tab. As the name suggests, the tools under this tab allow you to create new geometry.

Close the Cow object if it is still open in Modeler. Click the File button and select Close All Objects. If the geometry of the Cow object has been modified in any way, a requester will pop up asking if you want to save the changes made to the Cow object. Select Don't Save to prevent any harm from coming to the cow.

Once all the Modeler viewports are clear, click the Create tab. All buttons under the heading Objects allow you to create objects. Click the Box button to activate the Make Box tool. Next, click and drag the mouse inside one of the viewports to create a box. To give the box thickness, release the mouse button and click and hold in one of the other viewports to draw the square out to a box.

You are now looking at a "preview" of the object. Its size and shape can be manipulated within the Make Box function until its shape is frozen, at which time other tools will be needed to modify its shape.

There are several ways to "freeze" the box. Simply turn off the Make Box function by clicking on the button again, which will "make" the box. You can also hit the Enter key or click the RMB to freeze an object.

These basic functions work the same for most of the object creation buttons. Click the desired button (Box, Ball, Disc, etc.) to activate the tool, draw it out in the viewports, then deactivate the button or hit the Enter key to make the object.

Selecting and Deselecting

When you modify an object, you typically want to affect just a portion of that object. Therefore, you select the portion of the object so that only those selected portions are affected. Parts of an object can be selected in Point mode or in Polygon mode. However, it is important that no tools are activated when you start the selection, because sections of an object can only be selected or deselected when no tool is active.

There are two ways to interactively select portions of an object with a mouse. The simplest way is to click and hold the LMB and draw it over the desired section. This action will highlight the selected areas. When a portion of an object is selected, only that highlighted portion will be affected by any action in Modeler. (The exception is saving the object—the saving action saves the entire object, not just the selected portions.)

You can continue to selection portions of the object for as long as you hold down the LMB. After you release the mouse button, clicking on the LMB and drawing it over the object again will now deselect those portions. To continue to add to the selection once you have released the mouse button, hold down the Shift key.

The second way to select areas of an object with the mouse is to use the RMB and the lasso tool. Holding down the RMB with the lasso tool allows you to select specific areas of the object. As before, if you release the mouse button, repeating the RMB action will now cause the area to become deselected unless you hold down the Shift key.

To quickly deselect all the selected areas of the object, click on an empty area of the menu bar on the left. Clicking an empty space near the tool buttons will cause all the highlighted sections to turn off. Once again, selecting and deselecting can only be done when no tools are active.

Sometimes you need to select points, and sometimes you will want to select polygons. The bottom of the Modeler screen contains the two buttons that allow you to choose to work in Point mode or Polygon mode.

Locus of Control

In Modeler, only a very specific point of an object is the center. No matter where in the viewport an object is created or moved to, that center is the pivot point of that object.

The *pivot point*, sometimes called the object's *axis*, is the handle for that object. When the object is saved and loaded into Layout, the pivot point is the specific point around which the object revolves. The pivot point is often in the center of the object, like the center of a wheel; however, it might be off to the side, like the hinges of a door. The universe of the Modeler is like a big cube, and an object's rotation is based on the exact center of that cube. If the geometry of the object is moved to the far corner of that cube and saved that way, that object will be way off center when loaded into Layout and rotated like a planet around the sun (a manipulation you may want to do on purpose some day).

Beginners frequently have problems keeping their models "on center." An object often ends up far off axis and the beginner attempts to compensate by adjusting its position in Layout. To help keep the models within reasonable tolerances, the Modify tab contains several useful tools. These tools are listed toward the bottom of the list of buttons under the Move section. Clicking the Center button automatically moves the object to the center of the Modeler universe. Center 1D will center the object on one axis that you specify. The Rest_On_Ground tool will make the bottommost point of the object equal to the ground plane. If you quickly familiarize yourself with these tools, dealing with objects will become much easier.

Numeric Values

Like it or not, everything in 3D animation is about numbers. It is made less painful by the fact that you can do most everything by scooting the mouse around, but quite often it is necessary to enter exact values. Nearly every function in Modeler can be addressed numerically, quite handy when you are building things to scale, or need a rotation of an exact angle. These values get entered in the Numeric box.

The Numeric box functions for all the Modeler tools, changing its options to match the active function. The quickest way to open the Numeric box is to use the keyboard shortcut. Pressing the lowercase *n* key will open the Numeric box even if the tool is already active. The Numeric box can also be activated as follows: go to the top-left corner of the Modeler screen, click on the button labeled Modeler, scroll to the listing for Windows, and select Numeric Options Open/Closed. As you can see, pressing the *n* key is far easier.

If the mouse is affecting changes to the object, you will see the values being updated in the Numeric panel value boxes. The values will appear in the box even if the Numeric panel is not open at the time of the action. This function is useful because you have a record of the last action taken, allowing you to make note of the values of the last action.

Numbers can be typed directly into the value boxes of the Numeric box. However, the values will not take immediate effect; you must either click the Apply button for modifications, or press the Enter key.

Undo, Redo, Copy, Cut, and Paste

Sometimes while you are creating an object, you might find you have taken a series of wrong steps. The LightWave Modeler has multiple levels of *undo*, with a default of eight steps of undo. Repeatedly clicking the Undo button will step through your previous actions. If you go beyond the number of undos you wanted to take, the Redo button reapplies the steps taken.

Though the default number of steps that can be undone is eight, it can be increased to as many as 128, but be warned that those 128 levels of undo can be quite taxing on even the best-equipped computer systems. You can set the number of undo levels in the General Options panel, as follows; click the Modeler button in the upper-left corner of the Modeler screen, scroll down to the Options section, and select the General Options command. At the bottom of the General Options window is the setting for the maximum number of undos.

The Copy, Cut, and Paste commands work very much like the copy, cut, and paste functions you would find in any word processing program. If, when you click Copy, nothing on the object is selected, the entire object will be copied into the memory buffer. If a few polygons are selected, only those polygons will be copied. If Modeler is in Point mode, selected points will be copied and not the polygons connected to those points. The Cut command works similar to the Copy command. Points or polygons are copied and removed from the current layer. Elements that are cut or copied can be pasted back into the same object, into another layer, or into a completely new object.

LAYOUT

When you start the program called LightWave 7, what opens is the Layout screen. Layout is where all the really fun stuff happens—here the objects and lights are positioned for the final rendering of the animation. Most of the surface texturing also is done in Layout.

Before you can start making animation, you need to understand some basic concepts about how the Layout interface operates. This section will not cover every detail, but it will cover a number of the basic functions to allow you to navigate well enough to work through the exercises in this book.

General Options and Display Options

When you enter LightWave, you are greeted with the Default layout screen, which is a perspective view that gives you an overview of your 3D animation stage (Figure 1.9).

You should understand one important concept from the beginning. There are three types of files that you need to keep track of when working in Layout: Scene files, Object files, and Image files. These three files generally each have their own directories, and all three are kept in a par-

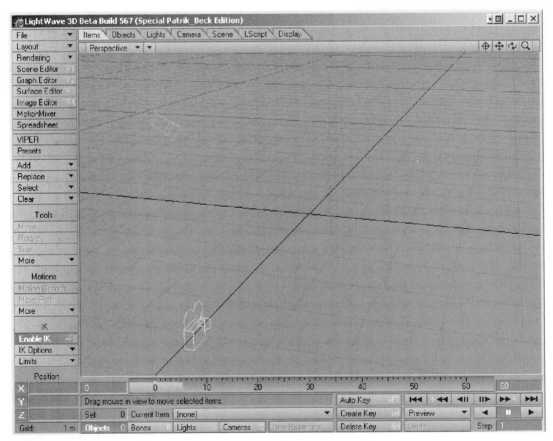

FIGURE 1.9 The default Layout view.

ent directory. This parent directory is considered the *Content Directory*. LightWave first looks in the Content Directory for all the files it needs in Layout. If it does not find what it needs, a requester will pop up asking for help finding the file. Source files can be kept in directories other than the ones specified for the official Content Directory (like loading images from the My_Pictures folder). However, you must remember that you have used source files outside the official Content Directory when you back up projects or move projects to another system.

A Content Directory usually has three subdirectories: Scenes, Objects, and Images, within it, though it is not strictly necessary. LightWave does expect to see these three directories, however. The default Content Directory is the Newtek folder itself, which has other directories as well as the Scenes, Objects, and Images directories.

The Content Directory is useful in environments that have shared recourse, like a school or workplace, where you would need to keep your personal files safe and private. It is also useful sometimes to keep all files for a particular project or for one client in one Content Directory to make the files more portable and more convenient to back up.

To specify a Content Directory, go to the upper-left corner of the Layout screen and click the button labeled Layout. Scroll down to Options and select General Options. The Preferences panel will appear with the General Options tab active. The very first line in the General Options tab is for the Content Directory. If you are using this text in a learning environment, you may want to specify your own personal Content Directory. Create a master directory that contains three directories named Objects, Scenes, and Images. Select the master directory as your Content Directory, and the Layout will automatically default to loading and saving to those directories.

The Preferences window also contains a Display Options tab. The default settings for the Display Options are fairly constrictive, but they do allow you to maximize your viewing for the system you are using. One setting you should consider changing is the Bounding Box Threshold. The Bounding Box Threshold is the number of polygons in an object that Layout will continue to display before it gives up and just represents it as a box when it is moved in the viewport. The default level is 0, meaning any object will blink into a bounding box if it is moved. Depending on the speed and memory of your system's video card, a more practical value for the Bounding Box Threshold is between 500 and 50,000.

When the Content Directory and Display Options settings have been altered, the new settings are recorded in a configure file that gets written automatically when LightWave is shut down. The settings will still be there the next time LightWave is started. If the program exits unexpect-

edly (such as in a crash or power outage) before the configure file gets updated, then settings will not be remembered. If the configure file is accidentally deleted, all the settings will return to their default values.

Setting the Content Directory for the Book

The concept of the Content Directory is confusing to many people, but it is really just a way to tell LightWave to "look here first" for scenes, images, and objects. This becomes an absolute necessity when working with multiple computers.

ON THE CD

This book includes a companion CD-ROM filled with support material for all lessons and tutorials in the book. All support material is located in a directory on the CD-ROM labeled Primer. Understanding the process of using the Content Directory function will make using the complimentary materials much more convenient.

There are three ways to access material from the CD-ROM. The first is to copy the Primer files from the CD-ROM into the current Content Directory on your hard drive. If you have the CD-ROM in your drive and the Content Directory still points at one of the directories on your system's hard drive, files can be loaded from the CD-ROM, but requestors will continually appear asking for locations of objects and images. The easiest way around this is to copy the Primer files from the CD-ROM to your hard drive. The files from the Images directory on the CD-ROM should be copied into the Images directory on your hard drive. The same should be done with the files in the Objects directory and the Scenes directory. Once you have copied the files, scenes should load without a problem.

Another good option is to copy the entire Primer directory from the CD-ROM to its own location on the hard drive. This can be inside the current Newtek directory, or any other section of your computer you have access to. Copying the files will require that you open the Options panel and point the Content Directory to the proper location. Click the button for Content Directory and select the Primer folder. Now, when you close LightWave and start it up again, it will automatically look in the Primer folder for all scenes, images, and objects. This method has the advantage of keeping all the book material separate from the stock LightWave content. It will also allow you to save your work in a convenient and private location if you are working on a computer that is shared by others.

The third way is the quickest but least flexible: the Content Directory can be set directly to the CD-ROM. Choosing the Primer directory on the CD-ROM as the Content Directory allows you to quickly load and browse Scene and Object files from the book. The drawback with this method is that you cannot save any new or modified files to the CD-ROM, which

means that the files would be saved to directories outside of the established Content Directory. This option should be used only if you are very low on hard drive space, just browsing the book, or do not have privileges to copy material to the hard drive.

Loading and Saving

At the top left of the Layout screen is a button labeled File. Among other things, the selections under this button will load and save Scene and Object files. The first time you select either Load Scene or Load Object, the program will automatically pop to the Scene or Object folder indicated by the setting of the Content Directory. The second time you do a load operation, LightWave will open to the directory of the previously accessed file.

Scenes and objects are saved in manners consistent with normal software. Selecting Save will overwrite the existing file, and LightWave will ask you to confirm if you really wish to do that. A Save As action gives you the opportunity to save the file with a new name and a new location. (Object and Scene files are relatively small compared to the current capacity of hard drives, so it is recommended that you save early, and save often.)

Depending on your computer's operating system, file extensions may be required. The proper file extension for an object is .lwo, as in Race-Car.lwo. This extension is an abbreviation for LightWave Object. The proper extension for a Scene file is .lws, as in Sunrise.lws; the extension is an abbreviation for LightWave Scene.

Object and Scene files saved with proper extensions are compatible between computer platforms. If you are working on only one system, LightWave will automatically do what is correct for that system. If you are in an environment where files get transferred between Mac and PC computers, the use of extensions is highly recommended. (Another recommendation is to keep the file names under eight characters, not counting the extension, and do not use any empty spaces in the name. This precaution may not be necessary much longer, but currently may save aggravation.)

There are a few additional saving options you should take note of. LightWave provides an option to Load Items From Scene. This option combines scenes; all the elements in a selected scene are loaded into the current scene. If you choose to load all elements into a scene, you need to be conscious of the relative size of the objects with which you are working. In most cases, LightWave does not care if you are working with millimeters or miles, but if you load a 50-foot chair into a 2-foot house, someone is bound to notice. You can go in and rescale everything so it all

matches, but that kind of defeats the purpose of doing a Load Items From Scene.

The Save Copy command allows you to save a duplicate of what you are working on without changing anything in Layout. Usually when you do a Save As of a scene or an object, that newly saved file becomes the Layout item. If you have the Cow object loaded, and you save it as BrownCow.lwo, the scene will now have BrownCow listed in Layout, and will save it that way when the scene is saved. The Save Copy command, on the other hand, will not change how the scene is listed in Layout.

If an item is added, changed, or deleted in a scene, that scene needs to be saved. Every time you start up LightWave it starts with an empty Layout. The Scene file only remembers what was done to it since the last time it was saved. Though this can be frustrating when a system crashes in the middle of a project, it can be a blessing when you have messed up. Once again, save early and save often. Even a floppy disk can hold several hundred Scene files. Because LightWave is so powerful, it allows you to make big mistakes really quickly, and you soon come to understand how important it is to regularly use the Save As button.

Object and Scene Files

It is important to understand the relationship of objects in scenes. The Scene file is the script for the animation: it tells everything where it should be and when things should happen. Objects are like the actors. They are called in for their roles, pushed around, and directed how to behave. The Scene file is a list of commands that basically says, "Get in here, go over there, now do this." An Object file is a file that says, "this is what I am, this is how I am shaped, and this is what I look like."

An important point that will be repeated several times is that *object characteristics are not saved with the Scene file.* If you have an animation of a red bouncing ball, the scene will look into the Objects directory, grab the ball, and tell it to move up and down. The Scene does not know the ball is red; that information is part of the object file. If, in the course of modifying the scene, the surface of the ball is changed from red to green, the ball object will need to be saved in order to retain those changes. Saving the scene will not save changes to the object.

Image files are a special case. If the image is part of the surface of the object, like the wrapper of a soda can, the image is a reference in the Object file characteristics. If the image is not connected to any surface geometry, such as in a background image, it is part of the Scene file. If an image has modified the actual geometry of an object, it is part of the

Scene file. Image file usage can get a bit complicated, but it is eased a bit by the fact that LightWave works with virtually all standard image formats.

Layout Items and Environment

There is more to a scene than just objects. A scene also contains lights and cameras, both basic and necessary. (There are also optional items like nulls, bones, skeletons, and effectors, but those will be discussed later.)

The currently activated box determines the class of Layout items on which you are currently working (see Figure 1.10). The Current Item box indicates the item that is active, the one that will be manipulated. Clicking the Current Item box will present a list of all of that class of items that is currently in the scene and allow you to select the one with which you desire to work.

FIGURE 1.10 Layout items and Current Item box.

Three processes—translation, rotation, and scale—may affect these items. These three processes are represented by three buttons under the Tools section of the Items tab: Move, Rotate, and Size (see Figure 1.11).

FIGURE 1.11 Layout tools.

Move

Translation is another way of saying "being moved." As with Modeler, the Layout environment is built around an X-Y-Z coordinate system. If an item is moved left or right, it is moved on the X axis. Two steps right of

the center is a value of 2. Two steps left of the center is a –2. The Y axis is up and down, above and below the ground plane, which is represented as a grid floor in Layout. If an item is moved two steps above the ground plane, it has a value of positive 2, and if it is moved below the ground plane it has a Y axis value of –2. The Z axis is forward and back. Moving toward you is the negative value of Z, and straight back from the center is a positive Z value.

Rotate

The *Rotation value* tells you which way an object is spinning. The angles for rotation are described as H-P-B (Heading, Pitch, and Bank). Learning rotation directions will quickly become easy once you begin using the program. For now, here is a quick description of the directions for each axis of rotation. *Heading* spins an object like a record on a turntable (or a CD-ROM in a disk drive for you kids). *Pitch* makes the object do somersaults, turning like a water wheel facing forward edge on. *Bank* spins the object like the blade of a fan that is facing you.

Whenever an item is added to Layout, it always starts with its pivot point exactly at the zero point for both the position and rotation. The X-Y-Z coordinates and the H-P-B angles all read 0, 0, 0.

Size, Stretch, and Squash

The *scale* factor is the size of the object. Scale can be adjusted with three different tools, Size, Stretch, and Squash. When an item is added to Layout, it defaults to a scale of 1, 1, 1, for all three axes. This means that the Scale values are multiples of the default size. If the object is scaled by 2, it will be twice as big as when it was loaded. A scale value of 0.5 means it will be half the size. Do not let this scare you, but a scale value of –1 will actually turn the object inside out!

The Size tool scales the object on all three axes equally; it magnifies and shrinks the entire object in proportion. The Stretch tool differs in that it can scale an object unequally, changing its relative thickness, height, and depth to different ratios.

The Squash tool is similar to the Stretch tool. The difference between the Squash and Stretch tools is that when an object is scaled on one axis, the other two axes try to compensate by moving in the other direction. The Squash tool automatically attempts to maintain the volume of the object by inversely scaling the unselected axes. Although this sounds rather complicated, it is quite intuitive. If Stretch is used to make a box

shorter, it just gets shorter. If Squash is used to make a box shorter, the sides move outward, just like it is really getting squashed.

The scale controls, Size, Stretch, and Squash, are used mostly for objects and bones; the controls have no effect on Cameras, and will affect only certain types of Lights.

Keyframes

The term *keyframe* has been appropriated from classic animation terminology, but it means basically the same thing in 3D animation. In traditional animation, to chart out the movements of the animation certain vital points, known as *extremes*, were drawn first. After the extremes were worked out, *key* frames were drawn to show the path the animation would take to tie together the extreme poses. The keyframes are intended to be all the important points in the animation, separated by transitional frames called *inbetweens*. Those with the lucky job of creating those in-between frames are known by the unflattering name *'tweeners.'*

In 3D animation, the computer does the actual rendering of the images, but it needs the same keyframes, sometimes referred to just as *key*, to know what goes where and when. A keyframe says to a Layout item "When you get to this frame, I want you to be in this position, at this angle, scaled to this size, and have these values." An animated item will have several keyframes, each with its own set of directions. When the key points are separated by inbetweens, the computer will calculate the amount necessary to change the values for each frame for it to go smoothly from one key to the next. The computer, in other words, becomes the 'tweener. There may be one key for an object at frame 5, and another at frame 26 placing it somewhere else. The computer will calculate the movement necessary for each of those 21 frames between frame 5 and 26 to create a smooth movement.

The concept of keyframes is an important one. Each item in Layout has its own set of keyframes. Any item may have anywhere from a single keyframe for the whole animation, to a keyframe on literally every frame. Different items have different sets of keyframes. A light may have a keyframe of frames 0 and 120, but the camera could have keys and 0, 20, 90, and 106. Keyframes of Layout items are all independent of each other.

At the bottom of the Layout screen there are three buttons concerning keyframes: Auto Key, Create Key, and Delete Key (see Figure 1.12).

Skipping Auto Key for the moment, let's look at the button for making a keyframe, Create Key, and the one for getting rid of a keyframe, Delete Key. When you click the Create Key button, a requester pops up asking on

FIGURE 1.12 Auto Key, Create Key, and Delete Key buttons.

which frame you would like to have a keyframe generated for the currently selected object with its current set of values. The default frame number in the keyframe requester box is the current frame in the Layout view. Most of the time you will want the key to be on the frame you are working on, but you may want the item to be keyframed at another place in the animation. To put the key at a location other than the current frame, simply type the desired frame number in the Create Key At box.

The Delete Key's function is the exact opposite of that of the Create Key. If an existing keyframe is to be removed, the Delete Key function will get rid of it. Once again, the Delete Key function does not need to be activated in the current frame. The frame number with the key to be removed can be specified in the Delete Key At box.

The Auto Key button works with keys that are already created. When Auto Key is active, any adjustments made to the item will be locked into the keyframe. If an item is keyframed into position and then moved with Auto Key turned on, the new position is now the keyframed position. This is a mixed blessing at best. In normal operations, most animators prefer not to use the Auto Key option because it is so easy to accidentally alter keyframes. With Auto Key turned off, the new values for the keyframe need to be locked in by using the Create Key function. If the new position is less desirable than the original keyframed position, moving off that frame and back to it again will cause the object to return to its original key settings.

One more word about Auto Key. the Options>General Options panel of the Preferences menu contains the Auto Key Create option that becomes available when Auto Key is active. What this will do is automatically create a keyframe every time a layout item is manipulated in Layout. In certain situations this might be useful, but it is recommended that beginners in particular work without the Auto Key Create option and the Auto Key function turned off.

Channels

The term *channels* is relatively new. A channel is basically any event that can be keyframed. As LightWave matures, more and more animation el-

ements are given the option to have keyframes applied to them. Later, when we discuss surfacing, we will see how even the surface color of an object can be made to change throughout an animation.

When a keyframe is created for an object in Layout, the Create Motion Key requestor box appears. Inside this box are listings for Position, Rotation, and Scale. Each of these listings has three channels—Position has X, Y, and Z, and Rotation has H, P, and B. You can deactivate the channels as a group by clicking on the group heading button or access the channels one at a time by clicking on the individual letters themselves. Each of the letters in the Create Key popup menu is considered a channel and can be controlled on an individual basis.

Why would you want to be able to keyframe on individual channels? Imagine an animation of a top spinning on a table for 300 frames. The top may spin completely around 100 times during the course of the animation. The top will also move randomly around the table as it spins. The actual spinning can be keyframed at the first and last frame by using only the H (Heading) channel. This channel will make the top spin at a constant speed from beginning to end. By deactivating the Rotation channels and using only the Position channels, many keyframes can be created for just the X and Z positions without interrupting the spin cycle. Deleting channels works in the same way.

LightWave has many, many channel settings. With the use of expressions as plug-ins, many of the channels can be linked together for more complex animation, but everything starts with a good understanding of the basic underlying principles of LightWave and 3D animation.

Item Properties

Item Properties is an important new addition to the LightWave Layout (see Figure 1.13). Every item in Layout has certain properties that are unique to that class of items. Lights have settings for intensity, for example, that would have no correlation to anything an object does.

FIGURE 1.13 Item Properties
button in Layout.

The Item Properties button is located at the bottom center of the Layout screen. Clicking the Item Properties button will bring up an Items Properties panel appropriate to the currently selected item (see Figure 1.14).

FIGURE 1.14 Item Properties for Objects, Lights, and Cameras.

Each class of Layout items will have a different set of options, but items of the same type will all bring up the same properties panel. The Object Properties panel is much different than the Light Properties panel, but all types of Objects will have the same Item Properties options just as all Lights will. The only difference in Item Properties menu options for items of the same type is that certain options may not be available for that particular item, in which case it will still appear but be grayed out and unavailable.

Some Item Properties menus have a number of submenus and item tabs within them. It can sometimes be a bit of a search to find the one function you need to access when it is buried with all these menus.

Mouse Controls

As in Modeler, everything in Layout can be moved with the mouse. Some functions require a single click; some require a click and hold. Once again, we are faced with the issue of the one-button versus the two-button mouse. Nearly all the functions are accomplished with the left mouse button (LMB) on a two-button mouse, which is the equivalent of the single button on the Mac one-button mouse. Unless otherwise stated, mouse clicks are LMB clicks. When a right mouse button (RMB) click is

required and you have no right mouse button, hold down the Control *Command* (Apple) key prior to clicking the mouse.

Possibly the most intuitive interaction in LightWave is the X and Z movement of an item in Layout. With the item selected and the Move tool selected, moving the mouse right and left while holding down the mouse button moves the Layout item along the X axis. Moving the mouse forward and back moves the selected item along the Z axis.

Rotating an item with the mouse is similar to using the Move function. Click on the Rotate button and hold down the mouse button as you drag the mouse. Moving the mouse left and right rotates the item on the H (Heading) axis like on a turntable; moving the mouse forward and back makes the object flip over on the P (Pitch) axis.

The point that stumps most users is how to move an object up and down on the Y axis. To move a Layout item along the Y axis you must hold down the RMB. Holding down the RMB will move the item *only* on the Y-axis. This is also true with the B (Bank) rotation—you must hold down the RMB in order to rotate an item on the B axis. *Command Key*

The mouse can also be used to select items. The Preferences panel under General Options contains the option Left Button Select. By default the setting is active, and most users leave it on. When this selection is active, you can select an item in the Layout viewport by clicking once with the mouse on or close to that item's pivot point. This is an occasionally frustrating but very useful function; it saves you from the necessity of selecting the Item Type and scrolling through the Current Item listing to select it.

Directly below the Layout viewport is the scrub bar (Figure 1.15).

FIGURE 1.15 The scrub bar.

To the left of the scrub bar is the start frame, typically 0 or 1. To the left is the end frame, a default of 60, but it can be any number you want. The bar determines the current active range of the scene you are working on. Click and hold on the scrub bar button to scrub through the animation. Note that complex scenes may have trouble keeping up with the scrubbing in real time.

The numbers to the left and right of the scrub bar determine the current working segment of the animation. The animation may be 600 frames long, but you need to work on frames 375 to 410. Putting those values in for the start and stop frames allows you to concentrate on just

that section of the animation. The start and end frames may be changed at any time. The frames that actually are rendered are determined at the time of rendering.

Constraining Movements

Control is an important element in animation. Many times you need to alter just one axis, or you want an axis locked off so it will not get changed. There are two ways to accomplish these tasks in Layout.

Handles that appear with each Layout item are a new feature in Layout. *Handles* are the multicolored arrows and circles that are connected to the pivot point of each item. Each Layout tool has three handles per function; each handle represents an axis. By clicking directly on a handle, only that axis will be affected. The handle constrains movement to only one direction at a time. Each handle represents a channel to that particular tool.

You can also completely lock off an axis for a Layout item. At the bottom-left corner of the Layout screen is the Numeric box (see Figures 1.16 and 1.17). We will discuss the box in the next section. For now, just notice that every time a tool is selected, the appropriate channels show up in the box.

FIGURE 1.16 Numeric box for Rotation.

FIGURE 1.17 Numeric box for Position.

Just like in the Create Key box, clicking on the letters for a channel deactivates that axis. If the Y axis for the Move tool is deactivated, even grabbing the handle in the Layout viewport will not make it move.

Turning off individual channels works on a per-item basis. One object can have its rotation completely disabled; the one right next to it might be free to spin but cannot be stretched on the Z axis. This information is saved in the Scene file; deactivated channels for items will be remembered the next time the saved scene is loaded.

Numerical Entry

Animation is all about numbers, whether you are creating objects or moving them around. Perhaps you want to Move, Rotate, or Scale an object to an exact amount. For these purposes, you will use the Numeric box in the lower left-hand corner of the Layout screen.

The Numeric box has two functions with regard to tools. It displays the current numeric value for the function being applied to the Layout item, and it also allows you to enter values directly. (As we described in the previous section, an additional function of the Numeric box allows you to disable certain channels of a tool on a per-axis basis.) The Tools section of the Items tab contains the Numeric button. This button places the cursor into the Numeric box. The Numeric box is for all intents and purposes always "on." You can at any point click the mouse inside any of the data fields of the Numeric box and type in values. Below the Numeric button in the Tools panel is the Reset button. The Reset button resets all the active channels to 0.

If a new value is typed into the Numeric box, or the Reset function has been used, these new values need to be locked in with a keyframe. If Auto Key is active, the new values will be automatically applied to the keyframe.

Undo and Redo

Layout has a button at the bottom of the screen just to the right of the keyframe buttons called Undo (Figure 1.18).

FIGURE 1.18 The Undo button.

To be honest, the undo function is not very good. The Undo button provides one "undo" to the Move, Rotate, and Scale commands—only if nothing else was done since that last command. Once undo is applied, the button will switch to a Redo button that allows you to reapply the previous change. If an item is moved off its keyframe, then moved again, the undo function will erase the last move. If there has been a change of frame, or something has been done to a different Layout item, the option to undo the move is lost. The undo function is quite valuable if you are accustomed to working with the Auto Key function active. It allows you to jump between the previous keyed values and the new keyed values by

clicking Undo/Redo. Remember, however, that once you move off that frame you lose the undo option.

Viewports

The Layout screen has the option of displaying several views at once with selectable levels of rendering. The default view of the Layout environment is a single perspective view that can display smooth, solid surfaces with a single texture map. Other options are available in the Display Options menu. Keep in mind that the amount of information LightWave can display is highly dependent on the power of the video card in your computer. The better the video card, the better the views and resolution LightWave will be able to display.

Clicking on the Display tab at the top of the Layout interface brings up a set of buttons pertaining to viewing the current scene. Clicking the Display Options button takes us to the Preferences panel with the Display Options tab active.

At the very top of the Display Options menu is Viewport Layout. Clicking on the button will give you a list of viewport options (Figure 1.19).

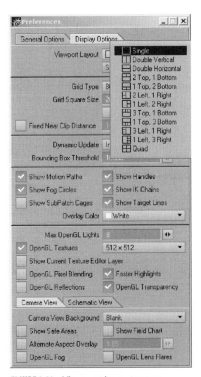

FIGURE 1.19 Viewport Layout menu showing viewport options.

These viewport options display the ways the Layout screen can be divided. The type of display you choose is completely a matter of choice, and can be adjusted on a per-project basis. (The Save As Default button allows you to save a favorite setting as a new default so that Layout will always appear in that configuration every time you start it.) Even if you do not save the screen configuration as a default, the setup of the current screen is saved with the Scene file so that when it is reloaded it will appear just as you saved it. Take a look at all the other settings in the Display Options panel. These settings help optimize the performance of an individual system and will be covered later.

Many of the functions in the Display Options panel are duplicated by the buttons under the Display tab, as well as some of the functions in the control bar of the viewport (Figure 1.20).

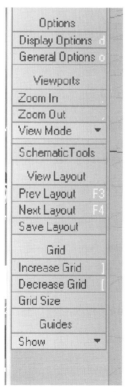

FIGURE 1.20 View Control buttons.

The View Layout buttons allow you to quickly cycle through the screen segmenting options, quite handy when choosing the best

configuration for a given project. The pair of buttons labeled Zoom In and Zoom Out are probably two of the least used buttons in Layout because the viewports each have their own set of controls (Figure 1.21).

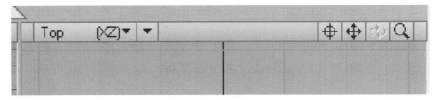

FIGURE 1.21 The Viewport toolbar.

At the top of each viewport are a set of controls to set the view type and level of rendering, and a set of navigating controls. Notice that these controls are almost identical to those found in the viewports of Modeler.

The view type control allows you to choose what angle or view the viewport should display (Figure 1.22).

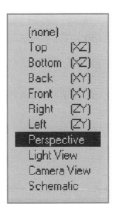

FIGURE 1.22 View options for the viewport.

The Camera view is the most important view because that is the view used in the final render. Any view other than the Camera can be used to help you set up the scene. The viewing option selected will affect only the selected viewport; by segmenting Layout into multiple windows you can view your scene from multiple directions simultaneously.

Next to the view selection button is a small down-pointing triangle that is easy to miss. Clicking this triangle brings up the rendering options for the selected viewport (see Figure 1.23).

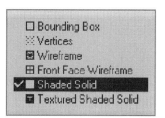

FIGURE 1.23 Rendering options.

It is important to understand that the rendering options selected for the viewport do not affect the final render. The rendering option settings for the viewport only affect that viewport.

You may wonder why you would want anything but the highest possible rendering level for a working view. There are several reasons to use the lower levels, mostly involving speed. Whenever a Layout item is manipulated in the scene, every object in that scene needs to be redrawn in every viewport that Layout currently displays. Even the best video cards have problems updating a scene with many complex textured objects in four viewports at once. Another reason is that sometimes it is helpful to work with objects you can see through. It is surprising how easy it is to lose stuff in a virtual world. Working in Wire Frame, Bounding Box, or Point view is like working with X-ray vision. Once again, each viewport can have its own render level setting, and that setting can be changed at any time.

On the right side of the viewport control bar are the navigational controls (see Figure 1.24). These controls are used to navigate in the subjective views; that is, the right, left, top, bottom, back, front, and perspective views. If the navigation control is not appropriate for the current view, it will remain ghosted and unusable.

The Camera view and the Light view options cannot be altered by the toolbar controls. They are only altered when the Camera or Light is altered.

FIGURE 1.24 Navigation controls.

The first control is a welcome new addition, the View Centering tool. When this tool is active, it will target the currently selected item to the center of the viewport. If a new item is selected, the view will jump to that item. The View Centering tool locks on to the pivot point of an object, not necessarily the center of the object itself. When the center tool is turned off, the view will remain focused on the last position.

Next to the centering tool is the Scroll View tool. Clicking and holding that button moves the current view up, down, right, and left. Next to the scroll button is the Rotate View button. The view can only be rotated when the viewport is in Perspective mode.

The last button on the right resembles a magnifying glass and is used for zooming in and out on the viewport. Clicking and holding on the magnifying glass icon allows you to interactively scale the image in the viewport.

Let us take a quick look at grid size. LightWave does a number of things automatically to make working in Layout as easy as possible. One of the things it does is adjust to a working scale relative to the size of the objects that are loaded. You might be creating an animation with a knitting needle or the Space Needle, two objects that are several magnitudes of scale apart. If you load them one at a time, LightWave will scale the mouse actions to an appropriate level for what it thinks the most effective scale would be. What sometimes happens is that the mouse movement is too gross for fine work, or too precise for great objects. This scale control for the mouse is based on the grid size. The smaller the grid size, the greater the detail. The larger the grid size, the more quickly you can move around. You can judge the grid size by the relative size of Camera and Lights in the viewports, because the Camera and Lights are virtual items and have no real scale of their own.

To adjust the grid size in a scene, go to the Display tab and locate the Increase Grid and Decrease Grid buttons. The grid that is represented by the ground plane in the viewports will change as its size is increased and decreased. Changing the grid size will affect all viewports and the scale of the mouse control, but it will not change anything in the animation.

OpenGL and Previews

OpenGL is a display technology currently being used by LightWave. The performance of OpenGL is heavily dependent on the host computer. Understanding how the OpenGL is implemented will help get the best performance and useful display out of LightWave.

The most important thing to realize is that the OpenGL display is *not* the final render. The OpenGL display you see in the Layout screen is an

approximation or rough representation of the full render. As the technology becomes more sophisticated and affordable, the display in the Layout screen is certain to become more detailed. The scenes we can view in real time today would have required hours of rendering just a few years ago. A few years from now we will most likely have real-time displays that rival hour-long renders today. But for now, there are some physical limitations we need to be aware of.

One of the most unsettling errors that often crops up in an OpenGL display is the famous missing polygon. An object can be perfectly modeled and solid, but both Modeler and Layout solid shaded displays may show it with an area missing (see Figure 1.25).

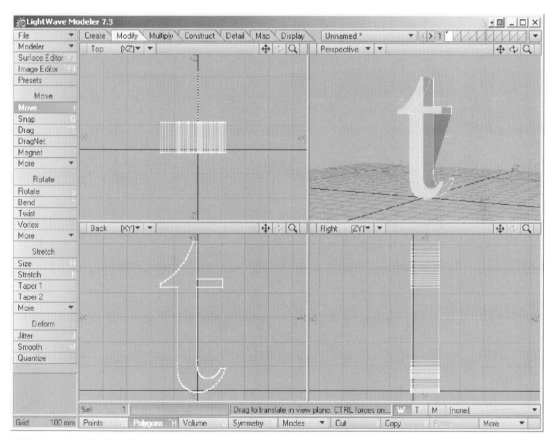

FIGURE 1.25 Model rendered completely versus a misrendered polygon.

It appears that the object is missing a chunk of its surface, but the missing surface is really due to a misrendering of the OpenGL display. Unfortunately, an object with something truly wrong with it can look the

same way. There is no quick fix for this error other than actually render-ing the object to confirm if it has a problem.

The OpenGL has the potential for showing a single image map on a surface, surfaces illuminated by lights, and fake reflections through the use of reflection maps. It also can show an object's base surface color, its sensitivity to light (diffusion), and its luminosity. This capability is very helpful for identifying surfaces of objects by their base attributes. Seeing the effects that lights make on a scene is also very helpful. Once again, it is important enough to repeat, the OpenGL display is only a rough ap-proximation of the final rendered scene. The OpenGL only shows super-ficial representations of the surfaces of objects, and with lights, will only display a very "straight ahead" illumination.

Figure 1.26 shows a scene with two objects and two spotlights. The objects have only been given the default texture. The only difference be-tween the two views is that the image on the left is in OpenGL and the other is a rendered image.

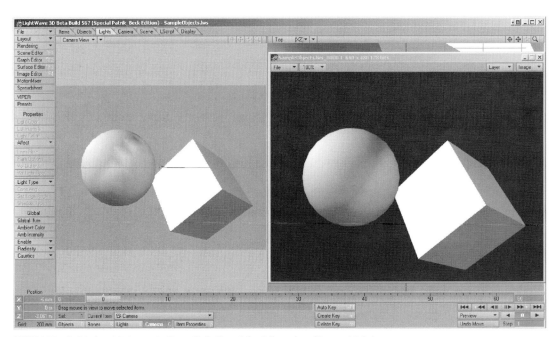

FIGURE 1.26 A side-by-side image in OpenGL (left) and the full rendered image (right).

We show you this contrast to make the point that the OpenGL dis-play should not be solely relied upon to set up animation renders.

The performance of the OpenGL and your video card strongly affects how well an animation can be previewed. A *preview* is a dress rehearsal of

the animation before it goes to the final render. An animation can be previewed simply by grabbing the scrub bar at the bottom of the screen and sliding it back and forth to advance and reverse the animation. Using the scrub bar is good for quick checks of basic motion, but may not give an accurate feel for timing.

A slightly more elegant way of previewing an animation is by using the Transport Controls located in the lower-right corner of the Layout screen (see Figure 1.27).

FIGURE 1.27 The Transport Controls.

The Transport Controls contain a forward button (right), a reverse button (left), and a pause button (middle). Clicking the forward button will step the animation forward a frame at a time as fast as it can, depending on the complexity of the scene, the level of rendering, and the power of the hardware involved. Big scenes will play back at a crawl, and simple scenes might play back at faster than real time. To force the preview to play back at the correct speed, once again we need to go to the Preferences menu.

In the Preferences menu, under General Options, is a check box selection for Play at Exact Rate (Figure 1.28).

FIGURE 1.28 Play at Exact Rate selection.

Play at Exact Rate will force the playback to display the scene at the correct rate. The problem with this is that if the display is not able to generate all the frames quickly enough, it will skip frames in order to keep up with the selected speed. To reduce the number of dropped frames during a playback, reduce the size of the main viewport and reduce the rendering level setting. You can also set the Step Range to something other than 1. The Step Range setting is made in the data box located just under the Transport Controls. If the Step Range is changed from 1 to 3, only one-third as many frames need to be drawn during playback. For a quick preview, this is often sufficient.

The most accurate previews require a rendered preview. The Make Preview button is located at the bottom-right of the screen next to the Transport Controls. This option will render each frame of the primary Layout viewport and compile it into an animation that will play back in the viewport. Note that this is *not* a full render; it is an animation made from the OpenGL display. This method can be useful previewing motion and timing but very little else. In complicated scenes, rendering even this low-resolution OpenGL preview can be time-consuming. The Frame Step option in the Make Preview window gives you the option of rendering the preview in 2s, 3s, or whatever Step Range you wish (see Figure 1.29).

FIGURE 1.29 The Make Preview window.

When the Preview is done rendering, the Preview Playback Controls allow you to play back the animation at the appropriate reduced rate (see Figure 1.30).

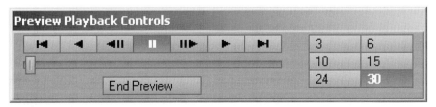

FIGURE 1.30 The Preview Playback Controls.

The Preview Options window offers several settings for the rendered preview animation (see Figure 1.31).

FIGURE 1.31 The Preview Options window.

Previews may take a long time to render, so it is handy to be able to save them to view at another time. The preview animations can be saved as either an AVI or a QuickTime file and can be used for approval purposes, or even as animations themselves in low-end applications. Holding the animation in memory can be a strain on system resources, so preview gives you the option of deleting the animation to free up memory.

 You can abort a preview render before it gets to the last frame by pressing the Esc key. By clicking the Preview button and selecting Play Preview, you can view the portion of the preview that has been rendered.

Editing Plug-ins

Many features and functions of LightWave are implemented through the use of its plug-in architecture. When LightWave is first installed, most of the necessary plug-ins are already in place. However, you might find it occasionally necessary to manually add additional individual plug-ins or sometimes whole groups of plug-ins. You can add them by clicking the Layout button in the upper-left corner of the Layout screen and selecting Plug-ins>Edit Plug-ins (see Figure 1.32).

Selecting Edit Plug-ins opens the Edit Plug-in panel. Plug-ins are grouped here by category or type. The grouping method does not affect the operation of the plug-in. If only a single plug-in is to be added, use the Add Plug-in selection on the right side of the Edit Plug-ins panel.

FIGURE 1.32 The pull down menus for the Layout Plug-ins>Edit Plug-ins command.

Clicking the Add Plug-in button will open a requestor box that asks you where the plug-in is located. Once the plug-in file is located, it is selected and loaded as any other layout item. A confirmation will appear when the plug-in has been added successfully.

If a group of plug-ins are to be added, such as entire directories, the Scan Directory function should be used. Using Scan Directory is much like adding a single plug-in, except that the *parent* directory containing the plug-ins should be selected. Find the directory that contains the group of plug-ins and choose the *directory* that contains the plug-ins. LightWave will then scan that directory, including any subdirectories, and if it finds any files that look like LightWave plug-ins, it will load them and add them to the existing list of plug-ins.

When plug-ins are added to Layout, their addition is noted in the configure file so that they will be there the next time LightWave is started up. If LightWave is shut down abnormally before it has an opportunity to write to the configure file, such as in a system crash or a power outage, the addition of the plug-ins will not be recorded. Also, if the configure file gets deleted for some reason, there will be no record of the new plug-ins that have been added.

RENDERING ISSUES

Rendering is the final stage of creating a LightWave animation. All the surfaces, Lights, and Camera settings are gathered and the computer calculates to the best of its abilities what that frame should look like. A frame may be ready to go as soon as it is done rendering, or it may be just one element in a composition of layers as part of a larger project.

The rendering of a frame "develops" the image from a blueprint that is the layout scene. A full render of a single frame can take anywhere from less than a second to several days. Rendering time is dependent on the complexity of the scene, the rendering quality, and the speed of the computer. Most frames will render in a few minutes or less on a typical modern computer.

The Render Options Panel

In the upper-left corner of the Layout screen is the Rendering button. Clicking this button brings up a list of rendering functions. At the top of the list is Render Options. Select Render Options to open the Render Options panel (see Figure 1.33).

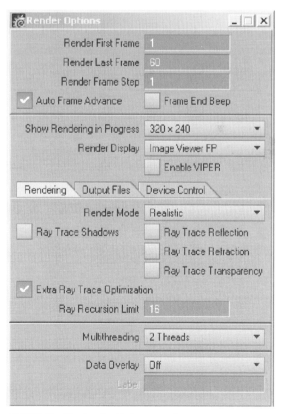

FIGURE 1.33 The Render Options panel.

Many of the settings in the Render Options panel are mandatory, some are optional, and a few are left over from the early days of computer animations. In the Render Options panel you specify which frames of the scene are to be rendered, where the finished rendered frames are to be saved, and in what format they will be saved. The panel also has a number of options that allow you to quickly toggle on and off several calculation-intensive processes.

Frame settings are located in the top section of the Render Options panel. Here you instruct LightWave which frames to render. The scrub bar at the bottom of the Layout screen allows you to determine the working range of frames for the scene, but which frames that are actually rendered are specified in the frame settings. The first and last frame information is saved with the Scene file; however sometimes it is necessary to abort a render before the entire scene is rendered, and by changing the Render First Frame setting you can pick up where it left off.

Notice the Render Frame Step option. Most of the time you will want to render by 1, which is to say you will render every frame between the specified first frame and last frame. Sometimes it is useful to render every fiftieth, tenth, or thirtieth frame to spot check an animation for rendering errors, so having the option to render in definable steps is quite convenient.

The Auto Frame Advance option tells LightWave that when one frame is finished rendering, it should go on to the next. This option should be checked; otherwise, LightWave will wait until it is told to either go ahead or quit.

Next to Auto Frame Advance is the Frame End Beep button. This does exactly what you would think; when a frame is finished rendering, your computer will emit a beep. Setting this option is purely a matter of personal choice.

The next section of the Render Options panel concerns the image display (see Figure 1.34).

FIGURE 1.34 Image Display box.

The Show Rendering in Progress selection gives you the option of watching the frame being rendered a polygon at a time, with the choice of a low-resolution or high-resolution render window. The render window will also display helpful information like current frame being rendered, the start and stop frames, the rendering time of the last frame, and more. There will be a warning pop up indicating that the rendering in progress may increase rendering times. An increase in rendering time is due to the amount of time it takes to display the image while rendering, typically a very small amount of increase, usually less than a few seconds on modern machines.

Render Display is an image viewer option to display the frame when it is finished rendering. The image can be displayed with the built-in Image Viewer FP on the monitor screen, or, with the proper drivers, can be displayed through a separate hardware display device. The Image Viewer option will display a single rendered image, but will store all the rendered images until the Image Viewer panel is closed.

The Enable Viper button allows you to store rendered scene information of the last rendered frame. This option does take a second or two of time and system resources, so it is recommended not to use Enable Viper during a final render.

The last three tabs at the bottom of the Rendering Options panel are Rendering, Output Files, and Device Control. Device Control is a holdover from the days when the only way to record an animation was to lay it a frame at a time into a frame-accurate video recorder, so you can pretty much ignore that tab.

The Rendering tab enables ray tracing. Shadows, reflections, and the bending of light through refraction can all be rendered realistically through the use of ray tracing. Ray tracing gives you more accurate rendering at the cost of longer rendering times. The settings here activate and deactivate the ray tracing options for everything in the scene.

You set Multithreading under the Rendering tab as well. Simply put, Multithreading is used when you have more than one processor in your computer. The number of threads should match the number of processors in the computer, so a dual processor machine should have the number of threads set to 2.

At the bottom of the Rendering tab is the option for Data Overlay (see Figure 1.35).

The Data Overlay selection "burns in" the selected information at the bottom of the screen. This is useful for test renders and approval copies. If you use Data Overlay, do not forget to turn it off when you go for the final render, because once the data overlay is rendered onto a frame it cannot be easily erased.

FIGURE 1.35 The Data Overlay button.

The middle tab is Output Files, perhaps the most important tab of all. The Output Files options determine how and where all the rendered images are saved. The three ways to save a rendered image are as an animation, as single frames, or as alpha images. Each has choices for file formats.

Activating Save Animation will cause LightWave to compile the rendered frames into an animation file. The animation format will be determined by the format specified in the adjoining Type setting, typically an AVI or a QuickTime file. Below the Type setting are the Options settings, which are settings unique to the animation format selected. Clicking Animation File brings up the directory requestor box that allows you to select the location of the finished animation and its name. The name of the completed file will appear in the space to the right of the Animation File box. Be warned that if a rendering is interrupted in the middle of a scene before the animation file is closed, it is likely that the animation file will be corrupted and useless.

The best way to save frames is as single RGB images, the option found in the middle of the Output Files tab. The Save RGB option will save each finished rendered frame in the image format you choose. Clicking the Type button will give you a list of the image formats to choose from. Clicking on RGB Files will open the directory requestor box where you can choose the location where the sequence of frames will be saved and what they will be named. Once that is chosen, a sample of the name will appear in the space to the right of the RGB Files box.

Beneath the RGB Files section is the Save Alpha option. This is a holdover from the days before we were able to imbed the alpha information into a 32-bit image and needed a separate black and white "cookie cutter" sequence for an Alpha channel. Transparent empty areas of the frame will appear black on an alpha frame, solid areas will look white, and semitransparent will have a gray feathering.

At the bottom of the Output files tab is Output Filename Format. This selection determines the way the file name will look for saved sequences of the RGB or alpha files. Part of this is personal choice, and part is what is necessary for the computer and video system being used. Some systems require image format extensions on numbered sequences, and others do

not like them. When a format is chosen, it is instantly reflected in the file name boxes.

 Note that an animation and *individual RGBs could be saved during the same render.*

Choosing an Image Size

LightWave renders RGB images made up of picture elements (*pixels*) where each has a specific mix of red, green, and blue. The height and width in number of pixels specify an image size. The more pixels an image contains, the bigger the image file is, and the more information it can hold. A bigger image also means an increase in rendering time.

The size of a rendered frame is an attribute of the Camera settings. With the Camera selected, clicking the Item Properties button at the bottom of the Layout screen will bring up the Camera Properties panel (see Figure 1.36).

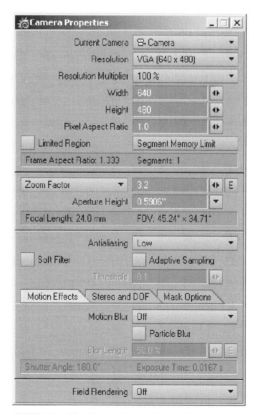

FIGURE 1.36 The Camera Properties panel.

The top section of the Camera Properties panel contains all the settings for the rendered frame size. (LightWave Layout supports multiple cameras in a scene, and each camera may have a unique setting, but only the currently selected camera will be the view that is rendered.) Clicking the Resolution button brings up a number of standard image sizes (Figure 1.37).

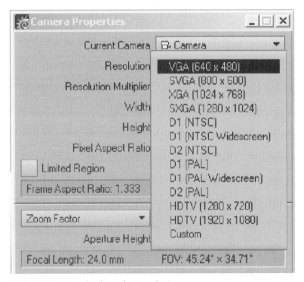

FIGURE 1.37 Standard resolution choices.

There is a good chance that the image size you require for a project will be one of those listed here. If the desired resolution is not listed, it can be entered manually in the Width and Height numeric boxes.

Just above the numeric boxes for Height and Width is the Resolution Multiplier setting (Figure 1.38). The default setting of 100% will render an image of exactly the specified size. The Resolution Multiplier allows you to quickly scale up or scale down the frame size.

Changing the Resolution Multiplier is a little different from changing the Width and Height settings. There are certain things in a LightWave render that are measured in pixels rather than the relative size of the geometry of the objects. Things such as glow and many of the post-process filters are based on the size of the image. This means that a glow rendered on an image that is 320 × 240 will have twice as much effect as the same glow setting on an image rendered in a frame size of 640 × 480.

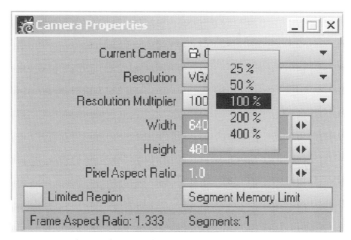

FIGURE 1.38 The Resolution Multiplier.

The Resolution Multiplier adjusts the pixel range on the scaled images so smaller test images will more accurately represent the final full-size rendered image.

Below the Width and Height settings is the Pixel Aspect Ratio. This setting adapts the shape of the pixels to conform to the specifics of the hardware device that will eventual present the rendered frame. This is a shoehorn fix to help squeeze digital images through antique technology. As a rule of thumb, standard video has an aspect ratio of 0.9, computers and print use square pixels with a ratio of 1.0. Film and high definition video also use square pixels *most of the time*. The presets include most standard resolutions, and the size and aspect ratio will be set automatically.

LightWave has no preset resolutions for print. This is because an image for print usually has a very specific space to fill and the width and height of the image needs to be entered manually. To calculate pixel dimensions of an image to render for a specific print job, it is necessary to know physical dimensions of the space it needs to fill and the final print resolution. A typical print resolution is 300 dots per inch (dpi). For our purposes, a print dot equals a rendered pixel.

For example, say a client needs an image rendered for a postcard mailer. The image needs to fill the 3 × 5 postcard. The postcard will be printed at a resolution of 300 dpi. At what image size should the frame be rendered?

1. The postcard is 5 inches wide. 5 × 300 = 1500
2. The postcard is 3 inches high. 3 × 300 = 900

The values that should be entered into the Camera Properties panel for Width and Height should be 1500 and 900, respectively. Because the image is going to print, the aspect ratio should be set to 1.0.

 Many users who are accustomed to working with print images rely heavily on the dpi settings that are imbedded in some image formats. When an RGB image is saved outside of LightWave, it defaults to a setting of 72 dpi regardless of the actual image size. It may be necessary to load the image into another program and change the dpi setting (just the dpi setting; do not resample or scale the image) to get the best results when image goes to print.

Finally, we come to the Limited Region setting. As the name implies, Limited Region will render a rectangular area encompassed by a yellow bounding box. When Limited Region is activated, a yellow bounding box appears in the Layout camera view. This bounding box can be adjusted by holding down the *l* key on the keyboard and clicking the edge of the bounding box and dragging the edge (see Figure 1.39).

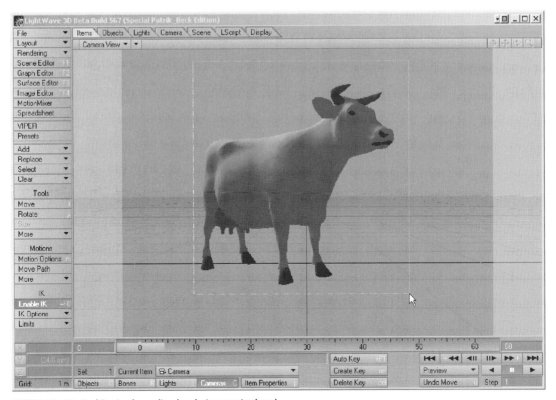

FIGURE 1.39 Limited Region bounding box being manipulated.

The area enclosed by this bounding box is the only section of the frame that will get rendered. This option is useful for test rendering small sections of a frame, or rendering just portions of a sequence. This setting is saved with the Scene file, so be sure to turn it off for the final render; otherwise, the entire sequence will be rendered with the limited region.

Image Quality, Antialiasing, and Fields

The standard D1 video resolution is 720 × 486 pixels. Not only render animations, but film and video are squeezed through the NTSC standard size as well. An image printed at 300 dpi would yield a picture of barely the size of a match book cover, about half the size of a business card. Yet that 720 × 486 can look pretty good when stretched out on a big screen television.

This is because an image can appear to have a higher resolution than it actually does. If the pixels of an image were simply rendered on a one-to-one basis, a thin diagonal line would appear as a row of single pixel dots (see Figure 1.40).

FIGURE 1.40 Diagonal line rendered on a 1-to-1 ratio.

While Figure 1.40 shows us a true representation of the rendered line, it is not very pretty. The stair stepping that you can see is commonly known as the dreaded "jaggies," technically known as *aliasing*. When information is digitized, it samples the data and averages it to the closest number it has available in the specified resolution. Fine detail can "fall through the cracks" during the digitizing process by running counter to the nature of the digitizing process. (For a less confusing example, a vertical or horizontal straight line will show no jaggies because that is the way digital sampling likes it.)

To combat the problem of aliasing in a rendered image, we have *antialiasing*. The process of antialiasing works with surrounding pixels to reduce the jaggy look of the rendered image (see Figures 1.41 and 1.42).

FIGURE 1.41 Diagonal line without antialiasing.

The averaging effect of the surrounding pixels gives the appearance of a level of detail that surpasses the actual image resolution. Put simply, an image can be given the appearance of having detail of less than a pixel in size, which seems illogical, because a pixel is a single point of information.

There are two ways of antialiasing, with and without *adaptive sampling*. Generally speaking, adaptive sampling is usually much faster but does not produce as clean an image as full antialiasing.

FIGURE 1.42 Diagonal line with antialiasing.

When antialiasing is turned on, the frame will be rendered in multiple passes. With adaptive sampling turned on, the first rendering pass will render the full frame and the subsequent passes will attempt to identify jaggy areas and smooth them out. The Threshold setting sets the level of adaptive sampling. (A Threshold setting of 0.1 will look for jaggies twice as much as a setting of 0.2.)

Antialiasing with adaptive sampling turned off works differently— the frame is completely re-rendered with every pass. Each render pass offsets the render by half a pixel, and then all the passes are averaged in the final frame. As you would expect, this process multiplies the rendering time.

Levels of Antialiasing

Antialiasing comes in two flavors, regular and enhanced, and with several levels of intensity ranges from low to extreme. The standard antialiasing is not as effective as the enhanced antialiasing, but it does tend to give a sharper, cleaner look. The enhanced antialiasing setting does a better job at eliminating the jaggies, but tends to sometimes make the image appear a little softer (not necessarily a bad thing).

The antialiasing settings of low and enhanced low will render the image in five passes—the initial image is rendered, and then the frame is offset by half a pixel to each of the four corners for the next four passes to complete the frame. The medium antialiasing setting does the same thing, except it renders nine passes for a full render. The high setting takes 17 passes for a render, and the extreme setting takes 33 passes. For the most part, you can take the length of time it takes to render the frame without antialiasing and multiply it by the number of passes to estimate pretty accurately the amount of time it will take to render the frame with antialiasing. Multiply that by the number of frames for the whole scene.

Generally, you want to use the highest level of antialiasing you can afford in rendering time. Enhanced antialiasing in most cases does as good a job as the next step up in standard antialiasing (enhanced low = medium standard) at the cost of a little softening of the image. Images with lots of fine detail and diagonal lines need much higher levels of antialiasing. Simple objects and scenes can get away with lower levels of antialiasing and the use of adaptive sampling. The choice and level of antialiasing needs to be adjusted on a per-project basis determined by the elements in the scene and destination of the project.

Think of this as a rule of thumb: in most cases, enhanced low is a good enough setting for most video and multimedia animation. If the image will be printed, use at least medium antialiasing. If it looks as if bugs are crawling on the textures during an animation or you see strange moiré patterns, turn off adaptive Sampling.

The multiple passes of the antialiasing function are used to generate Motion Blur and Depth of Field effects. With the Depth of Field setting, the antialiasing passes attempt to duplicate the effect of parts of the scene being out of focus by slightly offsetting the camera while pointed at the focal point (see Figure 1.43). Depth of Field requires an antialias setting of at least medium to become active, and usually requires more to actually look good. With Motion Blur, the object is moved along its motion path during each antialiasing pass, simulating the motion between frames (see Figure 1.44).

Interlace and Field Rendering

LightWave can do Field Rendering. Standard NTSC video is 30 frames per second, but each of those frames contains two sets of images. The frame of video is split into two sets, the even lines and the odd lines, and each set is called a frame. Video is an *interlace* format. This means that when a

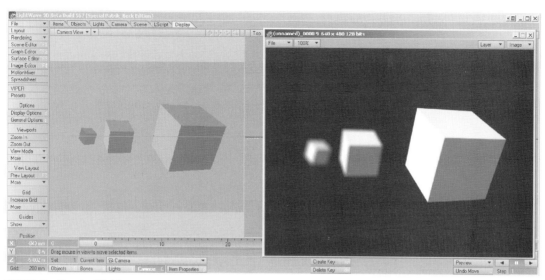

FIGURE 1.43 Depth of Field.

FIGURE 1.44 Motion Blur.

full frame is shown on the TV screen, to get it onto the screen fast enough it skips every other line, then goes back and fills in the lines it missed the first time.

In a way, video is more like 60 half-resolution frames per second (fps). Every two frames are sliced into strips 1 pixel high and shuffled together. In film, the rate is a solid 24 fps, which is one of the main reasons film and video look so different from each other.

If you use field rendering, you have a choice between using Even First or Odd First. You need to make this choice because of the variation between video hardware and video editing software. The best thing to do is to field render a short, simple animation with extreme movement so that the field order is easily discerned and sent through the video output device in question.

To side-step the problem of determining the correct field order, do not use field rendering. Rendering the animation with Motion Blur can look just as good, and can have a more "film-like" quality.

Image Formats, 24/32, and the Alpha Channel

It is important to choose the appropriate image format for your task at hand. LightWave is very flexible when it comes to loading and saving images, but some applications require specific formats to work correctly.

The two biggest issues you face in deciding in which image format to save the rendered frames is whether compression can be used and if the file should have an imbedded Alpha channel. One image format saving option, JPEG, is referred to as having a lossy compression format. When an image is saved in a JPEG format, the compression algorithm throws away data that it deems unnecessary. This sounds drastic, but the LightWave saver is permanently set at 100% quality and JPEG images are almost identical to uncompressed images. However, the degrading property of the JPEG process is additive. One level of JPEG compression is pretty safe, but loading the image and saving it repeatedly will multiply the artifacts created by the JPEG process.

Another drawback of the JPEG saver in LightWave is that it currently cannot retain the imbedded Alpha channel of 32-bit images. A standard 24-bit image has 8 bits for each RGB pixel (8 bits for Red + 8 bits Green + 8 bits Blue = 24 total bits). With 32-bit images, an extra 8 bits of data are added to each pixel to define transparency, the alpha value (24 bits of color information + 8 bits of transparency = 32 total bits) (see Figure 1.45). The Alpha channel, sometimes referred to as a *transparency mask*, is

usually represented by a grayscale image with solid black where the image is completely transparent and solid white where it is completely opaque with no transparency (see Figure 1.46).

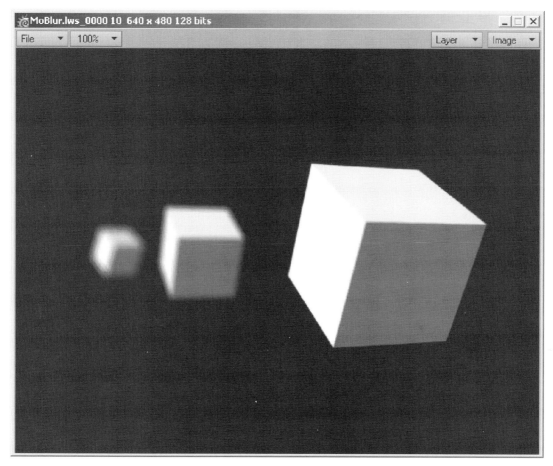

FIGURE 1.45 Image in RGB.

An Alpha channel is used mostly when combining LightWave rendered images with other elements. Many editing packages today will allow you to simply load the numbered sequence into the timeline of the project, which will automatically detect and use the Alpha channel to key the new graphic over the previous layer. Some editing packages require that you indicate that the Alpha channel is to be used to key the transparency.

FIGURE 1.46 Image of matching Alpha channel.

The Alpha channel is the absolute best way to put LightWave renders over other elements. It gives nice clean edges and even allows for areas to be partly transparent. Rendering images over a green or blue background and using a color keyed later on will not work nearly as well.

CONCLUSION

Getting started with LightWave involves learning a great deal of information all at once. If you are just beginning in 3D animation, do not let this

flood of information discourage you. There are many areas within computer animation but as you learned in this chapter, they can all be broken down into manageable parts. By focusing on, and mastering, one area at a time, you'll be well prepared for the 3D world.

LEARNING THE ROPES

In This Chapter

- The Basics of 3D Animation

- Keyframes

- Lights

- Surfacing

Y ou have many things to learn when you first begin 3D animation, a situation complicated by the fact that to understand the purpose of one thing you need to know about something else. Fortunately, most of what you need to know can be broken down into small, easy-to-understand steps. All of the steps presented in this chapter are vital, and it is important to be comfortable with the processes and functions presented. As long as the basics are understood, the more complicated and advanced parts will be more easily understood. A solid foundation is the key to mastering LightWave.

THE BASICS OF 3D ANIMATION

In this section you will learn the basic skills necessary to create simple objects, how to create fundamental motion, and how to render a complete scene.

Modifying and Creating Objects in Modeler

Objects are created in Modeler. When Modeler is first opened you are presented with an empty work space. The default setup gives you four views. LightWave allows a high degree of customization to its interface screen, and you will probably develop your own preferences, but for the purpose of instruction, all directions given are assumed to be for the default Modeler setup (see Figure 2.1).

Each of the viewports allows you to view objects from different angles. Along the top of the Modeler interface is a row of tabs (see Figure 2.2).

Each of the tabs brings up a row of buttons along the left side of the screen. The buttons activate tools and functions inside Modeler. The top five buttons are present on every tab. The top two buttons, File and Modeler, have pull-down submenus (see Figure 2.3).

The next three buttons, Surface Editor, Image Editor, and Presets, are also present on each tab but have no submenus.

Creating a Box

A *primitive* is a basic geometric shape. All objects are made up of points and polygons, whether it is a simple square box or a Jurassic T-Rex.

To create an object, activate the Create tab. On the left side of the Modeler interface is a section with the heading Objects (see Figure 2.4).

FIGURE 2.1 Default Modeler screen.

FIGURE 2.2 Modeler's tabs.

FIGURE 2.3 Submenus in Modeler.

FIGURE 2.4 Objects buttons.

Click on the Box button to activate the Make Box tool. Now click and hold the mouse button in one of the viewports, and drag. You will see a square being created. Release the mouse button and go to one of the other views and click and drag on the edge of the preview square to change the flat square into a 3D box. At this point the box can still be resized by clicking next to the desired edge and dragging it. Clicking and dragging the x in the center of the box moves the center of the box (see Figure 2.5).

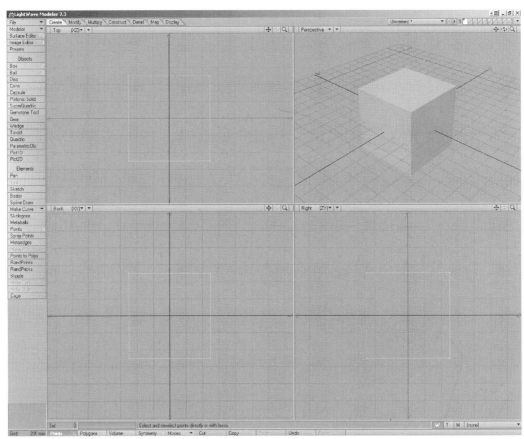

FIGURE 2.5 A box created in Modeler.

The highlights at the corners and the center of the Box object indicate that it is still the preview shape and can be easily manipulated. The box will not become solid until the Box button is turned off, another tool is selected, or the Enter key is pressed. Once this happens, the bounding box highlighting the shape disappears and the object's dimensions become locked in. To alter the geometry now after a Make function has been applied requires one of the modifying tools.

You have created a box-shaped object. This object can be saved and loaded back into Modeler, or loaded into Layout. The size, shape, and center of the object were created more or less at random. Later we will explore how to create exact shapes using numerical entry.

Creating a Ball

The Box object previously created is one layer of an object. Any additional geometry put on that layer becomes part of the object, even if the points and polygons are not connected or even touching. To create a separate object you must open a new object document.

Go to the upper-left corner of the Modeler screen and click the File button. Select the New Object listing (see Figure 2.6).

New Object	N
Load Object...	l
Save Object	s
Save Object As...	S
Save All Objects...	
Recent Files	▶
Revert Current Object	
Close Object	
Close All Objects	
Import	▶
Export	▶
Quit	Q

FIGURE 2.6 The File menu.

Selecting New Object will create a new, empty object layer. This action does *not* delete the former object. The previous object has been

shuffled into the background to allow you to work on the new object. The previous object can be returned to the foreground by selecting it in the Current Object popup button that appears just to the right of the tabs at the top of the screen (see Figure 2.7).

FIGURE 2.7 The Current Object popup button.

Right now we want the empty layer to create a Ball object. Just under the Box button in the Objects section of the Create tab is the Ball button. This tool works exactly like the Make Box tool. Click on the Ball button to activate it, and then click on one of the viewports and drag out the ball shape. Switch to a different view to draw the ball into three dimensions (see Figure 2.8).

Once the ball is at a desired size and shape, freeze the object. As with the Make Box tool, there are several ways to complete the object. Clicking the Ball button to turn it off will freeze the object, as will selecting a different tool or function, or simply pressing the Enter key on the keyboard.

Creating a Plane

In the 3D world, projects sometimes require a flat object. A flat plane can be used as a backdrop, a wall, or a ground plane.

Create a new object layer by clicking the File button at the top left of the Modeler screen and selecting New Object.

Click on the Box button to activate the Make Box function. Click on a viewport to draw out a rectangle. Click on the Box button again to turn it off. You have just created a single flat polygon (see Figure 2.9, page 68).

Numeric Options

Selecting objects to make and drawing them freehand in Modeler's viewports is fun, but imprecise. Computer animation is all about numbers; the same is true for creating the objects it uses. Everything you can do with a mouse can also be done by specifying the action with numbers. Using the Numeric Entry function gives LightWave directions as to how much, how far, and how many.

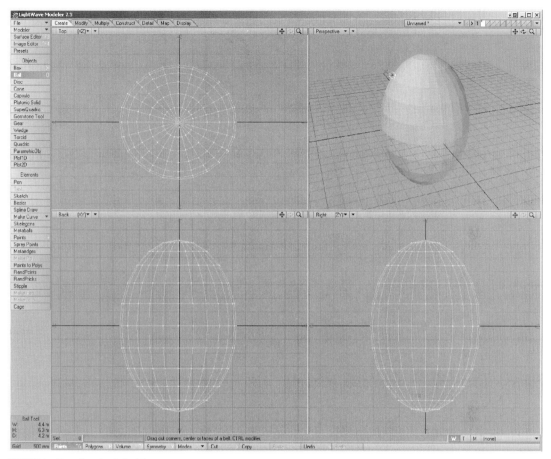

FIGURE 2.8 Drawing the Ball object.

The first step is to open the numeric entry panel. The most convenient way is to press the *n* key on the keyboard. Or you can click the Modeler button at the top left of the screen and select Modeler>Windows>Numeric Options Open/Close. Either method will open the Numeric options panel. We suggest that you become accustomed to using the *n* shortcut key because you will use the Numeric options panel constantly.

Both Layout and Modeler have many keyboard shortcuts. These shortcuts are visible on the function buttons themselves. Rather than clicking on buttons to activate the function, look at the keyboard equivalent and begin using that instead. Soon the keyboard shortcut will become second-nature and you will no longer have to go to the Layout tab to perform the desired function.

FIGURE 2.9 A plane in Modeler.

The Numeric options panel displays all the numeric options for the currently active tool or function. If there is nothing active, the panel will open a blank screen (see Figure 2.10). If the Box button is active, it will show all the numerical options for creating a box (see Figure 2.11).

The Numeric options panel and the mouse can be used together. When the Numeric options panel is open, any action performed by the mouse will be shown numerically in the data fields in the Numeric panel. The Numeric panel holds the numeric value of the last mouse function, which can be handy.

Using the Numeric Panel

The content of the Numeric panel adjusts itself to reflect whatever tool or function is currently active. At the top of the Numeric panel is the Ac-

FIGURE 2.10 A blank Numeric panel.

FIGURE 2.11 Numeric panel showing options for the Box tool.

tion button, which is identical for virtually all the functions. Clicking the Actions button will bring up two options: Reset and Activate (see Figure 2.12).

When you select Reset, all the values in the Numeric options panel return to the default values, erasing any value that may have been entered manually or by operating the function with the mouse.

FIGURE 2.12 The Numeric panel Activate buttons.

Selecting Activate turns on the tool. The same thing happens when you click the mouse in one of the viewports. However, clicking on the viewport with the mouse will change the numeric values, while using the Activate button retains the numeric values.

While you are creating an object, the object in the viewport will immediately reflect any values entered in the Numeric panel. Changes in its size, position, and geometry can be seen as soon as the new values are entered into the data fields and the Enter key is pressed.

 Important! When you type numbers into the data fields in the Numeric Requester (or anywhere else in LightWave for that matter), remember to press the Enter key for the new data to be accepted. The Enter key must be pressed to tell LightWave to use the new data anywhere in Layout or Modeler where numbers are entered manually.

As stated previously, without the numerical requester, an object is not locked into final shape until it is frozen. Turning the tool off or switching tools will freeze the object, but closing the Numeric box will not. The Numeric box can remain open throughout the modeling session without affecting anything until the Reset, Activate, or Apply functions are activated.

Other Objects

In the Objects section of the Create tab is a list of other basic shapes: Disc, Cone, Gear, and others. These tools create objects that their names imply. Many of these objects require that you use the Numeric options panel to access their functions. Several of the functions, like Gear and Platonic Solid, have their own requesters that require you to enter values for the object.

Feel free to play around with the different objects that can be made with the dedicated buttons. Familiarity with these functions will save you time when it comes to modeling specific objects.

Foreground and Background Layers

So far in this section, we have created at least three objects, a box, a ball and a plane. Each object exists on its own object layer. At times it is necessary to be able to view one object by working on another. This is done by putting the reference object in the background and the object to be modified in the foreground. This can be set up using the Layer Browser.

The Layer Browser is accessed by clicking the Modeler button at the upper-left corner of the screen. Select Modeler>Windows>Layer Browser Open/Close to open the Layer Browser panel (see Figure 2.13).

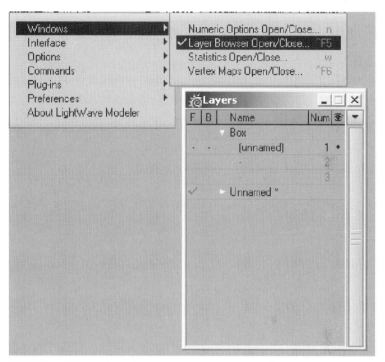

FIGURE 2.13 Selecting Layer Browser and Layer Browser panel.

The Layer Browser panel contains information about all objects currently active in Modeler. The title bar at the top of the panel indicates the heading of that column. The F at the top of the first column stands for foreground. The *foreground layer* is the layer that is currently active. Objects can only be worked on if they are in the foreground layer. B stands for the *background layer*. The background layer is a tool for reference. When an object appears in a background layer it appears as a ghosted wire frame underneath the current active foreground objects. Nothing done to the foreground object can affect an object in a background layer.

More than one object can be in the foreground layer, and more than one object can be in the background layer. If more then one object is in the foreground layer, everything in the foreground will be treated as a

single object. Anything done in that layer will affect everything that is currently active.

Separate Objects vs. Multiple Layers of an Object

There is an important distinction between separate objects, and multiple layers within the same object. Dealing with the multiple layer object format is fairly complex and will be explained in greater detail later in Chapter Four. For now, here is a basic explanation.

At the upper-right corner of the Modeler screen is a bank of 10 boxes (see Figure 2.14).

FIGURE 2.14 Modeler's Layer boxes.

Each of these boxes represents a separate layer of the object. (Users of LightWave prior to Version 6 will remember that these boxes represented separate objects rather than separate layers.) Geometry can be created in each of those layers, and the layers will behave very much like separate objects. The difference is that all the layers are saved as a unit, as a single object file. The Layer boxes at the top of the screen indicate several things. If a box contains a small dark triangle in its corner, geometry is present in that layer. If the box is a solid light color, that layer is active. If only the bottom of a box is lit, that layer is in the background (see Figure 2.15).

FIGURE 2.15 A Layer box with variations.

The choice of whether to create separate objects or to create a single object with multiple layers is completely dependent on the project at hand and personal taste. For the beginner it is suggested that all objects be a single layer to avoid confusion.

Assigning Surface Names

All polygons have a surface, and all surfaces have names. When a polygon is first created it is given the default surface name, which is Default. We obviously do not want to have every polygon of every object with the same surface name. Different surfaces on objects can be given unique surface names in the Surface function.

The Surface button allows you to specify a particular surface name and some basic attributes to the currently active polygons. The Surface button is located under the Polygons section of the Detail tab and brings up the Change Surface panel (see Figure 2.16).

FIGURE 2.16 The Change Surface panel.

Do not mistake this for the Surface Editor button that appears on every tab in the Modeler layout. The Surface Editor has a different menu and performs different but related functions.

The shortcut key to bring up the Change Surface panel is *q*. Memorize this shortcut because you will use it often.

To apply a new surface name, you must have some active polygons. Clicking on the Surface button brings up the Change Surface requestor box. In the requester box are a number of options, including a place to enter a new name and some surface attributes. The current surface, Default, appears in the Name box, and all the options are ghosted. The options are ghosted because a pre-existing surface cannot be modified in the Change Surface requester box. Once a new surface name is entered into the Name box of the Change Surface requester, the surface settings become active and allow you to make some basic adjustments to the object's surface.

The surface settings in the Change Surface requester are very basic. They are intended to make the surfaces easier to work with in the Modeler environment. The Color setting is for the basic RGB settings of the surface. The color can be adjusted by clicking and holding the mouse on each of the numbers and moving up and down, or by clicking on the color patch and bringing up the system color picker. The Diffuse setting makes the surface brighter or darker. Specular makes it shiny. Activating Smoothing will make curved surfaces look more like a continuous curve rather than the big bunch of flat planes they really are.

The Surface button and the Change Surface panel are really just for the initial naming of the active polygon's surfaces and to give them some rudimentary surface attributes. More extensive surface adjustments can be made later using the Surface Editor. The Surface Editor may be used in the Modeler, but surface editing is more efficient when done in Layout.

Saving Objects

Once an object is created, it needs to be saved. An object is saved in much the same manner as any other file on a computer. Clicking the File button at the top-left corner of the screen brings up several options for saving the object (see Figure 2.17).

FIGURE 2.17 The Save options.

Choosing Save Object will overwrite the old object if it had previously been saved. Choosing Save Object As will allow you to save the object with a new name, thus preserving the earlier version of the object. The Save Layer As Object option is handy when dealing with multi-layer objects, especially when you want to separate just one element. When working with multiple objects, and objects with multiple layers, it is easy to lose track of which objects have been modified. Modeler will attempt to help prevent you from losing data in several ways. If you attempt to save a new object file over an old object file, Modeler will ask for confirmation before it overwrites the file and the earlier information is lost. If you close the Modeler screen without saving an object, even if it is not currently active, Modeler will ask you if you wish to save the object before quitting. Once Modeler is shut down, all data is gone. The objects will not reappear in the viewport next time you open Modeler. When in doubt, do a Save Object As to ensure you do not lose something important. Object files are generally very small and take up little space on a hard drive (in the beginning, at least).

TUTORIAL

Creating, Surfacing, and Saving a Ball, Box, and Plane.

In this tutorial, we will create a number of primitive objects to exact specifications, give them surface names, then save them for later use in Layout.

Step 1: Creating a 1m Box

Under the Create tab, click on the Box button to activate the Make Box function. Open the Numeric options panel either by using the pull-down menu Modeler>Windows>Numeric Options Open/Closed, or by pressing the *n* shortcut key.

In the Numeric: Box Tool panel, click the Actions button and select Reset, then click the Actions button again and select Activate. A perfectly square 1m box should appear in the viewports in the exact center of the Modeler universe. Deselect the Box tool to freeze the box at that scale and position.

Step 2: Naming the Surfaces of the Box

Once you have the Box object, it needs surface names. Click on the Detail tab at the top of the screen to bring up the menu bar that contains the Surface button (or use the shortcut *q* key).

Once the Change Surfaces requestor pops up, enter a new surface name such as Box. Once a new name has been entered, you are allowed to change the color. See if you can make it red. You should be able to see the change in the surface in the OpenGL display if the viewport has been set to one of the solid viewing options.

STEP 3: SAVING THE BOX OBJECT

Once the box has been created and the surface has been named, it is time to save the object. Click on the File button at the top left of the screen and select Save Object. The Object should be saved in a directory inside the Objects directory that is inside the Content directory. If necessary, create a new directory inside the Objects directory to save the tutorial object in.

The normal extension for a LightWave object file is *.lwo*. Depending on the platform you are currently working on, that extension may or may not be automatically added. LightWave will automatically do what is necessary for the platform you are currently working on.

Save the box object with the very imaginative name of Box01. A file browser pointed to that directory may show the file as Box01.lwo.

STEP 4: CREATING A BALL

This is essentially identical to creating a box, except that the Make Ball function will be used. Start by clicking the File button and selecting New Object. The Ball object must be in its own layer.

Under the Create tab, activate the Make Ball function by clicking the Ball button. If the Numeric panel has been closed, reactivate it.

In the Numeric: Ball Tool menu, click the Actions button once and select Reset, then click the Actions button again and select Activate. Click on the Ball button to deactivate the Make Ball tool and freeze the object. There should be a perfectly round 1m ball in the center of the Modeler viewport grid.

STEP 5: NAMING THE SURFACE OF BALL

Click on the Detail tab at the top of the screen to bring up the menu bar that contains the Surface button (or use the shortcut *q* key). Once the Change Surfaces requestor pops up, enter the new surface name Ball.

STEP 6: SAVING THE BALL

As you did previously with the Box object, the Ball object must be saved. Click the File button and select Save Object. Save the Ball object in the same directory as the Box01 object, but name this Ball01.

STEP 7: CREATING A PLANE

Hopefully by this time you are detecting a pattern. We will change things just a tiny bit by using something besides the default values this time.

Click the File button and select New Object. Click on the Box button and open the Numeric options panel if it is not already open. Click Action and select Reset, and then click Actions again and select Activate to start it off with the standard 1m box. We want to create a flat plane, so the only value that will be changed is the height. Click the mouse in the part of the Numeric: Box Tool next to Height, type in 0, and press Enter. The top section of Numeric: Box Tool menu should now have these values:

Width 1m
Height 0m
Depth 1m
Center X 0m
 Y 0m
 Z 0m

Only the value for the Height should be changed from the default values; all the others should remain the same. Turn off the Box button to freeze the object. There should now be a perfectly flat 1m plane in the viewport.

STEP 8: SURFACING THE PLANE

As with the Ball and the Box, the Plane must get its surface named. Press the *q* key on the keyboard to quickly bring up the Change Surface requester (notice it was not necessary to leave the Create tab for the Detail tab to bring it up). Give the plane a surface name of Ground and color it brown.

STEP 9: SAVING THE PLANE OBJECT

Click on File, select Save Object, and save the Plane object in the same directory as the Ball and the Box objects and name it Plane01.

You should now have three objects in the directory that you have created. Each object is in 1m scale and each has a unique surface name. This was all done by you, your first steps into 3D modeling. Congratulations!

KEYFRAMES

This section will explain how an object is animated in Layout through the use of keyframes.

Loading Objects into Layout

When LightWave is run, it opens into the default Layout screen. Layout is where all the animation happens. Scenes are set up and the frames are rendered in LightWave (see Figure 2.18).

FIGURE 2.18 The default Layout screen.

The default Layout screen shows a Perspective view of the Layout environment, which is where your scene is built. The default setup has one camera and one light, both of which can be seen in the Perspective view.

The upper left of the Layout screen contains a button named File. The File button allows you to load and save both individual objects and entire scenes. Clicking the File button reveals all the options for loading and saving scenes and objects (see Figure 2.19).

FIGURE 2.19 Expanded File button.

In the previous section we created and saved several objects. Click on the File button and select Load, then Load Object and navigate to the directory where the Box object created in Modeler was stored. Select the Box object and load it.

Viewport Controls

When the object is loaded, it will appear in the center of the Layout grid. The default view is the Perspective view. The Perspective view can be adjusted by the viewport navigation controls at the upper right of the viewport (see Figure 2.20, page 80).

The navigation controls adjust the viewport's point of view. The first button of the navigation controls looks like a cross on a circle. This is the targeting control, and activating this feature will center the viewport on whatever Layout item is currently selected. The next button, the four arrows in the diamond shape, moves the view on the X, Y, and Z axes. The arrows-in-a-circle button rotates the view, and the magnifying glass button zooms the view in and out.

Operating the navigation controls can be done by clicking on the selected tool and holding down the mouse button as you drag the mouse. As with most movements in Layout, horizontal movement is achieved with the left mouse button (LMB), and vertical movement is achieved by holding down the right mouse button (RMB). (In the Perspective viewport, movement is controlled with the LMB controlling the X and Z axes and the RMB controlling the vertical Y axis, which is mirrored later on when objects are moved.)

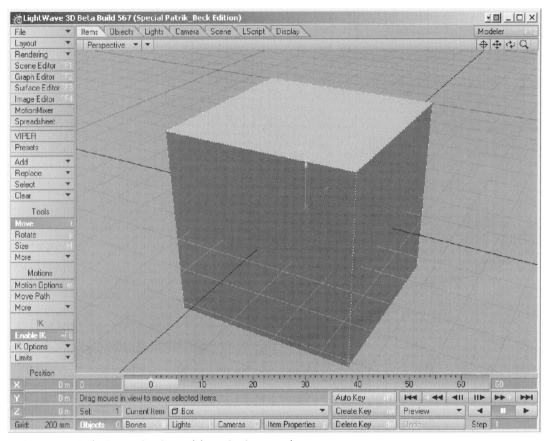

FIGURE 2.20 Box in the Perspective view and the navigation controls.

The Perspective view is the only view that has all the navigation controls active. Not all of the navigation controls work in all views.

The top left of the viewport contains the settings that change the view, and set the maximum level of rendering. There are several options for viewing the scene in the Layout viewport (see Figure 2.21).

Layout views

Each view has its own advantages, depending on the task at hand. It is important to understand that the only view that is seen in the final render is the Camera view. When the Camera view is selected, all the viewport navigation controls are ghosted because the view is controlled by the location and angle of the camera.

FIGURE 2.21 Expanded view
selector button.

The view options determine from which angle the scene will be viewed. A scene can be viewed directly up or down any of the axes using the Up, Down, Right, Left, Front, and Back views. There is also Perspective view, which allows complete freedom to rotate the point of view around the scene. These views may remind you of engineering drawings, and look very much like something that may have come from a drafting table or a CAD program. The Camera view is the most important viewing option because it is the point of view that is used when the frame gets rendered.

Next to the viewport options are the maximum rendering options. This appears as an easy-to-miss downward pointing triangle. Clicking this triangle brings up a number of rendering options (see Figure 2.22).

FIGURE 2.22 Expanded maximum rendering options.

The maximum rendering settings allow you to set the level of rendering in the Layout viewport. At times it is convenient to have all the objects in the scene shown only as points, or sometimes only as wire frames. Note that this setting *does not* affect the final render in any way; it is only for convenience in setting up the scene. In most cases, the Shaded Solid setting is a good choice.

Keyframing Objects into Position

When the Box object is first loaded into Layout, it appears in the Perspective view at a slight angle. The box itself is centered exactly in the middle of the Layout environment. You can zoom in, zoom out, and rotate in the Perspective view, but you will not affect the position of the box.

Switch the viewport to the Camera view option. You will see the Box object sitting squarely in front of the camera. This is because LightWave will always scale the camera position and the viewport grid in Layout to accommodate the largest object loaded in the scene.

When an object is first loaded into Layout, it comes in without any position or rotation. Even if the object has been moved or rotated in Modeler, when the object is loaded it is positioned with X-Y-Z position values and H-P-B (Heading, Pitch, Bank) rotation values all equal to zero.

This is done because all the position and rotation information is referenced to as the *pivot* of the object. The pivot point is the axis of the object, the handle by which the object is grabbed. The pivot point is the local universe for that object; whatever is done to the pivot point is reflected in the geometry of the object it belongs to. When the pivot is moved, rotated, or stretched, so is the geometry in the object.

The pivot point of the object is determined by how the object was created and saved in Modeler. The exact center of Modeler is the position of the pivot point. If an object was centered in Modeler and then saved, that object will have its pivot point in its center when it is loaded into Layout. If the object was moved up and off to the side while it was in Modeler and then saved, the pivot point will still be where Modeler's center is and will rotate around that point. There are ways to adjust the pivot point in Layout; but, in general, it is good practice to model well-centered objects.

The Box object is currently centered squarely in the Camera view. While it is perfectly centered, this is not a terribly attractive view. The Items tab brings up a list of buttons on the left side of the screen. Under the Tools section is a list of methods for manipulating Layout items. At the bottom of the screen is a list of various Layout items: Objects, Bones, Lights, and Cameras. The current Layout item we want to affect is the

Box object, so the Objects button is the one that should be active. While you are down at the bottom of the screen, be sure that Auto Key Create is turned off.

Click on the Rotate button to activate the Rotate tool. Click the mouse pointer inside the Layout viewport window and move the mouse while holding down the LMB. Moving the mouse sideways rotates the object on the H (Heading) axis, like a spinning top. Moving the mouse forward and backward while holding down the LMB causes the object to tumble forward and back on the P (Pitch) axis. Holding down the RMB and moving the mouse sideways causes the object to rotate like a fan blade facing you on the B (Bank) axis.

Rotation occurs when the Rotate tool is active and the mouse is moved in the viewport. For a little more control, you have Rotation handles that encircle the pivot point. Clicking the LMB on one of the circles near the little arrow will rotate the object on just one axis (see Figure 2.23).

FIGURE 2.23 Rotation handles.

For still more control, Layout provides a place for numeric input. The numeric entry box is at the bottom-left corner of the screen (see Figure 2.24). When any function is performed in the Layout screen, the numeric equivalent of that movement appears in the corner box. This is very similar to the way the Numeric options panel operates in Modeler. Notice that when the Box object is being rotated, the amount of the rotation is being displayed in the box as the rotation occurs. The rotation values being displayed correspond to the action of the mouse, but numbers can be entered directly into the numeric box at any time. Typing in the number 45 in the H column will set the object to a 45-degree rotation as soon as the Enter key is pressed.

FIGURE 2.24 The Numeric box.

Any action applied to a Layout item is not permanent until it is keyframed. The rotation applied to the Box object will disappear as soon as the scrub bar advances a frame, or one of the transport controls at the bottom right of the Layout screen is used. To make any changes applied to an object become part of the scene, the item must be keyframed.

Rotate the Box object so that it is at an angle in the Camera view. Click on Create Key in the bottom center of the Layout screen in the button for creating keyframes (see Figure 2.25).

Clicking the Create Key button brings up the Create Motion Key requester. (The keyframe may be applied to any frame of the scene, but the default is always the currently selected frame.) All the individual Position, Rotation, and Scale channels are listed to allow you to keyframe the channels one at a time. For now, leave all the channels active.

With the box rotated in the Camera view, create a keyframe at frame 0. Once the keyframe is created, the rotation is now part of the scene. This does not alter the object, only how it is positioned in this scene. If the object is loaded again it will not appear to be rotated. Moving the scrub bar at the bottom of the screen to advance through the frames should show you that the rotation of the Box object is now locked in.

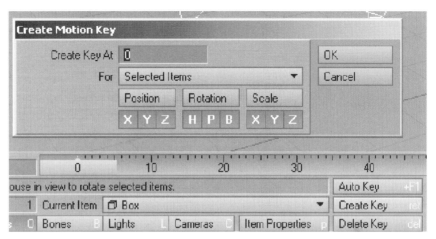

FIGURE 2.25 The Create Motion Key requester.

Camera Adjusts to Largest Object

LightWave automatically adjusts the camera in Layout to accommodate the largest object loaded into a scene. This can be a problem if you start with a grape and then load a beach ball. To stop LightWave from automatically moving the camera when a larger object is loaded, create a keyframe for the camera. Once the camera has gone through the action of receiving a keyframe, even if it is not moved from the original settings, LightWave will no longer adjust its position to accommodate incoming objects.

Keyframing Movement

The act of creating a keyframe, or *key*, locks in the position, rotation, and scale for a Layout item on that frame of the scene. For any of those values to change, you must have at least one more keyframe. A second keyframe needs to be created so that you have another set of position, rotation, and scale values that define the animation of the item. The beauty of the keyframe system is that the next keyframe can be positioned at any point along the time line, and LightWave will automatically calculate the amount of change necessary on each frame to take the item from the first set of position, rotation, and scale values to the next.

In the default Layout scene where the Box object has been loaded and keyframed at an angle to the camera, the default frame number is 60. Grab the scrub bar at the bottom of the screen and move it all the way to the end so that the current frame becomes frame 60.

Rotate the Box object once more so that it is at a different angle than it was at frame 0, and keyframe it at frame 60 with the new rotation.

Grab the scrub bar at the bottom of the screen and move it back and forth. You should see the Box object rotating smoothly from the position defined by the first keyframe into the position defined by the second keyframe over the course of the 60 frames.

Hitting the Play button at the bottom right of the screen will show the Box object turning at a speed as close to real time as your system can manage. Displaying a simple rotating box is a simple enough task for any system capable of running LightWave. If the solid box disappears during the act of playback, it is most likely because the bounding box threshold setting in the Display Options panel is set to 0. Refer to the Display properties discussed earlier.

The concept of keyframes is half of what creating 3D animation is all about. Even though this simple tutorial consisted of nothing more than making a box turn, the concept of keyframing runs through virtually every aspect of creating an animation.

TUTORIAL

BOUNCING A BALL

In this tutorial, we will take the previously created Ball object and make it bounce up and down. Although this may seem very rudimentary, animating a bouncing ball covers many aspects of 3D animation, as well as animation concepts in general.

STEP 1: LOAD THE BALL INTO LAYOUT

We want to start the project with a clean slate. Click on the File button at the top-left corner of the Layout screen and select File, then Clear Scene. This action clears out anything that was added to or changed in Layout and returns it to the default condition.

Once the scene has been cleared, load the Ball object. Click the File button and this time select Load, then Load Object. When the requester pops up, navigate to the directory where the Ball object was saved and select it.

Once the Ball object is selected and loaded, it should appear in the exact center of the screen (see Figure 2.26).

STEP 2: POSITIONING THE CAMERA

When the Ball object was loaded into Layout, the camera adjusted itself to correctly frame the object as large as possible in a TV safe area. Because the Ball will be moving up and down, we need to reposition the camera.

FIGURE 2.26 The Ball in the center of the Layout screen.

When changing the camera position, it is a good idea to look through the Camera view. Click on the viewport options button at the top-left corner of the viewport and select Camera view. The Ball object should now be seen squarely in the center of the viewport.

The camera now needs to be positioned so that it has a wider view for the ball when it bounces. At the bottom center of the Layout screen, click on the Camera button to make the camera the active Layout item. (There is a Camera tab at the top of the screen, but that tab has more to do with camera properties and not a camera's characteristics as a Layout item).

The camera needs to be moved to a specific position in Layout and keyframed so that it stays in that place. With the camera as the active Layout item, click on the Items tab at the top of the screen and select the Move tool. This allows you to interactively move the camera around the Layout environ-

ment. Because the Camera view is selected in the Layout viewport, we can see the effect that moving the camera has.

We want to move the camera to this exact location:

X = 0
Y = 1m
Z = – 8m

This can be done one of two ways: by using the mouse or by entering the values directly. By holding down the LMB and moving the mouse towards you, the camera will move back on the Z axis. Holding down the RMB and moving the mouse forward will cause the camera to move up the Y axis. The current position of the camera can be seen in the numeric data box at the bottom left of the screen. Careful movement of the mouse and patience will eventually get the camera into the desired position.

A much quicker way to put the camera in the exact position is to enter the coordinates directly into the numeric value box. If the Move tool is active, the data box will show the X-Y-Z parameters of the camera. Click the mouse in the data box and overwrite the current settings with the values specified above. (Be sure to hit the Enter key after the numbers have been entered so that the new values are activated.)

When the camera has been placed in the correct position, it needs to be keyframed to lock it in place. Be sure the current frame is 0 and click the Create Key button at the bottom of the screen. Create a key for the camera at frame 0 at the specified position. The Camera view in the Layout viewport should show a wider shot of the Ball object on the Layout grid.

STEP 3: POSITIONING THE BALL

Currently the ball looks like it is sunk halfway into the center of the Layout grid. This is because the center of the ball is its middle, and its middle is at the 0 point of the X-Y-Z universe. The Ball object needs to be moved up a bit so that it looks like it is resting on the ground. We should do this before we start animating.

At the bottom of the Layout screen, click the Objects button to make Objects the active Layout item. Because the Ball object is currently the only object loaded into Layout, it will automatically be selected.

The Ball object is 1m in diameter. That means the distance from the center of the ball to the edge is half a meter. With the Ball object selected, move it up the Y axis half a meter. A half meter will show up in the numeric data box as 500 millimeters. The exact values for the Ball object's new position are as follows:

X = 0
Y = 500mm
Z = 0

Once again, the Layout item can be moved either by using the mouse or by entering the numbers directly into the numeric box.

Once the Ball object is in position, it needs to be keyframed so that it stays there. Create a keyframe for the Ball object at frame 0 with the values specified above.

STEP 4: CREATING A SECOND KEYFRAME

We now have the Ball object sitting on the ground plane and the camera positioned to properly view the action. The next step is to move the Ball object up into the air. We need to change the position of the Ball object and keyframe it on a frame that is halfway through the cycle. Grab the scrub bar at the bottom of the Layout viewport and advance the scene to frame 30. On frame 30, move the Ball object into the following position:

X = 0
Y = 2.5m
Z = 0

Create a keyframe for the Ball object in that position on frame 30. This moves the ball object a total of 2m from frame 0 to frame 30. The movement can be seen by moving the scrub bar between those two points. The ball begins in its position on the ground, then moves upward over 30 frames.

STEP 5: BRINGING THE BALL BACK DOWN

The last keyframe in the cycle will be the ball in its original position in order to start the cycle over again. The ball traveled upward in frames 0 to 30, so it should take another 30 frames to come back down, which puts the final keyframe at frame 60.

The ball can be positioned into its original starting place manually with the mouse or by entering the data, or we can simply copy the original keyframe at frame 0.

Back up the scene so that the current frame is frame 0. With the Ball object selected, click on the Create Key button. When the Create Motion Key requester pops up, go to the Create Key At section and type in the number 60. This will keyframe the ball object at its current position (which should be resting on the ground plane) and make a keyframe for the Ball at that position on frame 60. Advance the scrub bar to confirm the key has been correctly applied on frame 60.

Once you have confirmed that the Ball object is indeed moving up and down on a 60-frame cycle, save this scene for later use. Click on File button and select File, Save, then Save Scene As. Navigate into the Scenes directory and save the scene as Ball01. This scene will be used in tutorials later in this chapter.

Pressing the Play button on the transport controls at the lower-right corner of the Layout screen should show the ball object moving up and down. Its motion is very mechanical, moving like a metronome with no sense of life or weight. Movement is a surprisingly delicate thing and with skill and craftsmanship even something as basic as a bouncing ball can be given character and personality. In the next section we explore some of the important tools we use to breath life into the cold numbers of 3D animation.

Introduction to the Graph Editor

At this point, the Ball object moves upward for 30 frames and then moves back down for 30 frames. Although this is exactly how we directed the object to move when we applied the keyframes, the animation shows us that there is more to animating than moving a thing from one place to another. The way objects speed up and slow down during the course of their movements is as important as where they are going. Many motions are cyclical, meaning the same motion is repeated, such as in a ball that bounces up and down, a character walking, or a constantly spinning wheel. Some motions are cumulative, which means that the motion keeps going. A spinning wheel has a cumulative rotation. The first time it does a complete rotation it spins 360 degrees; if it spins twice, the total rotation is 720 degrees, and so on.

Creating keyframes gives the Layout items a series of *targets*, which specify where and how the item is to be positioned on specific frames. To help manage these keyframes, we have the Graph Editor. The Graph Editor is a powerful tool that allows you to manipulate, organize, and control all the channels that are created through the process of creating keyframes.

Opening the Graph Editor

With the animated Ball object selected, go to the upper left of the Layout screen and click on the button for the Graph Editor. The Graph Editor panel will immediately pop up, displaying the channels active for the Ball object (see Figure 2.27).

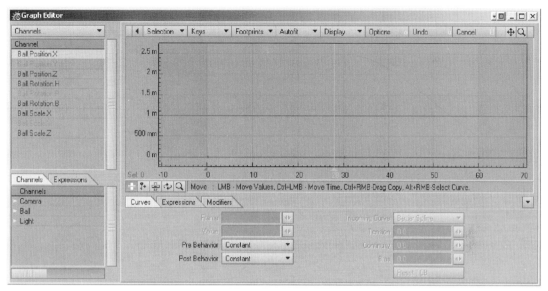

FIGURE 2.27 The Graph Editor with Ball object channels.

The Graph Editor gives you access to nearly everything an item does in Layout, plus it contains a number of tools to help you manipulate them. Fortunately, it is not necessary to completely master everything in the Graph Editor panel for it to be useful. Throughout the book we will continue to return to the Graph Editor to explore its different applications. (It should be noted also that the Graph Editor that is accessed for keyframed attributes in Layout has the same interface as the Graph Editor menu that shows up when keyframes are used to control other things like textures and light properties.) There are *a lot* of options in the Graph Editor panel; for now we will concentrate on only a few.

On the top-left quadrant of the Graph Editor is the channel bin. For the currently selected bouncing ball object there are nine active channels, three channels each for rotation, movement, and size. To the right of the channel bin is the graph panel with a graphic representation of the keyframes in both value and time. Clicking on a channel listing in the channel bin will make that channel active in the graph panel on the right. When the channel is selected, the envelope will become active.

For the currently selected object, the bouncing ball, clicking on the Y Position listing will activate the Y axis envelope and show a hill-shaped path that represents the 60 frames of the cycle. A small dot indicates a keyframe at frames 0, 30, and 60. The values of the keys can be altered by physically moving the keys around.

Selecting in the Graph Editor

Selecting and deselecting keys in the graph display area of the Graph Editor is very much like selecting points in Modeler. You can select keys in the Graph Editor in one of three ways. Clicking the LMB directly on a key will select it, but you run the risk of inadvertently changing the key value. A safer way is to hold down the RMB and draw out a rectangular selecting lasso that will select any keys it contains. The third way is to hold down the Shift key and double-click quickly in the area on the edge of the graph display. This will select all the keys in the selected channel. (Doing the same action when the keys are selected will deselect them).

A channel is selected by clicking on it. If you hold down the Shift key, clicking on a second channel will select it as well. This action can also select all the channels that are between the two. Holding down the Control key and clicking on additional channels will select only the individual channels.

The bottom-right quadrant of the Graph Editor contains several tabs, the most important of which is the Curves tab. The Curves tab allows you to specify the key's values and the envelope's behavior (see Figure 2.28).

FIGURE 2.28 The Curves tab.

The Frame section indicates the currently selected keyframe; below that is a readout of its numeric value. If a keyframe needs to have a specific value, as it often does, that value can be entered into the data box here. Below these are the Pre Behavior and the Post Behavior boxes. The behavior boxes determine what happens to the channel's envelope before the first keyframe and after the last keyframe (see Figure 2.29).

The behavior boxes contain several options. When a behavior is selected for an envelope, its effect can be seen instantly in the Graph Editor display. For something like the bouncing ball, the behavior Repeat would be the most appropriate. Selecting the Repeat option on the Y channel for Post Behavior will cause the ball object to move up and down in the 60-frame cycle forever.

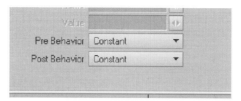

FIGURE 2.29 Behavior boxes.

Finally, the lower-right corner of the Graph Editor gives the spline options for the incoming curves. The spline options determine the shape of the envelope before and after the keyframe. If the envelope becomes almost flat before the key, the rate of change is very low. If the envelope is more vertical, that means that there is a more rapid change in the action. Typically, you want an action to "ease-in" at the end of a motion and "ease-out" when it starts moving. This action can be entered manually by setting the values under Incoming Curve.

Because the "ease-in, ease-out" action is so common, it is built into the Graph Editor interface. With the Y position channel selected, use the RMB to draw out a selection area that selects just the first and last keyframes on the Y position envelope. Move the mouse pointer directly over one of the keys and click and hold the RMB, without moving the mouse, to bring up an option box that will have Ease In/Out as one of its options (see Figure 2.30).

FIGURE 2.30 Ease In/Out option.

Selecting the Ease In/Out option will change the spline controls for the selected keys. The envelope will become flatter as it eases in and eases

out from the keys. Play a preview in the Layout view and note the immediate effect that changing the spline has on the motion. The ball now appears to slow down as it gets to the bottom of the cycle, then speed up as it gets to the top, as if it were bouncing on an elastic band. While this is interesting, it is not exactly the bouncing ball we were expecting. We want just the opposite action, where the ball speeds up as it gets to the bottom and snaps upward as it bounces.

To reverse the ease-in, ease-out action, look at the spline setting for the selected keys in the Graph Editor. The keys show a Tension value of 1.0, which causes the ease-in, ease-out action. Change the Tension to a negative value and change 1.0 to –1.0. A Tension value of –1.0 will accelerate the action as it nears a key rather than easing it. Viewing a preview in Layout will now show a more natural bouncing motion for the ball.

Spline Values

The active range of a Tension, Continuity, Bias (TCB) spline is between 1.0 and –1.0. Other types of splines are available, but the TCB is most commonly used and is the normal default spline. Other spline types may be specified as the default type by selecting a new default spline in the Options section of the Graph Editor.

Move Object vs. Move Path

The Ball object is moving up and down because it has three keyframes telling it where it is supposed to be and when it is supposed to be there. If we want to alter one of the keyframes we advance to the desired keyframe, move the object, and select Create Key to overwrite the old keyframe. (If the Auto Key function is active, any movement of the object will overwrite the old keyframe without asking for confirmation.)

Many times an object will have all of its motion properly keyframed, but will need to be moved off to the side. Rather than attempting to shift all the keyframes for all the channels a precisely equal amount, a much easier method is to use the Move Path function found towards the bottom of the Items tabs menu bar (see Figure 2.31).

FIGURE 2.31 The Move Path button.

The Move Path function allows you to grab the Layout item with all its keyframes and move the whole thing at once. Click on the Move Path button to activate it, then click and hold the LMB in the Layout viewport to shift the bouncing ball on the X and the Z axes. To move on the Z axes use the RMB. The Create Key function is disabled when the Move Path function is active.

Introduction to the Scene Editor

At the upper left of the Layout screen is a button for the Scene Editor. Clicking on the button opens the Scene Editor panel. In the Scene Editor panel you can manipulate several elements of the scene. The Scene Editor shows all of the current Layout items (see Figure 2.32).

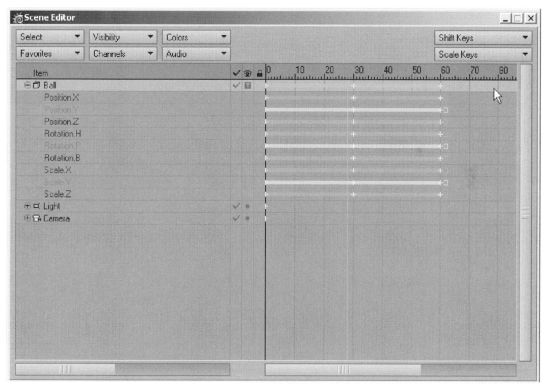

FIGURE 2.32 The Scene Editor.

Clicking on the little + button on the right side of the item expands the listing to show every active channel associated with that Layout item and its keyframes. Like the Graph Editor, the Scene Editor has many tools and functions, but only a few will be covered here.

Right-clicking on the Layout item within the Scene Editor brings up a number of valuable functions (see Figure 2.33).

FIGURE 2.33 Menu accessed with RMB on Layout item in the Scene Editor .

Clicking the RMB on the Light listing allows you to rename the light in the scene. This option is valuable when you have a scene that contains many lights and you need to quickly distinguish between a light representing a streetlight and one representing the sun. The RMB also allows you to clone the selected object. When you select Clone, you will be asked how many clones you want. The program will then proceed to duplicate the selected items. The duplicates will have all the same properties, envelopes, and keyframes as the original object. They will be difficult to see because they will all occupy the same space. If the bouncing ball object is cloned, the clones will sit right on top of each other. To move the clones apart but retain all the original motion, use the Move Path tool.

One of the most useful functions of the Scene Editor is the ability to shift and scale the keyframes in time. The easiest way to shift all the keys in time is to simply click on the channel bar on the right side of the Layout item listing. Click and hold down the LMB and slide it forward or back along the time line. This can be done on a per-channel basis by clicking on the individual channels, or for all the channels at once by clicking on the primary channel bar at the top of the list of channels for that object. Individual keys can be shifted the same way by clicking directly on top of the little dot that indicates the key and dragging it forward and back.

Scaling the action cycle is accomplished by clicking on the little square at the end of the channel bar and sliding it forward and back. Doing this will proportionally shift all the keys inside the channel bar in a ratio appropriate to the new length of the envelope. This can be done on a per-item or per-channel basis.

To scale and shift objects in the Scene Editor in exact amounts, we have two buttons at the top right called Shift Keys and Scale Keys (see Figure 2.34).

FIGURE 2.34 Shift Keys and Scale Keys buttons.

These are just the buttons you want when you need to make an item's action happen faster, slower, sooner, or later. You can specify the range of keys to affect and multiple items to affect.

Multi-selecting

The Scene Editor panel is the best place to multi-select items. Only Layout items of the same type can be selected as a group (objects with other objects, lights with lights, and so forth). Holding down the Shift key will select all the like items between two selected listings. Holding down the Control key will allow you to multi-select items one at a time.

T U T O R I A L **CREATING AND OFFSETTING MULTIPLE BOUNCING BALLS**

Currently in Layout we have a single bouncing ball. We want to have several bouncing balls in different places that are bouncing at different rates. (The bouncing Ball object should have a Post Behavior for the Y position channel set to Repeat in the Graph Editor.)

STEP 1: CLONING THE BOUNCING BALL

Open the Scene Editor. Click with the RMB on the listing for the Ball object and select Clone. Make two clones so that you have a total of three bouncing balls.

STEP 2: OFFSETTING THE ACTION

Click on the action bar for Ball(2) and slide it 40 frames to the right. The cycle is the same length, but the action will start 40 frames later.

Click on the very end of the action bar for Ball(3) and pull it to the left so it ends at frame 40.

STEP 3: SEPARATING THE BALLS

The three balls are now all bouncing at different rates, but they are still all in the same location. Return to the Layout screen and activate the Move Path function. Select Ball(2) and move it to one side, then select Ball(3) and move it to the other side.

View a preview of the three balls. With just a few mouse clicks, the basic animation of a bouncing ball has now become three times as complex.

Introduction to Parenting

Parenting is a simple concept with far-reaching consequences. Simply stated, a mouse action keyframed to the parent object gets passed to the child object. When the parent object is moved, rotated, or scaled, those actions also happen to the child object even though the child object may have no keyframes of its own.

A classic example of parenting would be setting up a solar system. The moon is parented to the earth, but the earth is also the child of the sun. If the sun is moved, the earth and the moon come along. If the earth is moved, the sun is unaffected but the moon comes along. If the moon is moved, it moves alone because it has no children of its own. The relationship between the parent items and the child items is referred to as the *hierarchy*.

The Scene Editor allows us to drag children to their parents and gives us a visual representation of the parenting hierarchy. To make one Layout item a child to another, click and hold on the child item listing with the LMB, then drag it so that it is just under the desired parent. A highlight bar will appear just under the parent to indicate when the child is in proper position. Once the child is in position, release the mouse button. (The drag-and-drop process of parenting does require a bit of practice.) Items can be un-parented in the same fashion by dragging the child item from the parent listing.

A less haphazard way to parent is to use the Motion Options feature. The Motion Option panel can be activated either by clicking the RMB on

the Layout item in the Scene Editor, or by clicking on the Motion Options button on the toolbar under the Items tab (see Figure 2.35).

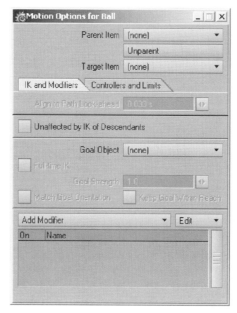

FIGURE 2.35 The Motion Options panel.

The Motion Options panel will affect whatever Layout item is currently selected. At the very top of the panel is the Parent Item box that allows you to scroll through a list of every potential parent item in the current scene. To remove the child from the parent, click the Unparent button, or select the {none} option from the list.

The hierarchy of the parent and child relationships are a little daunting at first, but will quickly become second nature. It is as simple as riding a bicycle, and a bicycle with its rider and wheels has its own natural hierarchy of parent-child relationships.

LIGHTS

Most people take lighting for granted when they begin animating. As you progress, you will realize how important really is. This chapter covers some of the basic mechanics of working with LightWave's various lighting options.

Lights as Layout Items

Until now, we have only moved and keyframed objects in Layout. Lights are an important part of Layout and in many ways are handled the same way as objects. When a light is selected, its position and rotation are keyframed exactly the same way as an object. Lights can also be parented to other Layout items.

The default Layout set starts with a single light pointing downward at an angle across the center of the scene. A scene may have only a single light, or it may have several thousand.

An actual light itself is invisible. We see only the effects the light has when it bounces off a surface or is diffused by haze or dust. In computer animation, the light is virtual and literally comes from nothing. There is no glass before the filament or atmospheric fog to give a visual clue where the light is. Unless the 3D light is directed at a visible surface, the light will remain unseen.

Selecting and Keyframing Lights

A light is a standard Layout item. It can be moved, rotated, parented, and, in some cases, it can even be scaled to different sizes. If the default light is currently visible in the viewport, it can be selected by clicking on it once. If the light is not currently visible, select the Lights button at the *bottom* of the screen. (The Lights tab at the top of the screen is for Light Properties and will not put us in the Lights as Layout Items mode.)

When the Layout item mode is Lights, the default light will show up in the Current Item box directly because it is the only light currently in the scene. With the light selected, it can be moved and rotated about the scene and keyframed into new positions.

When the light is rotated, the effect of the rotation can be seen on the surfaces of objects currently in Layout if the maximum render level of the Layout viewport is set to either Shaded Solid or Textured Shaded Solid. Remember that this is only an OpenGL approximation of how the lighting will look during the final render.

Adding Lights

Nearly every scene will need more than one light. To add more lights to the scene, click the Add button under the Items tab and scroll down to the Lights section (see Figure 2.36).

Layout provides several different types of lights, and each type has its own characteristics. These light types look slightly different from each

FIGURE 2.36 The Lights selections.

other when they are loaded into Layout, and their appearance gives us a
visual clue as to how they operate.

Using the Light View

A handy option in the viewport is the ability to see through a light. This
ability is extremely useful when aiming a light at a subject. By selecting
Light view as a viewport, you can easily see where the light is being
aimed. If you have multiple lights in the scene, the view will be through
the currently selected light. The Light view can remain active even if you
are working in Object or Camera mode.

Item Properties for Lights

As with all the items in Layout, lights have their own unique set of prop-
erties. With a light selected, click on the Item Property button to bring up
the Light Properties panel (see Figure 2.37, page 102).

Everything a light does can be accessed through the Light Properties
panel. Light properties can also be adjusted by clicking on the Lights tab
at the top of the Layout screen to bring up a number of light property
buttons on the menu bar.

The two basic properties of any light are the intensity and the color
settings. The color settings are the usual mix of red, green, and blue.
(Changing the color values of the light will affect the light in the OpenGL
display.) The normal intensity range for a light is 0 to 100%. As odd as it
seems, you can enter values greater than 100% and negative numbers for
light intensity.

Different Types of Lights

The Item Properties panel contains a setting for Light Type. Each type of
light has a different set of characteristics, and a scene may have several

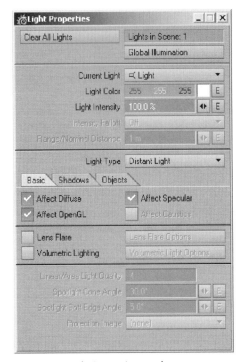

FIGURE 2.37 Light Properties panel.

lights of many different types. A light may also be changed from one type to another.

LightWave has five types of lights: Distant, Spot, Point, Linear, and Area. The first three, Distant, Point, and Spot, comprise the core lighting set, and it is important to understand how they work.

A Distant type light produces light with beams that travel exactly parallel to one another, such as laser light. The light produced by a Distant light originates from an infinite distance behind it and travels for infinity before it. The X-Y-Z values of a Distant light have *no effect* on the light. All that matters to a Distant light is its Rotation. The fact that a distant light's position is inconsequential can lead to the very odd and unsettling effect of the Distant light casting a shadow for an object that is physically behind the object.

The Point light is the opposite of the Distant light. A Point light illuminates a scene like a very small intense light bulb—rays of light emanate from an infinitely small point and spray out in all directions from that point. Because the light radiates in all directions from the point, the rotation of the Point light has no effect. The position of the Point light is very important.

A Spot light combines some of the characteristics of both the Point and Distant lights. A Spot light behaves very much like its namesake; it throws a theatrical-looking cone of light that can be aimed and focused. The edge of the circle of light created by a Spot light can be adjusted with the Spot Light Soft Edge setting. A Spot Light Soft Edge setting of 0.0 will create a very hard edge to the circle of light cast by the spot. If the Spot Light Edge Setting is set to equal the Spot Light Cone Angle setting, the light will be at full strength at the center and fade to nothing by the time it gets to the edge of the cone.

Linear Lights and Area lights are special purpose lights and require special handling. A Linear light throws light in a manner similar to a fluorescent light tube. LightWave treats a Linear light like a length of an infinite number of point lights. An Area light is like a big diffused light box. An Area light behaves like an infinite number of point lights held in a cookie tray. Area and Linear lights can create very natural lighting and soft edge shadows, but at the expense of rendering time and occasional noisy lighting artifacts.

Lights and Shadows

There are two types of shadows in LightWave, Ray Trace shadows and Shadow Map shadows. All Lights default to Ray Trace Shadow mode. A ray trace shadow is a very accurate, if severe, shadow. To get a softer edge to a ray traced shadow you must use Linear or Area type lights.

Shadow Map shadows are only available with Spot lights. While a ray trace shadow literally traces the path of a ray of light to get an accurate shadow, a Shadow Map shadow approximates what a shadow should be based on the basic geometry of the object. The Shadow Map shadow is usually accurate; also it is faster and can have the edges of the Shadow Map made fuzzy for soft-edged shadows. The disadvantage of Shadow Maps is that they do not respect transparency and can sometimes produce rendering errors if not enough memory is allocated to the Shadow map.

All lights default to having ray traced shadows turned on. Even if the light being added to the scene is a Spot light with the option to Shadow map, Ray Trace Shadows will still be active. To actually get ray traced shadows, you must turn on Trace Shadows in the Render Options panel (see Figure 2.38).

Shadows can be set independently for each light. A light can have shadows set to Off so that it casts no shadows.

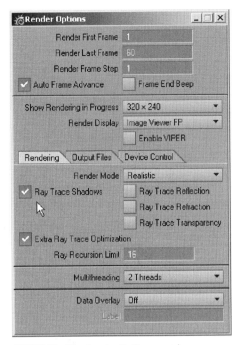

FIGURE 2.38 The Render Options panel

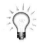

Shadow Properties for Objects

The Item Properties panel for Objects contains further options concerning shadows. The Rendering tab of the Object Properties panel contains checkboxes for Self Shadow, Cast Shadow, and Receive Shadow. These shadows are completely unlike anything in the real world, so it is easy to forget these options are there, but they can be useful.

SURFACING

This section will explain the basics of surfacing.

The Basics of Surfacing

All objects rendering in Layout have surfaces. Some objects have more than one surface, depending on how the surface names were applied to the polygons when the object was in Modeler. To adjust these surfaces we must use the Surface Editor.

Near the top left of the Layout screen is a button that brings up the Surface Editor (see Figure 2.39).

FIGURE 2.39 The Surface Editor.

In the Surface Editor we can alter, preview, and manage surface attributes of polygons. On the left side of the editor is a listing of all the surfaces for the objects currently loaded into Layout. If the Ball object is in the scene, the Ball object surface will show up in the list of surface names. Clicking on the surface listing makes that the active surface. Holding down the Shift key allows you to adjust multiple surfaces at once.

At the top-right quarter of the Surface Editor are the Load, Save, and Rename commands. Rename allows you to change the name of the current surface. This changed surface name is part of the object file and the

object must be saved to retain the changed name. Load and Save allow you to store and recall a single surface, respectively. Surface settings can be saved one at a time to a directory for loading onto other surfaces. (Note that Surface Saving has largely been replaced by the Presets panel.)

Below the Load and Save options is the texture sample panel. The sample window defaults to a 1m sphere illuminated by the same lighting setup that exists in the current scene in Layout. To the right of the surface preview window is an information window that gives you useful information about the currently selected surface (see Figure 2.40).

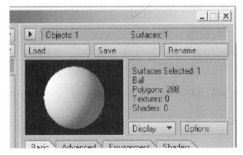

FIGURE 2.40 The surface sample panel.

The surface sample panel gives you several options for both what is displayed and how it is displayed (see Figure 2.41).

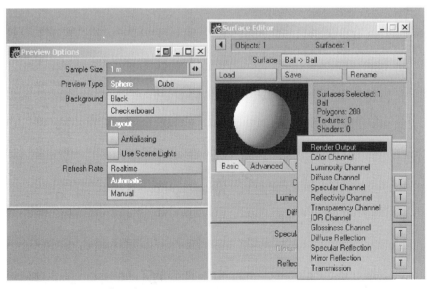

FIGURE 2.41 Options and Render type.

It is often useful to have the background of the sample image something other than black, particularly when dealing with transparent surfaces. Another useful function of the sample panel is the ability to alter the size of the sample texture. If you have modeled a drawbridge or a matchbook to scale, it helps to have a sample texture of a similar size when adjusting the surface.

Object or Scene Mode

Surfaces can be adjusted on a per-objector per-scene basis. In Object mode, several objects can share the same surface names, but the surfaces will still be unique to those objects. In Scene mode, a surface name applies globally to all the loaded objects; any object with a surface with the same name will be treated as a group. For example, suppose you have bowling pins with the numbers stenciled into the object as part of the geometry. Each of the 10 pins has three surfaces, PinWhite, RedStripe, and PinNumber. Each pin could have the same surface attributes, so you could work in Scene mode with a total of three surfaces. If you wanted each object to have a unique look, you would surface by object so each pin's surface could be addressed separately.

Presets

Surfaces, along with several other functions in LightWave, have banks of Presets. Clicking on the Preset button at the upper left of the Layout screen while the Surface Editor is open will bring up the Surface Preset panel. Several banks of presets can be accessed by clicking on the bar at the top and selecting the desired bank (see Figure 2.42).

FIGURE 2.42 Surface Preset panel and additional banks of presets.

Double-clicking on the sample image of the preset will copy that texture to the surface active in the Surface Editor. Conversely, double-clicking on the sphere in the texture sample window of the Surface Editor will put that texture into the list of presets.

Clicking on the sample image in the Surface Preset panel with the RMB brings up a number of options for managing the surface textures in the Preset panel (see Figure 2.43).

FIGURE 2.43 Surface Preset management options.

When a surface is copied into the Surface Preset panel, it comes with the name the surface had while in the Surface Editor, so you may want to rename it. You might also want to create your own library of textures to keep the preset shelf from becoming too cluttered.

Using Viper

Viper is an interesting animal. Viper allows you to quickly preview many of the functions in LightWave without doing a full render of the frame. Clicking on the Viper button at the upper left of the screen activates the Viper function and opens the Viper window. Once Viper is activated, a single frame needs to be rendered. Once a frame is rendered, the information from that render is stored in the Viper buffer. When changes are made to a surface, Viper looks at information that it stored from the last rendered scene, compares it to what has been changed, then makes a calculated guess as to what the new texture will look like with the new settings, based on the last rendered frame. After a frame is rendered, a version of that frame will appear in the Viper window.

Viper can be enabled either by clicking on the Enable Viper box in the Render Options panel, or by just clicking on the Viper button in Layout. After Viper is enabled, a single frame must be rendered, because Viper bases its calculations on this frame. Any frame in the scene can be rendered. Advance the scrub bar to the best frame and select Render Current Frame from the rendering button.

Viper has a few limitations that are important to know about. Viper is still very much a "best guess" approximation of what the final surface will look like. Viper does not handle anything involving ray tracing, nor some of the more advanced lighting set-ups, very well. The image in Viper is a guide to surfacing and not to be trusted for the final render. That said, Viper is extremely useful for many aspects of surfacing. Viper will properly show many of the sophisticated surfacing aspects like different blending modes, Procedural textures, and falloff. Viper can also preview the effects of textures with motion by rendering an animated preview.

Basic Surface Attributes

The Surface Editor contains several tabs, the first of which is the Basic tab. All surfaces start with the settings in the Basic tab. The surfaces are broken down into different elements called *attributes*. Attributes are the separate ingredients in the total mix that is the surface texture. Some of the attributes are straightforward, like the attribute for color, but others are not so easy to understand. Most attributes have an equivalent in the real world, but real-world textures are rarely broken down so easily into their component parts.

We will start with the attribute that is easiest to understand, color. The first slot in the Basics tab is labeled Color and is followed by three sets of numbers representing Red, Green, and Blue values. These numbers can be altered by holding down the LMB on one of the three groups and sliding the mouse up and down. Colors can also be adjusted by clicking on the colored square just to the right of the RGB numbers to bring up the color picker. (Which type of color picker appears depends on the computer you are using.) Changing the color setting will immediately change the color of the surface in the sample texture window, the surface in the Viper window, and the object in Layout if Layout is set to a Shaded Solid render.

Below Color is the setting for Luminosity. Luminosity causes the surface to light itself.

In the real world, luminosity will actually cast light and illuminate surrounding objects. In LightWave, luminosity will only cast light if radiosity is turned on.

The next attribute on the list is Diffuse, which is the opposite of luminosity. The Diffuse level determines how much the surface will respond to the light that strikes it. A Diffuse setting of 100% means that all of the light that hits the surface will bounce back, or be diffused, toward the viewer. A sheet of paper or cloth has a high Diffuse level. If the surface

has a lower Diffuse level, it does not get illuminated as much and appears darker. Most metals and reflective surfaces have low Diffuse levels. Diffuse is often used just to make surfaces appear darker and more muted without affecting the color balance.

The next two attributes, Specularity and Glossiness, go hand in hand. Simply put, the amount of Specularity means how shiny a surface is. Glossiness refers to how big a specular hot spot that shininess makes. Specularity and Glossiness are strong visual clues to the apparent hardness of a material. An apple and a marble may have the same Specularity, the same amount of shine, but the Glossiness will be very low on the apple's surface and much higher on the glass marble's surface. Changes in the Specularity and Glossiness levels can be viewed in the OpenGL preview.

The Reflection setting in the Surface Editor is not as straightforward as the previous settings. Reflections can be real ray traced reflections, or simulated through a process called *spherical reflection mapping*. The Reflection setting is one of the most complicated and involved of the surface attributes. For a surface to reflect other objects in the scene, Trace Reflections must be turned on in the Render Options panel. There are also settings in the Environment tab of the Surface Editor panel that control how Reflection operates. Reflection options are a deep subject that will be explored later in Chapter 6.

Transparency is exactly what it sounds like. This setting makes the surface transparent. Although this seems fairly simple, some issues will crop up that you may not expect. Remember that most of our objects are built with single-sided polygons. This means that if you create a box and make one side of the box partially transparent, you will not see an inside to the box because all of the polygons are facing outward. If you make a glass sphere, you will not see the back sides of the polygons that are facing away from the camera because they are only visible from the front. An easy way to fix this problem is to go to the bottom of the Surface Editor panel and activate the Double Sided button. With the Double Sided option active, LightWave will render a single-sided polygon as if it had a face on both sides. Be aware that LightWave generally does not like to render double-sided polygons; double-sided polygons complicate the rendering calculations and will, at the very least, double the rendering time.

When a surface has transparency, it also has Refraction, the next attribute. The Refraction attribute is ghosted unless the object has some degree of transparency. Refraction means the property of transparent substances to bend light. A magnifying glass magnifies because of refrac-

tion. To get Refraction to show up in a rendering, the Refraction level must be set to a value other than 1.0, and Trace Refraction must be turned on in the Render options panel. LightWave will render Refractions only if Trace Refractions is activated. Setting the proper index of refraction (IOR) is very important in duplicating realistic looking glass and liquids. The IOR of air is 1.0, which effectively means the rays of light are not distorted as you view them through the transparent surface. The useful range of IOR is between 1.0 and 1.5. Keep in mind that although tracing refraction creates photorealistic rendered images, tracing refraction is very computationally intensive and will increase rendering time dramatically.

Translucency is the effect of a surface being illuminated from the back. Normally, a surface is illuminated by light hitting the front of the polygon. Many surfaces, like paper and cloth, will transmit light that strikes it from the rear.

The Bump setting is not really an attribute, but a way of creating the illusion of detail on a surface. The Bump needs to have a texture assigned to it to have an effect. The Bump channel is used to create tiny little details on the surface of an object that would be too small to create using points and polygons.

Smooth is like the Bump function in that it duplicates the effect of having more points and polygons than are really there. All objects are created using flat polygons; for example, beach balls, fenders, and dinosaurs are all made up of flat polygon faces tied together by points. The Smooth option takes the crease out of the places the polygons meet and renders it as a continuous surface.

The Smooth Threshold allows you to set at what angle the smoothing will start. Frequently you will have an object that has angle surfaces and curved surfaces, such as the bevel on a text object. You want the bevel section to be smooth, but not the area where the bevel meets the straight part. Lowering the smoothing threshold limits where the smoothing can occur. The threshold setting can be adjusted by watching the object be modified in the OpenGL preview as you adjust the Smoothing Threshold. The smoothing action will be taking place in real time.

Textures and Envelopes

Two buttons, E (Envelope) and T (Texture), follow nearly all the surface attributes listed on the Basic tab. These provide ways to modify the initial settings for each of the attributes.

SETTING UP AN ENVELOPE TO CHANGE COLOR

Creating an Envelope for the Color channel in the Surface Editor can animate the color of a surface.

STEP 1: LOAD AN OBJECT INTO LAYOUT

Clear the Layout so you are starting with a fresh screen. Load the Ball object into Layout. Keyframe the ball object so that it rests squarely in the center of the Camera view.

STEP 2: SELECTING THE SURFACE

Open the Surface Editor by clicking on the Surface Editor button. There is only one object currently in Layout so the surface of the Ball object should be the only one that appears in the surfaces listing, and will automatically be selected.

STEP 3: CREATING AN ENVELOPE FOR THE COLOR CHANNEL

In the Surface Editor, click on the E button in the Color channel to bring up the Graph Editor for the Color values (see Figure 2.44).

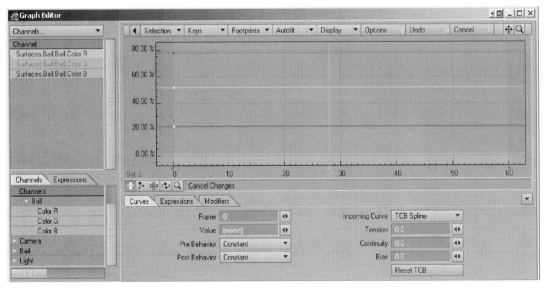

FIGURE 2.44 The Color Graph Editor.

The Graph Editor for the Color channels is the same as the Graph Editor used in Layout for motion. The difference is the band of color at the bottom of the graph window that displays the color throughout the range of the scene. There are three channels in the Color Graph Editor, one each for red, blue, and green. Clicking on the listing of red, blue, or green, will select that particular channel.

STEP 4: CREATING KEYS

Select the Make Key tool from the list of Graph Editor tools (the box that looks like a key with a + sign after it, shown in Figure 2.45).

FIGURE 2.45 Make Key tool.

With this tool you can create keyframes in the Graph Editor by clicking the LMB in the graph display. Holding down the mouse button allows you to move the key up and down in value. After the mouse button is released, the key's value frame number can be adjusted manually by entering those new values in the boxes at the bottom of the Graph Editor panel.

Once several keys have been added to all of the Color channels, you can see the results in a Layout preview. The colors of the surface change in accordance to the values of the keyframes.

The Envelope button for the Color channel is the only one of the attributes that has three different channels. The rest of the attributes have only a single channel to their envelope that controls the amount of that attribute's contribution to the surface. Notice that when the envelope for an attribute is first opened, there is a keyframe on frame 0 that has the same value as the value originally showing in the attribute box.

Removing Envelopes and Textures

How do you turn off the E or the T button? Hold down the Shift key and click the LMB on the active E or T to disable it. This works on the E or T buttons anywhere in LightWave.

Clicking on the T button brings up the Texture Editor panel (see Figure 2.46).

FIGURE 2.46 The Texture Editor panel.

Using textures allows you to vary the way an attribute is distributed over a surface. The values entered on the Basic tab apply equally over the entire surface. Textures break up value to give it variation.

There are three types of textures that can be used to apply an attribute to a surface: image maps, Procedurals, and Gradients. Each texture type has its own strengths and weaknesses. Several layers of different types of textures can be combined on a single attribute for sophisticated surfacing.

An *image map* texture uses an image loaded into Layout to apply a texture to a surface. The Color channel immediately comes to mind. An image map applied to the Color channel is an obvious application of

image mapping a texture, like using wallpaper to cover a surface. Image maps are used on other attributes as well. When a color image is loaded into anything other than the Color channel, the image gets treated as if it were a black and white, grayscale image. The white part of the image will be at 100 percent strength, black parts of the image will be at 0, and the gray areas between are scaled appropriately.

A Procedural is a mathematically defined texture. It can be a simple checkerboard pattern, or a complex interaction of fractal functions. When a Procedural texture is chosen as a texture layer, you have a list of different Procedural types to choose from. Some of the Procedural textures have names like Wood and Puffy Clouds that describe their nature. Other Procedural names are not so descriptive, like Ridged Multi-fractal. The sample sphere and the Viper window come in handy for previewing such textures when they are applied to a surface.

TUTORIAL

APPLYING A PROCEDURAL TEXTURE

Previously we changed the color of a surface by creating keyframes in Graph Editor of the Color channel. In this tutorial a Procedural texture will be applied to the Color channel of a surface.

STEP 1: LOAD AN OBJECT INTO LAYOUT

Clear the Layout so you can start with a fresh screen. Load the Ball object into Layout. Keyframe the Ball object so that it rests squarely in the center of the Camera view.

STEP 2: SELECTING THE SURFACE

Open the Surface Editor by clicking the Surface Editor button. There is only one object currently in Layout, so the surface of the Ball object should appear by itself in the surfaces listing and be automatically selected.

STEP 3: ACTIVATING VIPER

Activate Viper by clicking the Viper button. In Layout, render a single frame. When the frame is finished rendering, click on the render button in the Viper panel. A duplicate image of the rendered frame should appear in the Viper window.

Step 4: Opening the Texture Editor

In the Surface Editor, click the T button for the Color channel. This will open the Texture Editor panel. Go to the Layer Type listing in the top-right corner of the Texture Editor panel. The default Layer Type is Image Map. Click on Image Map and select Procedural. Notice that several of the setting options in the Texture Editor change to accommodate the change in layer type.

Step 5: Adjusting the Procedural Parameters

When Procedural is selected as a texture type, the default Procedural, Turbulence, appears. This is a marble-like, wispy texture. Directly under the listing for Procedural Type is Procedural Color with RGB values and the color box. (Note that the color selection is handled in the same way as on the Basic tab with the color attribute.) Change the Procedural Color to solid red, an RGB value of 255,000,000.

The Procedural texture layer will show up immediately in both the surface preview window of the Surface Editor panel and the Ball object that appears in the Viper window. However, the Procedural texture will not show up in the OpenGL display of Layout. Only changes to the Basic attributes will show up in Layout; however, one layer of image mapping per surface can be rendered in the Layout view.

Step 6: Changing the Size of the Procedural Texture

The surface size of the Ball object is 1m. We need this information to properly scale the relative size of the Procedural. The proper size of a Procedural texture is whatever size looks good.

At the bottom of the Texture Editor are a number of tabs for adjusting dimensional elements of the textures. The first tab is Scale. Scale changes the relative size of the Procedural texture. Procedurals exist in three dimensions, and have coordinates much like the objects we build. The default size for all textures is 1 standard unit, 1m. We will reduce the size of the texture by half. Enter the following values for the Scale of the Turbulence Procedural:

X = 500mm
Y = 500mm
Z = 500mm

One half of 1m is 500 millimeters (500mm). You should see the changes to the texture taking effect immediately, once you press the Enter key, in both the Viper and the sample window. The texture is now half its original size.

STEP 7: TRYING OTHER PROCEDURALS

Holding down the LMB on the Turbulence listing for Procedural Type brings up a long list of Procedural types. Notice that choosing different Procedural types will bring up different sets of parameters unique to that Procedural, but it will retain the color values and the Scale settings.

Scaling Procedurals and Getting Size

It is sometimes difficult to zero in on an appropriate size when applying a Procedural texture to a surface. A good rule of thumb is to estimate the size the surface covers and scale the Procedural to about one-tenth that size. This usually gets you close to what you want, and then you can scale the size up or down from there.

If you do not know how large an area the surface covers, click on the Automatic Sizing button. This is normally intended to quickly size image maps, but it also tells you exactly the size that an image needs to be to cover the entire surface. Use this information to scale the Procedural texture.

CONCLUSION

Entering into any new art form requires a certain amount of understanding of the mechanics of the process, and LightWave is no different. The fact that everything is out in front and easy to access is a boon to production, but can make learning the program a bit intimidating. Fortunately, it is very hard to actually cause real damage when learning to use Light-Wave.

3

BASIC SURFACING

In This Chapter

- Mechanics of Surfacing
- Basic Attribute Channels
- The Shaders Tab

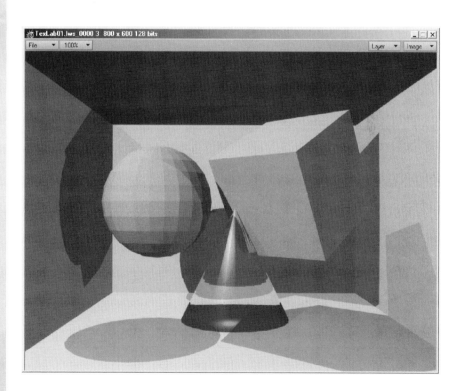

In this chapter you will learn the basic properties of surfacing.

MECHANICS OF SURFACING

Surfacing an object is the art of balancing the attributes that contribute to the way a polygon reacts to being illuminated. The illumination can come from the Layout lights, from reflected indirect light, or even self-illumination through luminosity. There are very few hard-and-fast distinctions in real-world textures; real-world textures are not built from separate components of sharply divided categories. Nearly all of an image's properties interact to some extent, but to keep things manageable, each image's properties need to be broken down into its attributes. These attributes will sometimes interact naturally, but will most often need to be manually matched. The Surface Editor gives us great control over an image's available attributes, allowing us to mimic real-world surfaces and to create surfaces with attributes that could never exist outside a computer rendering.

The Texture Lab

ON THE CD

To explore the mechanics of texturing a surface, load the TexLab01.lws scene from the Surface folder of the Scenes directory from the CD-ROM. This file contains a collection of basic objects arranged inside a room (see Figure 3.1).

The objects inside the room are all 1m objects, the default unit. The room itself is 3m by 2m. Each object in the scene has one surface name; the surface name represents the object. Opening the Surface Editor will reveal the list of surface names in the scene.

All the surfaces of the TexLab objects will have the default dull gray surface texture. The objects are centered by default, but have been keyframed here to spread them throughout the room.

A little extra care has been put into lighting the scene, so that it more closely resembles a real lighting setup than what you get with the defaults. Three-point lights illuminate the objects, each with a different intensity and slightly different colors. The ambient light level has also been reduced from the default level of 25 percent to only 5 percent. The scene also has Trace Shadows activated. The three points of slightly varying colors help bring out the depth and contours of even these simple objects. Good lighting is the first step to building good textures.

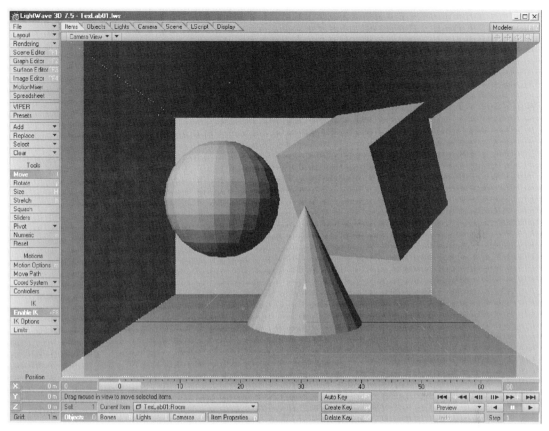

FIGURE 3.1 The Texture Lab screen shot.

Using Viper

Viper is a very important tool for the process of creating textures. Viper gives nearly instant feedback on the effects that changing values have on the surfaces. Keep in mind that Viper is not a perfect representation of the final rendered surface, because there are certain things that Viper cannot take into account. Some lighting effects, reflections, and transparency, which all rely on ray tracing, will not be correctly rendered in the Viper window. Even with these limitations, Viper is still very useful in adjusting surfaces' attribute values.

You must do two things in order for Viper to work. Viper needs to be activated, and a frame needs to be rendered. When Viper is "awake," it will grab information from the rendered frame and use it to render the preview in the Viper window. Viper will render the surfaces based on the location of the polygons in the last rendered frame. The current frame

in Layout can be changed, but Viper will still be referencing the last rendered frame. (Viper will acknowledge certain things, like movement within the texture and movement of the lights in the scene.)

One of the handiest things about Viper that many people tend to forget is that you can select a surface by clicking on it in the Viper window. To demonstrate, activate Viper and render a frame of the TexLab scene. Once the frame is finished rendering, click the Surface Editor button to open the Surface Editor panel. If a duplicate of the rendered frame does not appear in the Viper window, click the Viper window's Render button. The image in the Viper window should look much like the rendered image. (At this point the window looks exactly like the OpenGL Preview, except that there are no shadows. The shadows are in the rendered image because they have been ray traced.) Clicking on the items in the Viper window while the Surface Editor is open will select the surface name for whatever polygon was clicked.

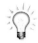

Rendering a Frame for Viper

When Viper is activated, a frame must be rendered so that Viper has an image to work with. However, the single frame does not need to be rendered at full resolution or with all the antialiasing passes completed. Once a full render pass of a frame is done, you can abort the render and Viper will use the single completed pass.

Presets and Surface Management

Surfaces can be saved and retrieved two ways. They can be saved as separate files using the Load and Save commands in the Surface Editor, which saves the texture information as an SRF file. Alternatively, surfaces can be copied and loaded from the Presets library.

If you click Presets button while the Surface Editor is open, the presets for the surfaces appear. Double-clicking the thumbnail image in the Presets panel will copy the preset texture onto the currently selected surface. To store a surface in the Presets panel, double-click the sample window in the Surface Editor, which will copy the sample image into the Presets panel. Clicking inside the Presets panel with the right mouse button (RMB) allows you to move the textures into specific libraries inside the Presets panel.

You can also copy and paste textures within the Surface Editor during a session. A RMB click on a surface listing will bring up a copy/paste

option for that surface, which will copy a surface texture and remember it until either LightWave is shut down or another surface is copied.

In the Surface Editor, more than one surface can be selected at one time, which is useful when you want to adjust certain attributes as a group. Hold down the Control key to select the surfaces one at a time. Hold down the Shift key to select all the surfaces between two selected surfaces.

BASIC ATTRIBUTE CHANNELS

The way a surface looks and reacts to light can be broken down into categories referred to as *attributes,* sometimes referred to as *channels.* Some surface attributes, such as Color, are very straightforward. Others, such as Diffuse and Bump, are more obscure; and still others, like Transparency and Reflection, have applications that are deceptively complex. Some attributes work with each other; others work against each other, but all are tied together in some way. It is important to have a good working knowledge of all the basic attributes to understand the complex interactions of the advanced surfacing settings.

Base Value, "E," and the "T"

Nearly every Attribute channel on the Basic tab has a numerical slot, an E button, and a T button (see Figure 3.2, page 124). The first "slot" sets the base value for the channel. The value entered here is the starting point for that attribute. The E button stands for Envelope; clicking the E button will bring up the Graph Editor where you can create keyframes that will allow your base value to change over time.

Next to each E button is a T button, which takes you to the Texture Editor. In this case, *texture* refers to the ways you can modify the base value of the attribute over the area of the surface. Textures can be image maps, Procedurals, or Gradients, all of which will be covered later in Chapter 6.

Turning off T and E

To deactivate the T or the E function in a surface channel, click on them while holding down the Shift key. This function has the distinction of being the most easily forgotten function in LightWave.

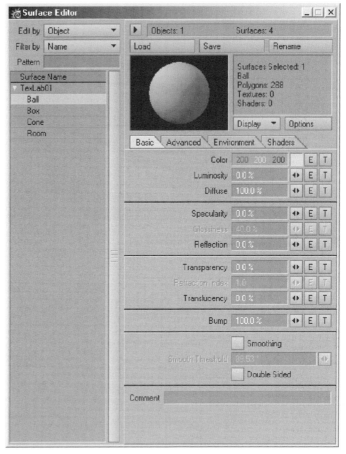

FIGURE 3.2 The Surface Editor lists the active surfaces on the left of the window, and defaults to the Basic tab in the Attributes section on the right of the window.

Color

The Color attribute is unique in the Surface Editor for several reasons. It is the only attribute that comes with three channels of its own, one each for red, blue, and green. The base color can be changed by clicking the left mouse button (LMB) directly on the three digits in the Color channel listing and scrubbing up and down to scroll the color values. You can see the color change in the tiny color box to the left of the numbers, in the sample window at the top of the Surface Editor, in the Viper window, and even in Layout in the OpenGL display.

Clicking on the tiny color box to the left of the Color channel numbers will bring up your system's standard color picker. The color picker

will allow you more precise control of selecting the base color of the surface.

Clicking the E button for the Color channel brings up another unique aspect of the Color channel, the unusual Graph Editor (see Figure 3.3).

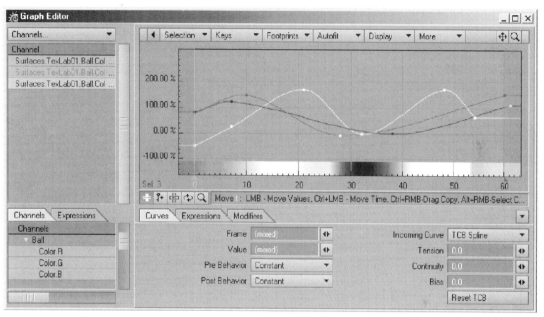

FIGURE 3.3 The Color Graph Editor.

The Color Graph Editor is unique in that it is the only Graph Editor in LightWave with a color readout. The Color Graph Editor has three native channels: the red, green, and blue values. Creating keyframes of various values inside the Color channel Graph Editor will change the base value of the surface, and that color is represented with the color swatch under the graph grid. The color changes that are keyframed in the Color channel Graph Editor can actually be seen in the OpenGL preview. (Although keyframing color values and seeing them change in real time is neat, it has not proven to be terribly useful.)

Luminosity

The definition of luminosity is not exactly what you might think it would be. As a surface attribute, *luminosity* determines the level at which the surface illuminates itself. Giving a surface luminosity alone will not make it glow, nor will it cast light onto surrounding surfaces (although there are advanced techniques that will allow you to do that).

We tend to think of luminosity as an all-or-nothing setting: it is either luminous or it is not. However, as an attribute, luminosity means how much the surface will be illuminated by being hit by direct rays of light. In most cases, luminosity is used in very small amounts—just a few percent—to help bring out a surface in a particular render. By its nature, luminosity illuminates a surface in a very flat and unnatural light. It is often used to give a surface the appearance that it is being lit from within, like a TV screen or a vessel containing energy.

Luminosity can be used as a light source with radiosity, and can be used in conjunction with the glow function.

Diffuse

The term *diffuse* does not have a direct counterpart in the real world. The diffuse level of a surface measures how intensely it reacts to light. We see things because light hits a surface and bounces that light into our eyes. A sheet of white paper is very diffuse; nearly all the light that strikes it is reflected back, which is why it looks so bright. A sheet of metal, on the other hand, may have a very low diffuse value; the brightness of the surface changes very little no matter what amount of light strikes it.

Lowering the Diffuse level is often used to make a surface appear darker, but there is more to this setting than that. A surface with a Diffuse value of 50 percent will only react to half as much as a surface with a Diffuse level of 100 percent. If the 50 percent Diffuse surface gets twice as much light, the two surfaces will come out even. Varying the Diffuse levels in a surface allows you to create subtle and realistic surfaces.

Specularity and Glossiness

These two attributes work hand in hand. Simply put, *Specularity* equals shininess. The *Glossiness* value determines the size of the white specular hot spot. The higher the value for Glossiness, the smaller and tighter the specular hot spot will be.

Specularity and Glossiness are the biggest visual cues to the perceived hardness of a surface. Play with the values and watch the sample sphere at the top of the Surface Editor. Notice how the small values give it a sense of being soft and light, whereas the higher values give it the sense of hardness and weight.

 Jumping ahead for just a moment, the Advanced tab in the Surface Editor has a Color Highlights setting. This attribute should really be grouped with Specularity and Glossiness. All the Color Highlights setting does is mix the underlying color of

the surface with the specular hot spot, which can help create surfaces that have a matte rather than glossy finish, such as cloth or unfinished wood.

Reflection

Reflection is a medium-sized can of worms. If you give one of the objects in the sample scene a reflection value of 100 percent and render a frame, the image will appear to be unchanged. This is because Reflection is heavily dependent on the Environment settings.

There are two ways to give an object a reflective surface. LightWave can do true ray trace reflections with the surface becoming a true mirror, reflecting the objects that surround it. LightWave can also do a good job of creating a fake reflective surface, which is very useful for such things as flying logos, where the logo is the only object in the scene, and there is nothing else in the environment for the surface to reflect.

T U T O R I A L ## SETTING UP REFLECTIONS

There are several ways an object can appear to have a reflective surface, with or without ray tracing.

STEP 1: REFLECTING BACKGROUND ONLY

We will select the Ball object and make it appear to be reflective using the background gradient image. In the Surface Editor, select the Ball surface and set the Reflection value to 80%. After setting the Reflection value, the Ball in the Viper window appears unchanged. Rendering a frame will also show no change in the Ball surface. In the Surface Editor, click the Environment tab and look at the Reflection Options section (see Figure 3.4, next page).

The default setting for Reflection Options is Backdrop + Ray Tracing. Because Trace Reflections has not been enabled in the Rendering options, only the Backdrop appears in the surface reflection. Or, it should be said, the Backdrop does not appear, because the default Backdrop is solid black and adds nothing to the surface.

Under the Scene tab of Layout, click the Backdrop button to open the Effects menu to the Backdrop tab. Select the Gradient Backdrop option with the default spread of colors. Once the Gradient Backdrop is activated, hit the Render button in the Viper window to refresh the image. You should see a color pallet of the background gradient appear as if it is being reflected in the Ball surface (see Figure 3.5, page 129).

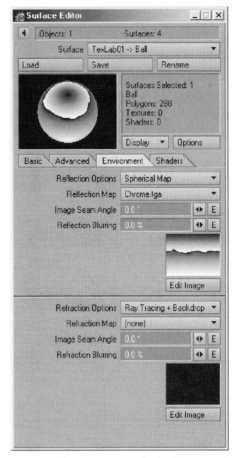

FIGURE 3.4 The Environment tab. The Chrome.tga image is being applied to the sample sphere as a spherical map.

STEP 2: IMPROVING REFLECTIVE SURFACE

The Ball surface, even though it has a mock reflection, still looks a little washed out and odd. This is because most reflective surfaces have low diffuse levels and are shiny. Give the Ball surface the following settings:

Diffuse—20%
Specularity—100%
Smoothing—On

Smoothing is turned on for the Ball surface just because most reflective surfaces look better on curves.

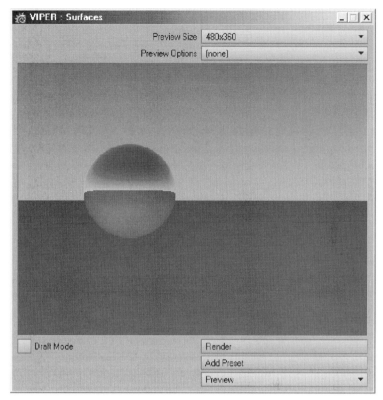

FIGURE 3.5 The Ball object with Backdrop reflection.

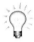

Diffuse vs. Reflection

Images that appear as reflections on a surface add to the surface's brightness, often making it appear washed out. Lowering the Diffuse level can compensate for this. A good rule of thumb for balancing Diffuse with Reflection is that the totaled values should add up to 100 percent.

STEP 3: RAY TRACING REFLECTIONS

To get true reflections, you must use ray tracing. In the Rendering Options panel, activate Trace Reflections. To see the reflections you must render a frame, because reflections will not show up in the Viper window.

Notice that now when a frame is rendered, you no longer see the Gradient Backdrop. This is because the Ball object is completely enclosed by the outer box and is reflecting the walls that surround it.

STEP 4: USING A SPHERICAL REFLECTION MAP

A spherical reflection map works much the same way as the Backdrop reflection; it uses a separate image to duplicate the appearance of a reflective surface by mapping mock reflections. It is as if the image was mapped on the inside of an inward facing sphere and the surface was reflecting it.

In the Surface Editor with the Ball surface selected, go to the Reflection Options of the Environment tab and select Spherical Map. Choose the image to be used as a Reflection Map by clicking in the Reflection Map box and selecting Load Image. From the Images directory, load the Chrome image. You should instantly see the effect of the spherical chrome image map in the viper window. You can see this on the sample sphere back in Figure 3.4.

The Spherical Map option does not require ray tracing, but it can be used with ray traced reflections. The Reflection Options contains a Spherical Mapping + Ray Tracing setting, which works just like Backdrop + Ray Tracing, as discussed previously.

STEP 5: THE VAMPIRE EFFECT

At times you might not want objects to show up in the reflections. To demonstrate, select the Room object and open the Object Properties panel. Under the Rendering tab, activate Unseen by Rays. Use the Spherical Map + Ray Tracing setting in the Reflection Options and make sure that Trace Reflections is turned on.

Render a frame and observe how the Room object does not show up in the Ball object's reflective surface, but the other objects in the scene do. These settings allow the chrome reflection map to still appear on the reflective surface of the ball. This effect can also be reversed; an object will be seen by rays but not seen by a camera, which is a very handy method for positioning reflected images onto a surface.

The spherical reflection map has an interesting option. The Display properties panel contains an option for OpenGL Reflections. This is not terribly useful, as the reflections as they appear in OpenGL are only rough approximations of how they appear in the final render. On the other hand, the real-time reflection maps look very impressive in the Layout preview.

Ray Recursion Limit

The Render Options panel contains a setting for the Ray Recursion limit. Ray Recursion *is the number of times an image will bounce back and forth between two reflective surfaces. In most cases, this setting can be reduced to either 2 or 4. (One recursion will not show any reflections at all.) This setting will drastically reduce rendering time in many cases, yet still give you the reflective texture that you want.*

Transparency and the Refraction Index

On a very basic level, the Transparency attribute is exactly what it sounds like—the Transparency value determines how much can be seen through the surface of the polygon. The complication is that transparent surfaces have many different characteristics. A shear piece of green cloth can be seen through, but will not filter the light the way that a green plane of glass will. Smoke is partly transparent but will not bend light the way the completely clear water will.

TUTORIAL

UNDERSTANDING TRANSPARENCY

Giving a surface a level of transparency is not always a straightforward process. The effect that the transparent or practically transparent object has on the surrounding environment gives us visual cues to the physical nature of the object.

STEP 1: MAKING THE CONE DISAPPEAR

Using the default TexLab01.lws scene, open the Surface Editor and select the Cone surface. (If you have not already done so, render a single frame so that Viper has an image to work with.) Click on the arrows for Transparency and scrub the values back and forth. If OpenGL Transparency is activated in the Display options, you can see the Cone object in Layout fading in and out. Set the Transparency level for the Cone surface to 100% and render a frame.

Notice in the rendered frame that the Cone object is completely gone. Even the shadow of the cone is gone because the shadows are being ray traced and ray traced shadows respect a surface's transparency value. Also notice the effect the transparent surface has in the Viper window. The 100% transparent cone object is represented by a hole in the image; it is not showing the objects that are placed behind it. This is one of the reasons the Viper surface preview is not always to be trusted.

STEP 2: COLORING THE TRANSPARENT SURFACE

Color has an effect on transparent surfaces. Select the Cone surface once again and change its surface color to be completely green (000,255,000). Render a frame and observe that nothing has appeared to change. This is because the object is still 100% transparent. To make the transparent polygon appear as a colored filter, you must turn on the Color Filter in the Advanced tab.

In the Surface Editor go to the Advanced tab and find the Color Filter setting near the bottom of the menu. Set the Color Filter to 100%. Nothing will

appear to change in the Viper window, but render a frame and notice the difference.

With the Color Filter at 100%, two things will happen with the transparent object. The objects that can be seen through the transparent cone will be tinted green, and the shadows that are being ray traced through the object will be cast as green shadows.

STEP 3: IMPROVING THE TRANSPARENT SURFACE

Many transparent surfaces are also shiny. The Specularity setting of a surface is not affected at all by the transparency level. If an object is 100% transparent and effectively invisible, as in the example above, it will still display the specular hot spot. The shininess of an object does not fade with transparency. The amount of specularity and its level of glossiness give strong visual cues as to what substance the object is apparently made out of. Low levels of glossiness generally imply a lighter plastic material, whereas very small high-gloss spots indicate a hard glassy material.

You may also want to activate the Smooth option for the Cone surface.

STEP 4: ADJUSTING THE INDEX OF REFRACTION

Refraction is the bending of light as it passes through a transparent medium. For the transparent surfaces in LightWave to refract the objects behind it, you need to activate the refraction in two places. In the Surface Editor, just under the Transparency setting, is the setting for Refraction Index. Set the Refraction Index for the Cone surface to 1.10. This will have no affect until Trace Refraction is activated.

In the Rendering Options panel, activate Trace Refractions and render a frame (see Figure 3.6).

Notice that the object behind the Cone is distorted due to the refraction of the transparent cone object. The objects are also still green because the Color Filter is still at 100%. Turn off the Color Filter by returning its level to 0 and render the frame again.

When the Cone object was rendered with 100% transparency, it became invisible. Now the Cone object has specular shiny spots that indicate its surface, and the background that appears distorted through refraction behind it. It is important to note that the ray traced shadow has disappeared due to the 100% transparency of the Cone object; it does not recognize the focusing effect that the refractive quality of glass would

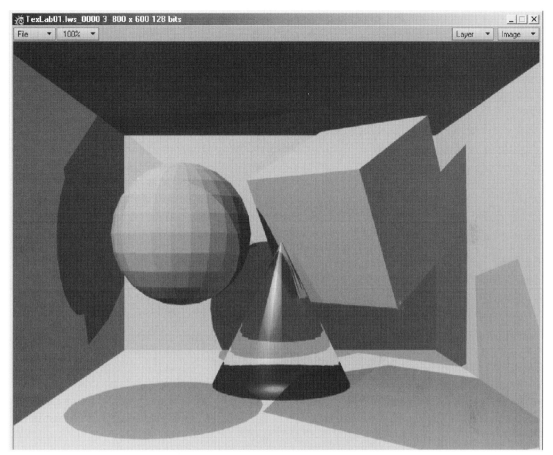

FIGURE 3.6 The Cone with refraction.

have. (Refractive qualities need to be addressed with Caustics, which is covered later in this book.)

Translucency

Translucency means lighting the surface from behind. This sophisticated attribute actually is pretty straightforward. You might assume that Light-Wave would light the surface from behind by default, but LightWave normally illuminates surfaces with the light that strikes the face of the polygon. Remember that most polygons are one-sided; they actually do not have a back. Even fully solid objects do not normally allow light to be transmitted through them.

For example, put your hand between a lampshade and the lamp's lit bulb. In real life you would expect to see the outline of your hand on the outside of the lampshade. Because LightWave usually only illuminates polygons from the front, you would not see your hand because the light from the bulb is coming from behind. Translucency allows light to pass through the polygons, illuminating them from behind.

Translucency is a subtle effect, and one of those delicate things that is noticed more when it is missing. It is useful for textures of substances that trap light and bounce it around inside it, like snow, milk, Styrofoam, and even skin.

The Bump Channel

The Bump channel surface attribute is a method for giving a surface the appearance of having very small details without using actual geometry. Using the Bump attribute, very simple objects can appear to have very fine details.

ON THE CD

The Bump channel requires the use of the T button and the Texture Editor. Both image maps and Procedural Textures can be applied as Bump maps. From the CD-ROM, load the sample scene TexBump.lws from the Surface directory of the Scenes folder (see Figure 3.7).

Procedural and image map techniques will be explored later; for now just examine the examples. These objects are the same as those used in the previous examples, except that Bump-mapped textures have been added. The Sphere object has an image of the earth wrapped around it; the image's lighter areas cause more intense Bump maps, but the ocean areas of the earth map are solid black and have no Bump effect. The box object has an arrow image mapped onto it. This arrow shape is simple enough to have been modeled into the geometry of the box, but would have had far less flexibility than is afforded when mapped on as a texture.

The Cone object and the walls are Bump mapped using procedural textures. The walls have a ripple Bump map that is creating ever-expanding rings, and the Cone object has an array of dots. Notice the drastic effect on the cone; the Bump map makes it appear there are actually circular dents modeled into the object.

Strengths and Weaknesses of Bump Mapping

Bump mapping gives an object a level of detail that would be virtually impossible through points and polygons alone. Bump mapping is perfect for adding low-level detail to give an object a physical sense of texture. Dust, rust, and grime are small visual cues to a surface's physical texture.

FIGURE 3.7 Bump maps have been applied to all the surfaces in this scene.

The sphere shows the Bump channel used for continents on a planetary scale. Bumps can be used for very small or very large objects.

Bump mapping is also useful for very subtle items. In the 3D world, all objects are created with planes that are perfectly flat. In the real world, virtually nothing is mathematically perfectly flat, a fact that is exemplified by surfaces that are shiny or reflective. In 3D, the perfect flatness is what causes a specular hot spot on a plane to appear as a solid uniform white spot. Reflections on a surface also appear to be perfect. Very small levels of Bump mapping, just a few percent spread over the flat planes, go far in adding a bit of naturalness to a rendered image. (Try adding some ray traced reflections to the walls of the above tutorial and see what happens with the Bump map ripples.)

Bump mapping does have its limitations. The displacement that appears with Bump mapping is an illusion; it does not actually move any points around. In the example scene, the Bump maps on the cone object

make it look as if there are holes dug out of it, but if you look closely you will see that the edge of the cone is a solid edge. Realistically, the side of that cone should look like a brick of Swiss cheese. Bump mapping only gives the illusion of bumps, like an optical illusion, and does not actually change the geometry.

Even when not viewed from the edge on, Bump mapping can only go so far. It is possible to set the Bump level to greater than 100%. There are times when Bump levels of 150% or 400% would be useful, but extreme values often come with their own set of dangers. Bump values of greater than 100% have the tendency to flip direction as the object moves past the camera. This particular rendering error is difficult to pin down, because it will show up only when the full animation has completed rendering.

Smoothing and the Smoothing Threshold

Smoothing is a handy tool used to make an object look as if it has more detail then it actually does. Remember that all 3D objects are created by points strung together by straight lines. To make an object appear to have a smooth curve, we need lots of points strung closely together in an arc. The Smoothing option in LightWave erases the crease where the edges of the polygons of an object come together, and render it as a smooth, continuous surface.

In the basic texture lab scene in the tutorial, the default surfaces of the Ball and the Cone objects do not have Smoothing turned on, which gives them a faceted appearance with all the individual polygons showing. Turning on Smoothing for those objects makes them appear as if they have continuous curves.

The most common mistake made with Smoothing is treating the Smoothing setting like an on/off button. The angle of the smoothing action is controlled with the Smoothing Threshold button (see Figure 3.8).

The default angle for Smoothing is 89.53 degrees, just a tiny bit less than a right angle. Any amount less than that and Smoothing will attempt to smooth over details. Many times you will want the Smoothing angle to be much smaller, for example, when you have beveled text. There are also times, particularly when you are deforming a character, when you want all the smoothing you can possibly get; in that case, you would increase the Smoothing angle.

As with Bump mapping, Smoothing can only go so far. The giveaway with smoothing is when the curved surface is seen edge on. Smoothing

FIGURE 3.8 Display of different smoothing thresholds on an identical nozzle-shaped object.

cannot add points to the outline of an object; the object still has its original string of points and straight lines (see Figure 3.9, page 138).

Smoothing and Viper

Viper has a problem with the Smoothing function. When Smoothing is adjusted in the Surface Editor, it does not show up in the Viper window. However, the smoothing effect does show up in the OpenGL display, so when you find it necessary to fine-tune the smoothing angle of the surface, you can observe the effect in real time in the OpenGL display.

FIGURE 3.9 A low polygon sphere without Smoothing and with Smoothing turned on.

THE SHADERS TAB

The last tab in the Surface Editor menu is the Shaders tab. Shaders fall half-way between standard attributes and full-surface textures. Shaders are plug-ins that assist in texturing a surface, and creating effects that may be difficult or impossible to do using only the native texture attributes. A shader plug-in may completely take over the surfacing of an object, or it may have no visible effect at all. The whole purpose of the plug-in architecture is about just that, doing things that do not fit in the general scheme of the interface.

TUTORIAL

APPLYING SHADERS TO SURFACES

The following steps will produce a few effects that can be applied through the use of surface shaders.

STEP 1: LOAD THE DEFAULT TEXTURE LAB

Once again, load the scene TexLab01.lws. This scene starts with all the default texture settings. Open Viper and render a single frame.

STEP 2: APPLYING THE HALFTONE SHADER

Open the Surface Editor, select the Ball surface, and go to the Shaders tab. Click on the Add Shaders button and select Halftone. Halftone shading is an old method of dithering black and white to give the appearance of shades of gray, a look often associated with old newspaper prints and encyclopedias.

Once the Halftone shader is selected, the effect should instantly appear in the Viper window, changing the surface of the Ball object to white with black dots.

STEP 3: MODIFYING THE HALFTONE SHADER

There are two ways this particular shader can be modified: by altering the shader settings or by altering the standard attributes.

Double-click the listing for Halftone to bring up the Halftone settings. This situation is exactly where the Viper window comes in handy, because any changes to the Halftone shader setting will quickly be reflected in the Viper window. Change the setting for Spot Type from Dot to Checks and observe the drastic change it makes to the surface. Play with the settings for Spacing, Variation, and Angle and watch the results in the Viper window.

Return to the Basic tab of the Surface editor. Go to the Diffuse channel and set the Diffuse level to 50%. Notice how the black dots, the shaded area, now creep up further around the edge of the Ball. Set the Diffuse level to 150%; now the dots that give shadowing to the Ball recede, making it look brighter.

Halftone and Other Attributes

The color of the Ball object can also be changed and rendered with the Halftone shading. This method can give the rendering a very pleasant Retro or children's book kind of look. For more bizarre combinations, Reflection and Specularity can be applied to create some unusual textures.

Step 4: Interference and Thin Film

The Interface and Thin Film shaders do pretty much the same thing; they duplicate the rainbow banding you often see on sheets of plastic and the grooves on a CD.

Select the surface for the Cone object, go to the Add Shader button, and select the Interference shader. Rainbow bands of color should appear on the Cone surface in the Viper window.

Once again, this shader allows you to alter the surface texture by modifying some of the surfaces attributes like Specularity and Color. Double-clicking on the listing for the shader brings up the Interference settings. Viper proves its worth once again by instantly reflecting changes made to the settings onto the surface of the cone object. Repeat the steps used with the Interference shader, but this time use the Thin Film shader. You will notice a slightly more subdued version of the Interference shader. Both work by creating bands of color based on the camera's angle to the surface of the object. Which shader you choose to use is your personal choice.

Conclusion

Learning how to create textures in LightWave is an important skill to learn. The basics of the texturing process can be learned very quickly, but it takes quite a bit of experience and experimentation to realize how the different tools can all work together. Once you start developing a sense of how the different attributes and layers interact, texturing starts to become second nature. Learning how to combine the functions of the separate attributes and use combinations of procedurals, image maps, and gradients, helps you to recreate real world textures or invent a look that has never before existed.

DETAILING OBJECTS

In This Chapter

- Object Creation
- Modifying Object Geometry
- Adding Points and Polygons to an Existing Object
- Construction Tools

his chapter will cover important concepts in creating objects. There are basic objects, like boxes and spheres, that can be created with the click of a button. More complicated or unusual objects are created by modifying similar objects, or building them from scratch one point at a time.

OBJECT CREATION

It all starts with the objects. Building an object is much like playing a piano. Anyone can play a piano; you just reach out a finger and push down a key. The hard part is playing it well, getting all the notes to line up the right way at the right time. But even then, it is still just the action of pushing down a key that makes the music. Sometimes it is Chopin and sometimes it is chopsticks.

With objects you are working with points instead of notes, and sometimes you'll be creating brontosaurs and sometimes it will be a simple box. Just as with the piano, however, you start with the basics and improve your skills through practice, practice, practice, practice.

Basic Object Creation

All objects are created in Modeler. The most straightforward way of creating an object is to use the dedicated Objects buttons. The Create tab in Modeler contains a list of buttons under the Objects heading (see Figure 4.1).

FIGURE 4.1 The Object buttons.

There are two ways to generate objects using these buttons. Most objects can be "drawn" in the Modeler viewport interactively with the mouse, certainly the most intuitive way to create an object. The other way is to enter the values numerically in the Numeric Input panel. Many modelers use a combination of both, starting the object by dragging it roughly into position with the mouse. The values created with the mouse movements are constantly updated in the Numeric Input panel. Modelers use the mouse to determine the basic size and scale of the object, then round the numbers to exact values.

When an object creation tool is activated, the object is in its pre-formed state, which means it can be resized and manipulated. Once the object is in its desired form, the *Make* action is pre-formed. The Make action freezes the object when the Make Object button that was in use is turned off, or when the Enter key is pressed on the keyboard (only if the cursor is not currently active in a box), or when the modeler uses a RMB click. Once the object is formed, any rescaling or modification of the object must be done with other tools.

T U T O R I A L

CREATING A PLATONIC SOLID

Not all objects are boxes and balls.

STEP 1: OPEN MODELER

Start up the LightWave Modeler. Click the Create tab. On the left side of the Modeler screen is a column of buttons with the heading Objects. Locate the button for Platonic Solid.

STEP 2: ACTIVATING THE PLATONIC SOLID FUNCTION

Click the Platonic Solid button to select the Platonic Solid function. Click inside one of the Modeler viewports to activate the Platonic Solid tool. The horizontal and vertical views will show what appears to be a box, but the perspective view reveals that the object is actually a triangularly shaped tetrahedron (see Figure 4.2).

Clicking the LMB and dragging in the viewport allows you to interactively affect the size of the pre-formed object. Clicking and dragging on the center of the object allows you to reposition it.

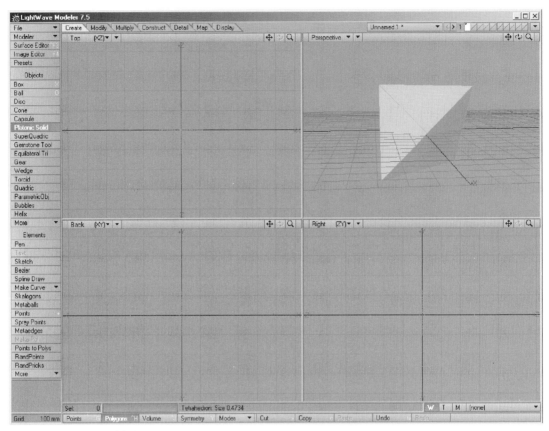

FIGURE 4.2 A Platonic Solid object.

STEP 3: USING THE NUMERIC PANEL

To access more of the options for the Platonic Solid tool, open the Numeric panel. To do this, either use the shortcut key (press the *n* on the keyboard) or pull down the Modeler>Window>Numeric Options menu.

The Numeric panel will automatically display the numeric options available for the currently selected tool, in this case the Platonic Solid tool.

The Shape section of the Numeric panel contains a number of options. The default shape is the Tetrahedron, but you can also choose from Octahedron, Icosahedron, and Dodecahedron. Notice that when the other shapes are chosen, the pre-formed object instantly assumes the new shape.

STEP 4: FREEZING THE PLATONIC SOLID

Currently your object is in its pre-formed shape. To freeze it into a real object, simply click again on the Platonic Solid button. The bounding box around the object should disappear, leaving you with a solid object.

 A few Make Object tools do not access the Numeric panel; these objects are not manipulated interactively by the mouse, but must have the values manually entered into their custom Numeric panel requesters.

Start up the LightWave Modeler. Under the Objects section of the Create panel, click on the Gear button. This will activate the Make Gear function. Notice that no pre-formed object appears in the viewports, but a Make Gear requester pops up (see Figure 4.3).

Here the characteristics of the Gear object are entered. Once all the data is entered, click the OK button to make the object.

FIGURE 4.3 The Make Gear requester.

The Pen and Sketch Tools

Many modelers starting out in LightWave, particularly those from an illustration background, are often drawn to Modeler's Pen and Sketch tools. The freehand nature of these tools is handy for creating flat objects of irregular shapes. These tools can create non-flat shapes, although they can often result in the problematic non-planar polygons, which are discussed later in this section.

The Pen tool is a simple tool that takes a little practice to master. Under the Create tab in the Elements section of the toolbar click the Pen button. The Pen tool is now active, as you can see by the change of mouse pointer. Inside one of the Modeler viewports, click where you want your first point. This point will be the starting point of the object. Release the mouse button and click in the viewport a second time. A line will appear; this point can be moved around until the mouse button is released. Release the mouse button and click on the viewport a third time. You will see that the three points now make up a triangle. You can continue to add points by clicking and releasing. The new point is always entered after the last point created, kind of like stringing beads. A new point will not be created if the mouse is clicked too closely to the last point;

therefore, it is sometimes necessary to click the mouse a distance away, keeping the mouse button depressed, then sliding it closer before letting go (see Figure 4.4).

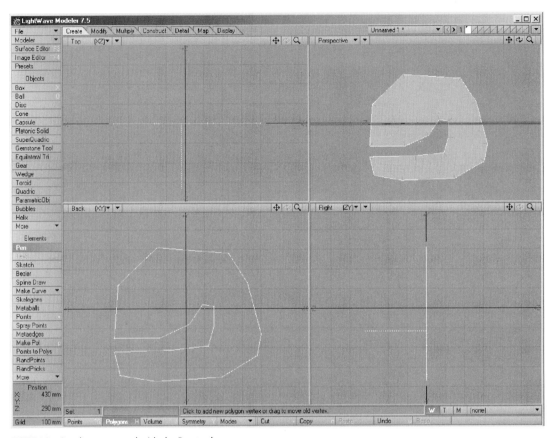

FIGURE 4.4 A polygon created with the Pen tool.

A bit more sophisticated than the Pen tool is the Sketch tool. The Sketch tool allows you to draw with the mouse much like you would with a pencil. The Sketch tool defaults to creating a special purpose polygon called Curve, or it can be instructed to create polygons.

Click on the Sketch button to activate the Sketch tool, then open the Numeric panel. The Numeric panel only shows two options for the Sketch tool, Curve or Face (see Figure 4.5).

Select the Face option and start drawing in one of the Modeler viewports. Click inside a viewport and move the mouse around while holding down the mouse button. As soon as you release the mouse button, a

FIGURE 4.5 The Numeric panel for the Sketch tool.

polygon will be created from the outline you have drawn. Your first attempts will be pretty ugly, but that is normal.

Non-Planar Polygons

This is a good place to bring up the issue of non-planar polygons. *Planar* means flat. All individual polygons need to be flat. If a polygon has only three points, it will be flat. If a polygon has more than three points, one of those points can be moved off the plane of the rest of the points and make the polygon non-planar. When you have a polygon with many points, like the ones created above with the Pen and Sketch tools, it is easy to accidentally pull some of the points out of alignment when using the modify tools. If a single polygon is bent, it will lead to rendering errors, because the computer does not know which direction the face of the polygon should be facing.

Single- and Double-Sided Polygons

Most objects are made up of *single-sided polygons*. They literally can be seen only on one side—after all, you usually only see one side of a polygon in an object. LightWave has the option to create two-sided polygons, but this is generally not recommended for several reasons, primarily because double-sided polygons take twice as long to render and can sometimes produce rendering errors.

Another reason not to use two-sided polygons is that a single polygon has no thickness. A polygon has nothing but face. Making a polygon double-faced in an animation will make the object appear unnaturally thin. If an object is to have a front and a back face, it should have some thickness modeled into it.

Rather than creating double-sided polygons in Modeler, you can tell a polygon to behave as if it is double-sided using the Surface Editor. The polygon will still have the drawbacks of a double-sided polygon created in Modeler, but you can turn the two-sidedness on and off.

At times you may need to use a double-sided polygon, such as when you have transparent surfaces. A transparent object made of single-sided polygons looks odd because you expect to see its back through it. A glass ball will have some reflection inside it; if it is a single-sided polygon, you will see only the polygons facing the camera.

A bad reason to use double-sided polygons is sloppy modeling. At times in the course of modeling an object, the polygons can end up facing the wrong direction, which will appear as holes in the object. This situation can be very confusing because the points show up in Wire Frame mode, where you can select the polygons that you cannot see (see Figure 4.6).

The quick fix for the situation in Figure 4.6 is to turn on the double-sided function in the polygon's surface attributes. Still better, make certain your polygons are properly aligned.

Flipping Polygons

The safest, though most tedious, way of getting all the polygons to face the proper direction is to manually select the offensive polygons and flip them one at a time. The Flip command is found in the Details tab, but expect to become very familiar with the short cut (*f*). The Flip command simply tells the polygon to face the other way.

LightWave provides an automated way to fix wayward-facing polygons that works in some cases. In the Details tab is the Align command. The Align command will examine the object and do its best to align the polygons so that they are all facing the proper direction. The Align command works best with enclosed solid objects, objects that have an easily discernible inside and outside. Align, unfortunately, has a nasty habit of flipping polygons that were right to begin with.

Getting Information

Whether you are working in Point mode or Polygon mode, frequently you need information on what you are working on. The Display tab con-

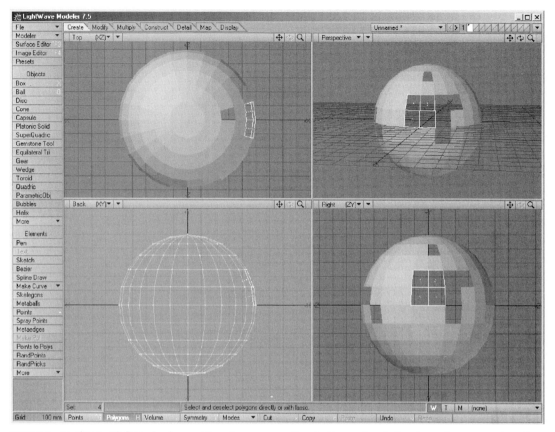

FIGURE 4.6 An object with flipped polygons. Though you can see the wire frame edges in the viewports, you cannot see the back of the polygon faces.

tains a button labeled Info (the shortcut key is *i*). When a point is selected and the Info button clicked, information appears about the selected point (see Figure 4.7).

The Info panel gives the exact numeric location of any points selected, the number of polygons the point is a part of, and the actual point number. In Polygon mode, the Info panel will show, among other things, the surface names of the selected polygons. (You will find it very helpful to identify the current surface name of a polygon in Modeler.)

The Info panel allows you to do some direct editing to the information of the selected points and polygons. Note that while the Info panel is open, all of the other Modeler functions are locked out.

To get information about the whole object in the active Modeler layer, the best thing to use is the Statistics panel. The Statistics panel can be opened from the pull-down menu Modeler>Windows>Statistics, or by pressing the *w* shortcut key (see Figure 4.8).

FIGURE 4.7 The Point Info panel.

FIGURE 4.8 The Statistics panel. Clicking on the Surfaces section brings up a submenu of available surfaces.

The Statistics panel will tell you what your object is made of, how many of which type of polygons are in the current object layer, and the number of surfaces you have and how many polygons each one has. The most useful thing about the Statistics panel is that you can use it to select and deselect. The Plus and Minus signs next to the information listed will select and deselect that particular listing. This function is very useful if, for example, you wanted to select all four-point polygons in the object, but deselect all with the surface name *wood*.

MODIFYING OBJECT GEOMETRY

Unless you only need objects that can be created with the default object buttons, you will need to modify the objects you create. Modifying may involve moving points and polygons around, or it may involve adding new points and polygons to existing objects.

Selecting Points and Polygons for Manipulations

There is an art to selecting the portions of an object that you want to modify. When nothing is selected, everything in the object layer is effectively selected and any modify tool will affect the entire layer. If any part of the object is currently selected, only those selected parts will then be affected.

LightWave provides several tools for strategically selecting desired parts of your object. The primary way is with the mouse. Clicking and holding the LMB while dragging the mouse over the polygons in the view window will select points or polygons. Holding down the RMB will allow you to lasso points and polygons. Releasing the mouse and repeating the motions after selecting will then deselect what you previously selected. To deselect everything in the object layer, click in an empty space inside the toolbar menu.

As previously mentioned, the Statistics panel can be used to select polygons based on point count and surface name. This method is very useful because surface names often follow object details. The selection manipulation tools can be found in the Selection portion of the Display tab.

Moving Parts and Wholes

The Move function is the most basic Modify function in Modeler. With the Move function, you can move the entire object layer, or just the selected portions. Keep in mind that when you use the Move command you are not really moving the object, you are moving the points and the polygons that make up that object. If you make a ball object that is centered in Modeler, then move it to the side, the pivot point for the ball remains where it is but its polygons will be off to the side like an apple on a string.

If an object, in part or in whole, is moved in Modeler, the amount of the last Move action will appear in the Numeric panel, even if the Numeric panel was not currently active when the move took place. The Numeric panel remembers the values of the last move action, even if the Undo button is clicked. This feature comes in handy when you want to keep the move values to nice round numbers (see Figure 4.9).

FIGURE 4.9 The Numeric panel for the Move tool.

Applying Numeric values

This tutorial will walk you through the process of making precise moves.

TUTORIAL

Load any object and open the Numeric panel. Go to the Modify tab and click Move to activate the Move tool. Click and drag the mouse inside one of the viewports to move the object. Notice that when you move the object, the amount of each move shows up in the Numeric panel.

When you move an object in the Modeler viewports without using any constraints, you will have difficulty moving the object an exact amount. Suppose you want to move the current item in Modeler 500mm. You might end up with numbers like 498.23mm or 501.568mm. Not only is this sloppy modeling, it can cause problems down the road when edges do not line up or polygons become non-planar.

A better process is to move the object or selected section to approximately where you want it to be, then click the Undo button. (If you know exactly what the value of the function should be, you can skip that

part.) Even after Undo has been clicked, the value of the last move still remains in the Numeric panel. The values in the Numeric panel can be adjusted to cleaner values (498.32mm can be changed to an even 500mm for example). Once the new values are entered in the Numeric panel, you must click the Apply button to apply those values to the object layer or to whatever is currently selected. Every time the Apply button is clicked, the values are applied again.

Rotate Command and Control

After the Move function, Rotate is probably the most-used modify tool. Rotate operates very much like the Move tool. Dragging the mouse in the viewport will cause the active object layers to rotate. If the mouse is clicked inside the object, the object will spin around itself. If the mouse is clicked outside the object, the object will circle the mouse cursor.

The Numeric panel can be used with Rotate just as with the Move command. Exact values for rotation are often the most critical values.

A couple of helpful shortcuts: the r key will rotate the object 90 degrees clockwise around the mouse pointer. The e key will rotate the objects counter-clockwise around the mouse. These shortcuts will work at any time, even if Rotate is not the currently selected tool.

Size and Stretch

Size and Stretch in Modeler behave in much the same way as their counterparts in Layout. The Size command affects the size proportionally over the entire selected area. The Stretch command affects the size on each axis separately.

The effects of Size and Stretch radiate from the mouse pointer. The location of the mouse pointer to the geometry affects how the object changes size, much the same way as the Rotate command works.

Bend and Twist

Bend and Twist are two similar tools that rely heavily on the Numeric panel. Both tools modify objects in manners that their names imply, although the change often seems to be moving in the wrong direction.

The Bend tool is used to bend an object in an arc-like direction. The default setting puts the bending arc at the top of the object; the base of the object stays rooted. This is fine for making a candy cane, but not if you want to bend a fish hook. The Shape option in the Numeric panel for the Bend tool provides a way to change which end of the object gets bent.

When the upward-sloping wedge is active, the head of the object gets bent. When the downward-sloping wedge is active, the bottom is bent (see Figure 4.10).

FIGURE 4.10 The Numeric panel for the Bend tool.

The Twist tool is similar to the Bend tool. The Numeric panel for the Twist tool also uses upward- and downward-sloping wedges to specify the orientation of the twisting action. In addition, it also has a pyramid and a valley shape. These options allow you to twist objects from the top, bottom, middle, or both ends.

The user's natural tendency is to place the mouse cursor in the center of the objects for twisting and bending. However, applying the effects while off of center can also have useful results (see Figure 4.11).

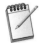

About Bend and Twist

When using Bend and Twist on objects that contain polygons of four or more points, you are almost certain to generate non-planar polygons. You can use the Polygons Statistics panel to see how many polygons are non-planar. Clicking the plus sign next to Non-planar in the Polygon Statistics panel will select those polygons. Once they are selected, you can use the Triple command to quickly force the polygons to become planar again.

FIGURE 4.11 A tube with many segments being bent into a ram's horn shape using the Twist tool off-axis.

ADDING POINTS AND POLYGONS TO AN EXISTING OBJECT

Modifying existing geometry is only part of object creation. Points and polygons also must be added and joined to existing geometry.

Object Parts and Layers

The single most confusing concept in LightWave modeling is the distinction between *objects* and *object layers*. An individual object can have several layers, and each of those layers can behave like separate objects, basically subobjects. When an object file is saved or loaded, all those layers go with it. Saving the object with its layers is a convenient way of grouping together what may be many parts of a single object. A good example to illustrate this concept is an animation of an airplane. An airplane has its main body, the wheels, the propeller, and the door. These

parts all must be animated separately in Layout. Rather than loading each of the airplane parts individually, they can all exist in separate layers in the same object file.

TUTORIAL CREATING A MULTI-LAYERED OBJECT

A text object is a good candidate for multiple layers. Separate letters can be animated individually, but you want all the letters of the word object grouped together.

STEP 1: CREATING THE BASIC WORD OBJECT

Under the Create tab, click the Text button to activate the Make Text tool. Type in a three-letter word. (The word *CAT* is used in this example.) Click the Text button again to freeze the object.

STEP 2: SEPARATING THE LETTERS INTO THEIR OWN LAYERS

Currently all the letters are in the first layer, and we want each letter to be in its own layer. Make sure that you are in Polygon mode by clicking the Polygon button at the bottom of the Modeler screen. Make sure that no Modeler tool is active. Then click on the second letter of the word to select it.

With the second letter, in this case *A*, selected, click the Cut command at the bottom center of the screen. This will delete the currently selected polygon from the viewport and copy it into the Paste buffer.

Go to the second object layer by clicking on the second box in the group of ten at the top right of the Modeler screen. This should be an empty layer. Click on Paste command at the bottom of the screen. The second letter should now appear in the layer.

Return to the first layer and repeat the process by selecting the third letter, using the Cut command, then pasting it into the third layer.

The first, second, and third object layers should contain the first, second, and third letters of the word object (see Figure 4.12).

STEP 3: NAMING THE LAYERS

Now that each letter is in its own layer, each layer can be given its own name. (Note: This is not a necessary step, but it helps reduce confusion when the object is loaded into Layout.) Go to the Detail tab and locate the Layer Set-

FIGURE 4.12 The *CAT* word object divided into layers.

tings button. Click the Layer Settings button to bring up requester shown in Figure 4.13.

FIGURE 4.13 The Layer Settings requester.

This requester allows you to name the currently active layer. This name will appear in the object layer list when the object is loaded into Layout. Name each of the three layers the letter it contains. The layer that is currently active gets the name. Once all the layers have been named, save the object.

Notice that you also have the option to set up *parenting* for the layers. Parenting is merely a step-saving option that is useful in cases such as the airplane example, where you know that certain parts of the object will always be parented in a certain way.

STEP 4: LOADING THE OBJECT INTO LAYOUT

Once you load the object into Layout, it can be animated. Load the object and notice that although only one object file is loaded, three items are listed as objects (see Figure 4.14).

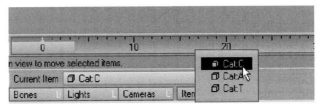

FIGURE 4.14 The layer breakdown in the current item list.

The letters can be selected, moved, and keyframed one at a time, and each of the letter layers can have separate object properties.

Stitching Polygons Together

It is sometimes necessary to build polygons one point at a time, and sometimes you need to add polygons to existing points to join parts together. These functions must be performed in Point mode.

To make a polygon out of nothing, you first need points. Click the Point button in the Create tab to activate the Make Point tool. Move the mouse pointer to a viewport and create three new points by clicking the RMB or pressing the Enter key.

Once you have made three points, click the Make Pol (polygon) button or press the *p* shortcut key. The Make Polygon command will string a polygon across the points in the order they were created. If you happen to make a lot of points in a zigzag fashion, you can select the points in the order that you want the path of the polygon to take.

The Make Polygon command can be used on a point of existing geometry as well. Sometimes you need to add polygons to connect existing parts. Select the points in the order of the path you want the polygon to follow. Select points in Point mode by drawing the mouse pointer over

them. If you need to release the mouse button before you have all the points selected, you can hold down the Shift key to continue selecting the points.

Beveling and Smooth Shift

Beveling and Smooth Shift are both ways of extending the planes of existing geometry. Although Bevel is usually associated with the beveled edges of text, it is actually a very powerful modeling tool. This tool is another way that using the Numeric panel benefits.

The Bevel function extrudes the existing polygons of an object. As the polygons move away from their original position, they can expand or contract, or bevel outward or inward. With Bevel, the extrusion happens along every polygon edge. Typically, only selected polygons on an object will be beveled.

A bevel can be done interactively. Create a Box object and select one of the polygons of the box. Go to the Extend section of the Multiply tab and click the Bevel button to activate the Bevel tool. Click the mouse button inside one of the viewports and drag to see the bevel effect in real time. The Bevel does not become permanent until you perform a Make action. When the Numeric panel is open, you will see the numeric value of the bevels.

Smooth Shift is similar to Bevel, except that it can extend past polygon edges. (The group of connected polygons are selected, then Smooth Shift is activated.) To use Smooth Shift, select a group of connected polygons and then click the Smooth Shift button to activate the tool. Drag the mouse in the viewport to move the polygons straight out from their starting place. Smooth Shift likes to have a level plane of polygons when shifting, but it can also work on curving surfaces. In the Numeric panel for the Smooth Shift command, locate the Maximum Smoothing Angle setting. If you are working with a non-flat surface, it is sometimes necessary to adjust the Maximum Smoothing Angle for the best results. The Smoothing Angle can be adjusted while the Smooth Shift is affecting the geometry, allowing you to see when you obtain the correct smoothing value (see Figures 4.15 and 4.16).

The Numeric panel for Smooth Shift also contains a Scale function. When the Smooth Shifted polygons move out, they flare forward, expanding as they move away. Reducing the scaling level counteracts the expansion of the polygons as they move out. The Scale can also be set to greater than 100% to magnify the polygons' sizes as they are Smooth Shifted.

FIGURE 4.15 Correct Smooth Shift values.

Mirror and Clone

The Mirror tool is pretty straightforward, but it is important to know how to use it properly, because you will use it often. Clicking the Mirror button under the Multiply tab activates the Mirror tool. You will use the Mirror tool most often when modeling *laterally symmetrical objects*, a fancy way of saying the objects are the same on both sides. You can model one side of faces, bodies, clothing, or shoes, then generate a mirrored duplicate to create the other side.

Once the Mirror tool is activated, the line you draw in a viewport with the mouse becomes the mirror. Most of the time you want the mirrors to be right angles to the axis, but the Numeric panel for the Mirror tool gives you a Free Rotation option, which allows you to mirror geometry on any angle you wish.

FIGURE 4.16 Incorrect Smooth Shift values.

Beginning modelers make a common mistake when they first use Mirror. When you mirror a model that is to appear continuous and smooth, you must make sure that the mirror lines up with points that define the sliced edge of the model. If the head is centered exactly on the X axis, the mirror also needs to be centered on the X axis. If the mirror line does not rest exactly on top of the points of the lip of the model, the points of the mirrored half will not fall exactly on top of the original points. This error will cause a gap between two points that should have been merged into single points and will appear as tears along the model's surface. You can use the Info function to find the exact coordinates for the points and the Numeric panel to enter those coordinates for the Mirror tool.

Sometimes you need to mirror things several times, such as when making railroad tracks or fence posts. Rather than repeatedly using the Mirror, you can use the Clone tool. The Clone tool takes whatever

geometry is selected in the active layer and makes duplicates of it. The real power of the Clone tool is that the duplicate objects can be offset in scale, rotation, and position. The following is a sample setting for a simple 1m box. Click the Clone button in the Multiply tab and enter these values into the requester box (see Figure 4.17).

Sample Clone Button Settings

NUMBER OF CLONES	10	
Offset	X	0m
	Y	2m
	Z	0m
Scale	X	110%
	Y	110%
	Z	110%
Rotation	H	15 degrees
	P	0
	B	15 degrees
Center	X	0m
	Y	0m
	Z	0m

These settings will create a column of boxes that increase in size and rotate, just one example of what can be done with the Clone command.

Array and Lathe

The Array tool is much like the Clone command except that Array can create duplicates of the original objects on all three axes simultaneously. It also has a Jitter function, which ensures that the duplicates are not perfectly aligned. Classic computer animation often featured huge arrays of primitive objects flying through space, and with the Array tool it's easy to recreate this look.

The Lathe function is much like Mirror, except that Lathe creates a ring of duplicates instead of a single reflection. Lathe can work on full objects—for example, a pearl necklace—or it can take a flat object and extrude in a circle.

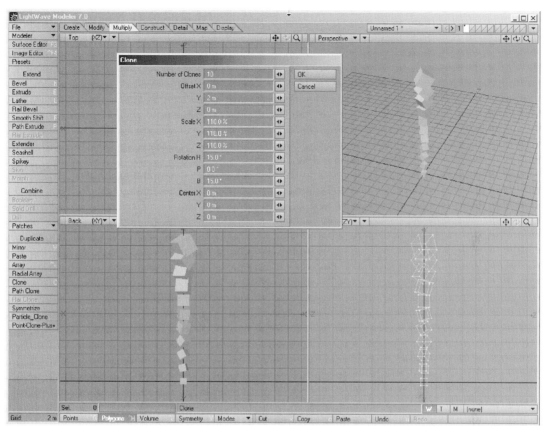

FIGURE 4.17 Clone panel with values.

TUTORIAL ## USING LATHE WITH SKETCH OBJECTS

STEP 1: CREATING THE STENCIL OBJECT

Under the Create tab, click the Sketch button. We will use the Sketch tool in the Curve mode to draw a cross-section outline of an item we will Lathe. Birdbaths and wine glasses are very popular lathe subjects, so we'll start with an outline that resembles one of them.

Starting exactly on the Y axis, so that the X value is 0, use the Sketch tool to draw an outline of a wine glass shape. This type of thing takes a little practice, so do not worry if your first few attempts appear a little crude (see Figure 4.18).

When you release the mouse, the sketch will appear as a Curve object; a Curve is like a spline. After the Curve has been created you can use the Drag tool to move its points around.

FIGURE 4.18 The wine glass curve stencil.

The beginning and ending points must have an X value of exactly 0, or there will be a gap or crossover in the center of the object after the Lathe process. Select the first and last points, and under the Detail tab click the Set Value button. The Set Value button allows you to specify the position of the selected item. In this case, we want the points on the X axis with a value of 0.

STEP 2: LATHING

Once the Curve has been created and the end points set to 0, it is time to Lathe. Under the Multiply tab, click the Lathe button to activate the Lathe tool. You will also want to have the Numeric panel open (see Figure 4.19).

In the Numeric panel, select Activate, then select Reset. This gives you the default values for the Lathe tools. You should see the Curve object being rotationally extruded.

FIGURE 4.19 The Numeric panel for the Lathe tool.

STEP 3: ADJUSTING THE LATHE SETTINGS

When a Lathe is performed on a Curve object, the polygons generated sometimes face the wrong direction. To fix this, you can use the Flip command on all the polygons after the Lathe has been completed, or you can change the rotation direction of the Lathe tool by switching the Start and End Angle values or by setting the End Angle to its negative value (see Figures 4.20 and 4.21).

Another setting that typically needs adjustment is the Sides setting. The Sides setting tells you how many steps the Lathe will take during the rotation. The more Sides the Lathe has, the smoother the geometry will be on the final object.

CONSTRUCTION TOOLS

The next level of object creation is down-and-dirty construction. Until now we have been adding and manipulating geometry, but sometimes objects require a little more finesse.

Subdivide

The Construct tab contains the Subdivide button. The Subdivide command simply takes a polygon and divides it in half. You use Subdivide

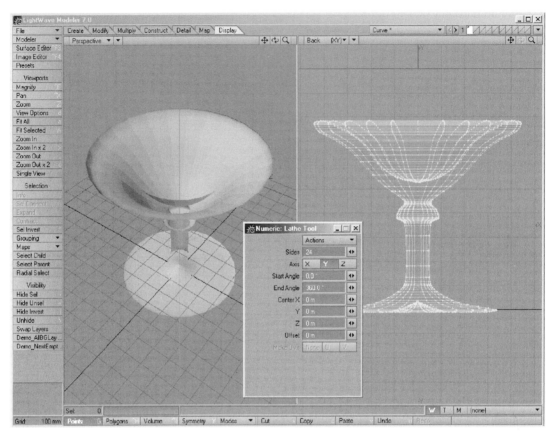

FIGURE 4.20 Lathed object with flipped polygons.

when you need more points or polygons in an object to add detail. When a polygon is divided, it is sectioned into quarters by being split side to side and top to bottom. This means you end up with twice as many points but four times as many polygons. Note that Subdivide only works on three- or four-point polygons.

Subdivide has three different options: Faceted, Smooth Subdivide, and Metaform. When a polygon is Subdivided using the Faceted option, there is no change in the shape of the object, but it has twice as many points. Frequently you will want the Subdividing action to respect the curved surfaces of an object, in which case you should use the Smooth Subdivide option. Smooth Subdivide will add points to help smooth an existing curve, rather than just placing a point on the straight line between two existing points. Using a Smooth Subdivide is useful for increasing the resolution of an existing object. A common use for Smooth

FIGURE 4.21 Lathed object.

Subdivide is to increase the resolution of a spherical object. If the sphere gets too close to the camera and you can see the flat edges of the polygons, use the Smooth Subdivide to make the low resolution sphere object appear to be more round.

Metaform is the most powerful of the Subdivide functions. It works like Smooth Subdivide, but does so more intelligently. Like the Smooth Subdivide, you can specify the maximum angle the smoothing should use. Metaform has largely been replaced with the new Subdivision surfaces, which we will explore later.

The Knife Tool

The Knife tool is like an interactive Subdivide function. The Knife tool does not separate the polygons, but splits polygons in half. This tool is used extensively to add detail to objects. To use the Knife tool, click the

Knife button under the Construct tab. Click the mouse in a viewport and draw the Knife line. You can move the Knife line around by dragging it from the end points of the middle. The Knife function is interactive and you can see where your new points will go (Figure 4.22).

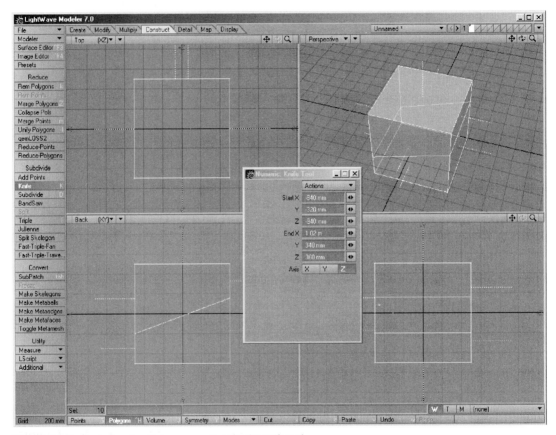

FIGURE 4.22 A cube being sliced into more sections by the Knife tool.

Merging Points and Polygons

Merging points is necessary when you want to join polygons. Two polygons may have their edges and corners perfectly aligned, but they are not necessarily "glued" together. You may have noticed that the Mirror tool Numeric panel has an option to automatically merge points if they share the same location.

For points to merge automatically, they must have the same X-Y-Z coordinates. Locate the Merge Points button under the Construct tab. (You must be in Points mode for the Merge button to be accessible.) Clicking the Merge Points button brings up the Merge Points requester.

When the default Automatic option is used, any points with the same position will be joined into a single point. This function is handy for eliminating duplicate points; frequently, surfaces will not smooth correctly if the polygons are not joined.

The other option you have is the Fixed setting. The Fixed setting will join any points that are close to each other, within the range that is specified by the Distance setting. Sometimes if you get sloppy with the Mirror or Copy and Paste functions, you end up with points being a tiny bit off the mark. Even an error of 0.001 will prevent the points from merging automatically. Using a Fixed merge of a very small amount can fix the problem quickly.

Merging polygons is a slightly different process. You may want to join several polygons to create a single polygon, for example, if you are creating an illustration that you want to bevel. To merge polygons, they must already share points and edges. In Polygon mode, select two adjoining polygons that are to be merged. Under the Construct tab, click the Merge Polygon button. The selected polygons will be merged. This function has no options.

Weld and Weld Average

The Weld function is a more persuasive form of the Merge function. When a series of points are selected and the Weld button is clicked, all the points are joined to the first point selected. Weld Average works similarly except that it averages the location of all the selected points and places the single joined point in the middle of the selection area.

Split and Un-weld

The Split function is used to divide a polygon using pre-existing points. The Split command is a little confusing because it requires both Point mode and Polygon mode to work. The button is also hard to locate because the Split button in the Construct tab remains ghosted unless appropriate points are selected.

To Split a polygon, follow these steps. In Point mode, select the two points of the polygon that will draw the line where you want the polygon to be split. Switch from Point mode to Polygon mode—the points will stay selected even though you will not see the point selection while in Polygon mode. Once in Polygon mode, select the Polygon that is to be Split, the one that has the non-visible selected points. Now click the Split button. The single polygon should now consist of two polygons that are separated along the line defined by the two selected points.

The Un-weld function is the exact opposite of the Merge command. Un-weld takes a single point shared by multiple polygons and splits it up. The Un-weld function is a convenient way of taking apart an object.

Taking an Object Apart

We will make half-spheres using several construction tools.

Step 1: Making a Ball Object

Under the Create tab, select the Ball tool and create a Ball object. Use the default settings for a 1m globe-type ball.

Step 2: Un-welding the Center Points

In Point mode, select all the points that circle the equator of the Ball object. This is where we want the ball to split. Once all points in circling the center of the ball are selected, go to the Detail tab and click Un-weld.

Step 3: Moving the Two Halves Apart

The ball is now split in two, but we cannot see it. Select the top half of the ball and move it up. (The easiest way to select only the top half is to select just one of the polygons on the top, and click the Select Connected button in the Display tab.)

Step 4: Merging Remaining Duplicate Points

The Un-weld command splits all the polygons connected to the selected points, not just the points on the rim of the equator. To reconnect the points of the polygons around the side, go into Point mode and use the Merge command to automatically join the polygon points that are still together. Because the top half of the ball has been moved apart, the points of the edge of the ball object will not be merged.

Triple

The Triple command can open a can of worms. If you always render with three-point polygons, you will never need to worry about non-planar

polygons. On the other hand, LightWave operates more efficiently with four-point polygons. The Triple command will take any polygon with greater than four points and Subdivide so it consists of only three-point polygons. If the Statistics panel shows that there are non-planar polygons in the object, click the + button in the Statistics panel to select the non-planar polygons and click the Triple button to fix the problem.

The Triple command works best on polygons with smaller numbers of points. Sometimes, such as when you import a logo, you wind up with a single polygon with hundreds of points. The problem is that Triple function does not always make triangles in ways that are beneficial to modeling; it simply hacks away until all polygons are three-point polygons (see Figure 4.23).

FIGURE 4.23 The letter L is being tripled in an ugly way.

To get more reasonable results when tripling large polygons, pre-cut the polygon. You can use the Split command to divide the large polygon

into logical divisions, then use the Triple command to break down the smaller chunks.

Degenerate Geometry

If you stayed awake in math class, you may have learned that a polygon is a shape that has three or more points. In LightWave, we have one- and two-point polygons. These are what are known as *degenerate geometry*. There is a difference between a single point and a single-point polygon. A single point has no surface. If a single unattached point is included in an object, it will not show up in any render when brought into layout. A single point can be turned into a single-point polygon by selecting the single point and clicking the Make Polygon button. Single-point polygons are useful little critters that are often used to make stars and dust, and used in particle animation.

Two-point polygons also have their uses. Selecting two points and clicking the Make Polygon button makes a two-point polygon. A line will appear between the two points. This line only has one dimension, its length. The thickness of the line is completely arbitrary and can be specified in the Object Properties panel in Layout. A number of two-point polygons can be linked to create a chain. These chains of two-point polygons have several uses, for example, to create long strands of hair with the Sasquatch plug in. They can also be used to create animated lines and even lightning bolts.

Not all degenerate geometry is created on purpose. Sometimes during joining and merging one- and two-point polygons are inadvertently created, which can cause weird lines when the objects are rendered. The Statistics panel will indicate whether you have any one- or two-point polygons in your current model. In most cases, you will want to select the one- and two-point polygons and then delete them.

CONCLUSION

The wrangling of points and polygons are important skills to master when creating objects. The difference between simple objects and complex ones are mostly just a matter of scale. Getting all the points in the proper position is as important as getting all the notes right in a piano solo. Sometimes you can get away with being a little sloppy, but you really want to spend the time to learn how to do it right.

CHAPTER

5

LIGHTS AND LIGHTING

In This Chapter

L ights in LightWave are interesting creatures. In some respects, they behave in manners similar to their real-world counterparts. In other ways, they can do things that would be impossible for a physical light source. LightWave offers five types of lights, each with its own set of characteristics. The names of the lights reflect the type of conventional light they most resemble, even though the resemblance might be slight.

Lighting is probably the most intricate process involved in rendering an image. It is also the most basic. A thorough understanding of the way lights work in LightWave is necessary for even the most rudimentary of animations.

WHAT LIGHTS DO

In its most basic sense, a light produces illumination. Rays shoot from the light source, bounce off surfaces, and are registered by the eye. In the real world you have comparatively little control over your light source other than intensity, position, and color. Controlling and mixing these three attributes is such an involved process that mastering the art of lighting can be a life-long task.

Virtual lights in 3D animation have a bit more flexibility. This flexibility is important because virtual lights are very literal and do not do anything except what they are specifically instructed to do.

The Light controls can be found in the Light Properties panel (see Figure 5.1).

Lights react directly with a surface according to two attributes, *Specularity* and *Diffusion*. The Specularity, Glossiness, and Color Highlights settings determine the shininess of the surface, but the light shining on the surface makes these settings usable. The Diffuse attribute determines how much the light will illuminate the surface; the higher the Diffuse setting the more light it will bounce to the camera. Light can be instructed to ignore the Diffuse and Specularity attributes. In the Light Properties panel Affect Diffuse and Affect Specular can be disabled on a per-light basis. A light can be in a scene that does nothing but create a specular highlight on shiny surfaces and not otherwise illuminate the scene. A light affecting only Diffuse can act as an unobtrusive fill light.

Where there is light, there is also shadow, although this is not entirely true in 3D. In LightWave we have great control over the casting of shadows. Each light can be instructed to or not to cast a shadow. Not only that, but we now have the ability to tell each light what color shadow it

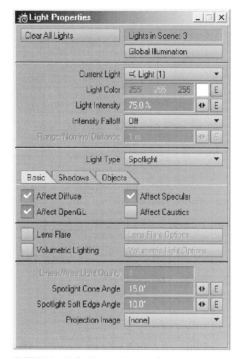

FIGURE 5.1 Light Properties panel.

should cast, independent of the light's color. The Light Properties panel allows us to turn on and off shadow casting for an individual light (see Figure 5.2).

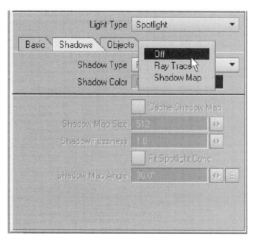

FIGURE 5.2 Shadow Option in the Light Properties panel.

Further control over shadows can be found in the Rendering section of the Object Properties panel. Each object has the option to Self Shadow, Cast Shadow, and Receive Shadow. These options are much more useful than they may first appear. Shadows have a tendency to get in the way of a good lighting setup. Several examples from this book contain scenes with objects inside a box, to illustrate a point. Turning off Cast Shadows in the box surrounding all the other objects in the scene avoids the need to cram all the lights inside the box.

Another interesting aspect of the Shadow control is that an invisible object can still cast shadows. In the Object Properties panel the object can be checked to be Unseen by Camera but still cast a shadow.

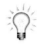

Shadows and Rendering Time

Rendering shadows is one of the more calculation-intensive functions. Any time you can turn off Self Shadow, Cast Shadow, or Receive Shadow of any object in the scene, even a null, it will help reduce the time it takes to render the frame.

Light Exclusion is another control that can be accessed on a per-light or per-object basis. The Object Properties panel contains a tab for Lights. A check in the Exclude column will prevent that light from having any effect on that object. (The Object Properties Light Exclusion also allows you to remove objects from Radiosity and Caustics calculations that can result in tremendous savings in rendering time.) In the Light Properties panel you can also exclude objects from lights using the Objects tab. This allows you to quickly check off all the objects that you do not want that light to affect.

A typical scene where this function would be useful is a simple chessboard scene where half the game pieces are white and the other half black. The white pieces require a completely different lighting setup than do the black pieces. Light Exclusion allows you to light two things differently in a single scene.

SHADOW MAPS AND RAY TRACE SHADOWS

There are two different types of shadows in LightWave: Ray Trace shadows and Shadow Map shadows. Although they can look very similar, the mechanics of each is very different.

Any light can have Ray Trace shadows. Select the Ray Trace Shadows option in the Shadows tab of the Light Properties panel, and activate Ray

Trace Shadows in the Rendering Options menu. When shadows are created with Ray Tracing, they literally trace the ray of light through the scene, which results in a fairly accurate rendering of a shadow. Ray Tracing can even acknowledge transparent objects and render shadows appropriately, even filtering the light through colored glass. The disadvantage of Ray Traced shadows is that they take longer to render and often result in shadows with very hard edges.

Shadow Map shadows render faster, can have a soft edge, and do not require Ray Tracing, but they do have some limitations. For one thing, Shadow Map is only an option when Spot lights are used. Shadow Map shadows are calculated by a kind of "best-guess" process in the computer of what the shadow should look like. As such, the shadows are not always perfectly accurate. Shadow Maps treat all objects as solidly opaque and do not acknowledge surface transparency. Shadow Map shadows do have a Shadow Fuzziness setting, which feathers the edge of the shadow to make it look more natural.

Shadows are set on a per-light basis. A scene often has a mixture of Ray Trace shadows and Shadow Map shadows (see Figure 5.3, page 178).

AFFECT OPENGL

The Affect OpenGL option in the Light Properties panel is purely for convenience in setting up the scene in Layout. This button will have no effect on the final rendering. This function is here because there is a limit to the number of lights the Layout can display in real time. There are also times that a light can be distracting and misleading. The OpenGL light render does not account for such things as falloff or shadowed areas.

The OpenGL display does do a pretty nice job of displaying light color, spot light cone angle, and specularity on surfaces. A particularly nice function of the OpenGL is that it respects the object exclusions from lights, giving you instant feedback on which lights are affecting which objects. Unfortunately, the OpenGL's rendering of lights does not yet acknowledge if the light has had Affect Diffuse or Affect Specularity disabled.

COLOR

Every light can have its own color. The default color setting for a light is 100% white. It is quite common for beginners to leave the light set to

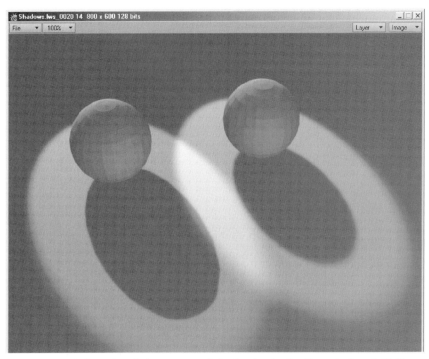

FIGURE 5.3 Two balls, each with their own Spot light. One is using Ray Trace shadows (left). The other uses Shadow Map shadows (right).

white default, which leads to flat-looking images. In the real world, lights have variations in color temperature. There is also the effect of light bouncing off colored surfaces, which creates an ambient light with the same coloration of the surface it bounced off of.

Without time-consuming radiosity renders, the only illumination in your scene comes directly from the scene lights. If all the lights in the scene are white, it is no wonder that the image renders flat and lifeless. Small variation in light color adds considerably to the rendered image's depth. This does not necessarily mean you should make one light solid green and the other bright pink. A main light with a slight golden glow contrasted with a second filling light that is slightly blue can bring out the contours of an object quite pleasantly.

When light colors mix, it produces an additive effect. If a pure red, a pure blue, and a pure green light all shine on the same spot, the net result is white.

INTENSITY AND FALLOFF

Intensity is simply the brightness of a light. Common sense might tell you that the functional range of intensity for a light is between 0 and 100 percent, but that is not the case. Light intensity can be set to far more than 100 percent, values of several hundred percent are not uncommon (although values of greater than 10 billion tend to get a bit strange). A light may also have a *negative* intensity value. A negative light cancels out other illumination and literally sucks the light out of the scene. A common complaint of computer-generated imagery is that it is over-lit. The option of using negative light is a powerful tool to help put a little darkness and contrast into the mix. Keep in mind that a negative light can be any color. The color of a negative light will remove just that color from the scene.

The rays of light from a LightWave light go on to infinity unless it has *falloff* applied. Real light loses strength as it travels due to dispersion and absorption. Virtual rays go on until they run into something. When falloff is applied to a light, the light strength decreases over the specified distance.

The best way to visualize the light falloff is to select falloff for a light and view it in either an overhead or side viewport. You will see a circle surrounding the light that will indicate the point at which the power of the light falls to zero (see Figure 5.4, page 180).

With falloff, the light is at full strength at the center of the light, then falls to 0 at the Range/Nominal Distance setting. When Intensity Falloff is set to Linear, the light decreases in a steady straight line; the line halfway to the edge of the circle means the light is at half strength. Real lights, however, do not have falloff in a straight line. By using the Inverse Distance setting for falloff, the light strength decreases more slowly closer to the light and more steeply as it gets near the end of the range, more closely resembling the action of light falloff in the real world (sort of an *S*-shaped curve). The Inverse Distance2 setting creates a more extreme curve.

AMBIENT LIGHT

The Ambient Light setting is found in the Global Illumination section of the Light Properties panel. Ambient light is a nondirectional light source that is just there. It is intended to represent the light that exists in the world from the millions of indirect sources. The default setting for Ambient Light is 25% and White. This has the same effect as selecting every surface in the scene and increasing the Luminosity value to 25%.

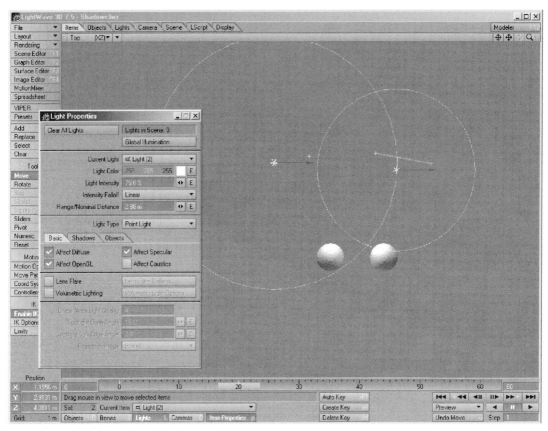

FIGURE 5.4 Overhead image of falloff circle around light. Falloff settings are not properly displayed in the OpenGL.

In almost all cases, you are better off reducing or eliminating the Ambient Light value altogether. Because Ambient Light illuminates all surfaces equally, it tends to flatten the dynamic range of the image. Experience has shown that the more adept an animator becomes at lighting their scene, the lower they tend to set the ambient light.

Ambient Light does have its uses. You can think of it as an easy global brightness tool. Sometimes a rendered image that looks good on the computer screen comes out either too light or too dark when exported to video or projection. Increasing the Ambient Light level makes the image lighter. Conversely, using a negative value for Ambient Light reduces the amount globally in the scene. Ambient Light is also useful for giving the scene a slight tint. Ambient Light can be any color you wish (see Figures 5.5 and 5.6).

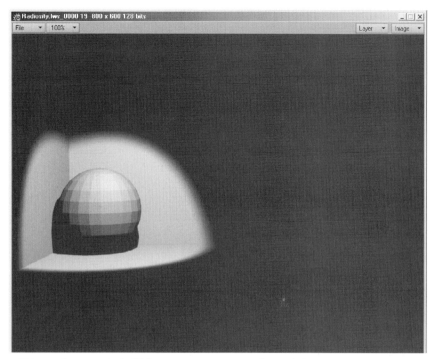

FIGURE 5.5 This is a typical still life-type image using a single Spot light trained on a sphere in a box. This very stark-looking image rendered in only a few seconds.

FIGURE 5.6 This is the same scene but with Radiosity enabled. This much more natural-looking scene took nearly 100 times longer to render.

Radiosity and Caustics

Radiosity is the capability of light to bounce off a surface and illuminate other surfaces. Proper use of the Radiosity function can yield truly photographic renderings of even the most basic objects. Radiosity simulates the way surfaces spread and diffuse light in a very natural manner.

Radiosity is currently the most render-intensive function in Light-Wave. There are ways to optimize the Radiosity calculations, but the use of Radiosity for most practical applications is still difficult to implement in anything other than still images.

Caustics are similar to radiosity, except that the bounced light is focused, much like the light passing through a wine glass or reflected from a mirrored surface. Because Caustics are generally indistinct blobs of light to begin with, the accuracy with which they get rendered is usually far less critical.

Types of Lights

There are five types of lights in LightWave. The first three are the original basic lights: Distant, Spot, and Point. The other two are Linear and Area. Each generates light, but differ in the angles in which they light the scene.

Distant

The Distant light generates rays of light that move in a straight line. This light is often compared to the rays of the sun. Because of the sun's distance, sunbeams are effectively parallel by the time they reach us. The most confusing thing about Distant lights in LightWave is that the rays go to infinity in front, behind, and to both sides of the light's position. Although the Distant light may be visibly positioned in the middle of the scene, the rays of light start at a point infinitely far behind the actual light and continue in a straight line forever in front of it. The physical position of a Distant light has no effect on the scene, only the angle. Rotation is the only thing that matters to a Distant light. Because Distant light originates from an infinitely distant point, the falloff settings are ghosted and have no function. Distant is also the only light that cannot be used to generate caustics.

Point

Point lights work in the opposite manner. A Point light sprays the rays of light equally in all directions. Because the light radiates equally out in a

sphere shape, the rotation angle has no effect on this light. All that matters to a Point light is its position. A point light can use falloff, but it also has a sort of natural falloff because the rays of light are constantly spreading farther apart as it moves away from the source.

Spot

The Spot light is the most flexible type of light. It contains a combination of the abilities of the Point and the Distant lights with some extra capabilities the other two do not have. The Spot light is the only light that can be focused, and the only light that can employ a Shadow Map.

The Spot light has a cone angle setting, which is represented by the rays shooting from the front of the light. If the cone angle is set to 180 degrees, the cone is folded completely back on it and becomes for all practical purposes a Point light (but it is a Point light that can use Shadow Maps). If the cone angle is set very low, for instance, 1 degree, and moved very, *very* far back in the scene, it becomes the equivalent of a Distant light. The Spot light Cone Angle also has a setting for Spot Light Soft Edge Angle. Inside this inner cone the Spot light is at full strength, then falls off to nothing when it reaches the maximum angle. If the Spot Light Soft Edge Angle equals 0, it creates a gentle feathered pool of light. If the Spot Light Soft Edge Angle equals the Spot Light Cone Angle, the light will be hard focused onto the edge of the rim of light.

A fun function of the Spot light is its ability to use a projection image. Using a projection image is exactly like using a slide projector. There are no controls for this setting other than selecting which image to use, which causes a few complications. All images projected from a Spot light come out square, even if the image is rectangular. The way around this problem is to edit the image in a paint program and letterbox it with black bars to create a square frame (the black bars will not be projected). The other problem with using a projected image is that there is no pixel blending or texture antialiasing available for the projected image. To avoid this problem, you must start out with a fairly high-resolution image. An image projected by a Spot light will by its nature get stretched as it hits surfaces and corners at an angle. Projection images are very good for things like throwing patterns of light on a wall and making fake caustics (see Figure 5.7).

Area and Linear Lights

Area lights and Linear lights are the newest additions to the light kit and must be handled with a certain amount of care. They are unique in that

FIGURE 5.7 A Spot light with the projection image of the earth map casting shadows on the wall.

they are the only lights where size does matter, and the only ones with quality controls.

A Linear light is most often compared to a fluorescent bulb. In Layout the Linear light is the equivalent of an extruded Point light. To get a mental picture of how a Linear light illuminates a scene, imagine the Linear light as a glass tube filled end to end with Point lights.

An Area light is much like its name implies—a flat plane that acts as a light source. Whereas a Linear light behaves like a tube filled with Point lights, an Area light behaves like a cookie sheet filled with Point lights. The difference is that an Area light has direction. An Area light casts most of its illumination directly to the front of it, with some light spilling from the sides.

Linear and Area lights are often recommended for soft-edged shadows and realistic lighting. The reasons these lights provide such pleasing effects is because, as pointed out, they are made up of the equivalent of thousands of minute Point lights. Each of those Point lights are offset a tiny amount from each other. When each one illuminates a surface it hits at a slightly different angle from the others, and the shadows fall slightly offset from each other. When all those Point lights in the tube are combined, it blends into a soft-edged, even illumination with a nicely feathered shadow.

However, using these lights comes with a price. As you can imagine, rendering the equivalent of thousands of Point lights and their shadows takes a considerably higher number of calculations than a single light. There is a quality option that ranges from 1 to 5 for Linear and Area lights. In most cases you will want to use the highest quality setting, but you can use lower settings for test renders if looking at the graininess and artifacts of the lower-quality lighting does not bother you. The Global Illumination panel contains a setting for Shading Noise Reduction that will blur the grainy edges of the Area and Linear lights, but it often has the undesirable effect of also blurring the surface areas where the light touches.

Keep in mind that Area and Linear lights in most cases have all the attributes of regular lights. They have the same color, intensity, and exclusion options as other lights. A nice trick for realistic lighting is to put Linear lights up in the corners of the ceilings of rooms with a negative value to give it a more natural looking shading.

With a little practice and some study, Linear and Area lights can be used to create lighting setups that come very close to duplicating the type of illumination that is normally associated with radiosity. A good plan of attack is to render one frame of a scene with a simple lighting setup and use radiosity. Once the frame is rendered, use it as a reference and study the way light is distributed around the scene. Using Linear lights, Area lights, and various standard lights, it is possible to come quite close to a mock radiosity lighting solution without horrendous rendering times.

LENS FLARES

Lens Flares are the reflection of light that catches in the camera lens. Most photographers go out of their way to avoid them, but in LightWave, we employ them for all sorts of purposes.

A Lens Flare is unlike anything else in LightWave. Technically, a Lens Flare is a post-process effect that is added to the scene after all the geometry of the scene is rendered, which is why Lens Flares do not show up in reflections or cast shadows. In other words, the Lens Flare is painted in 2D after all the 3D has been rendered. Lens Flares had evolved and become so versatile that they needed to get smarter. They need to know when they are blocked from view and that they should get smaller when they fade into the distance.

Lens Flares are attached to lights. This makes sense, although in reality the lens flare and the light properties actually have very little interaction. The Light Properties panel contains a box to activate Lens Flare. Any type of light can have a lens flare. The type of light will have no effect on the way a lens flare will appear. A Linear light, for instance, will not have a tube-shaped lens flare; it will have the same circular lens flare as a Point light.

A common misconception is that the intensity of the light affects the size of the Lens Flare. The only setting in the Light Properties panel that affects the Lens Flare in any way is the Light Color. A light can actually have no intensity at all and still support a Lens Flare.

Lens Flare Controls

Checking the Lens Flare box causes a Lens Flare with the default settings to be rendered at the light's current position. Clicking the Lens Flare Options button opens the Lens Flare Options panel (Figure 5.8), which has settings to change the look of the Lens Flare.

Most of the settings for a Lens Flare are pretty straightforward, although a few are a little tricky. The very first setting, Flare Intensity, determines the size of the Lens Flare. (A flare at the center of the screen with an intensity of 500% will pretty much white out the entire frame.) Because the rendering of the flare is a process that happens after all the geometry is rendered, the flare will render the exact same size no matter where the light was located in the scene. To compensate, the Fade with Distance options with the Nominal Distance setting increases or decreases the intensity of the flare based on its distance to the camera.

Another problem due to the post-process nature of Lens Flares is that they are normally layered on top of the rendered image, even if the light is passing behind an object. This results in the Lens Flare looking like it is shining through the object it is passing behind. To make the Lens Flares act more naturally, use the Fade Behind Objects and Glow Behind Objects settings. The name Fade Behind Objects is misleading; whenever an object comes between the light and the Lens Flare, the Lens Flare is

FIGURE 5.8 Lens Flare Options panel.

turned off. Glow Behind Objects keeps the Lens Flare on as it passes behind an object, with the sides of the Lens Flare still sticking out from behind the object. Glow Behind Objects is often used to give objects and logos that dramatic backlit look.

The Central Glow and Red Outer Glow settings make up the heart of most Lens Flares. Central Glow takes on the color of the light in the Light Properties panel. Central Ring creates the distinctive LightWave Lens Flare ring around the center of the flare. (The Central Ring has gotten a bit too much airtime; you will probably want to turn it off or change some of its settings.) Anamorphic Distortion is intended to give the Lens Flare a squashed oval shape consistent with an anamorphic camera lens. The 1.77 setting matches a wide-screen anamorphic lens. Anamorphic Distortion can be set to less than 1.0 to get a Lens Flare with a vertical stretch.

Streaks and Reflections

At the bottom of the Lens Flare Options menu are two tabs, Reflections and Streaks. These two tabs allow for a wide range of control over the look and behavior of the Lens Flares, not to mention hours of fun.

Activating Lens Reflections gives the Lens Flare the array of circular re-
flections you see in multi-element camera lenses. The position, type, size,
and color of each element can be specified, which would allow you to
create a lens reflection that is physically accurate to that of an actual lens.

The Streak tab is nothing but fun. Anamorphic Streaks create the
blue streak of light you often see in car headlights filmed at night. The
Star Filter does exactly what it sounds like it would do; it creates a star fil-
ter look. Notice that the number of stars in Star Filter can be set and that
the rotation of the stars can be keyframed, which makes good photon
torpedoes.

The Random Streaks settings get interesting. The default settings for
Random Streaks result in a rather harsh spray of lights. However, setting
the Intensity at over 100%, the Density to fewer than 5, and the Streak
Sharpness to less than 1.0 can result in a very interesting Lens Flare effect
that evolves and flows as it moves across the scene.

Saving Lens Flare Settings

There is currently no direct way to save an individual setting for a Lens
Flare, but there is a workaround. If in your experiments with Lens Flare
settings you find one that you would like to save, clear the scene of all
other objects and lights and save the scene. The scene should contain
only the light with the desired Lens Flare setting. When you want to
bring that flare into an existing scene, select the Load Items from Scene
option and select Yes when you are asked if you also want to load the
lights. This action will load the light with all the Lens Flare settings intact.

Lens Flares and OpenGL

The display option OpenGL Lens Flares allows you to view Lens Flares in
realtime in Layout. This is incredibly handy for setting up scenes, but
there are a few limitations that you should be aware of.

The Lens Flares that you see are only approximations of what the
final rendered Lens Flare will look like. If you stick with the default Lens
Flare settings, the OpenGL and the rendered image will look pretty simi-
lar. Some of the more advanced settings, such as portraying the random
streaks of the Fade Behind Objects settings, are not as accurate in the
OpenGL rendering.

There are a few things for which the OpenGL is invaluable. The Nom-
inal Distance setting is a good example. Lens Flares do not naturally
shrink as they move off into the distance. The Nominal Distance setting

can vary their size. Nominal Distance is the distance from the camera where the Lens Flare is at the strength equal to the setting of the Flare Intensity. Balancing the Intensity and Distance values is quite a trying exercise, but fortunately the OpenGL Lens Flares allow us to see the results of the settings without the need to render the full animation.

Another facet of Lens Flares where the OpenGL display is invaluable is customizing the elements in the Lens Reflections. The number of elements in the glass of a lens generates reflections in a Lens Flare. Each element can create a slightly different reflective ring. While the OpenGL only displays round reflective elements, even though a polygonal element is selected, it does accurately show the position and color of each of the elements. This takes out at least half of the guesswork from building a true representation of an actual Lens Flare (Figure 5.9).

FIGURE 5.9 A representation of the Lens Flare can be seen in the Layout view, though it may not be exactly what gets rendered.

CAUSTICS

Caustics is an unfamiliar word for something everybody knows. Caustics describes the spots and ripples of light that happens when the ray of light is reflected or focused. A caustic is the light passing through a wine glass to make a herring bone pattern on the table, the ripples of light that appear on the bottom of a water filled pool, and even the light bounce of a flashlight beam hitting a mirror.

Caustics work very much like radiosity. Caustics calculate the action that light takes after it hits a surface; in other words, the way it disperses to illuminate other surfaces in the scene. However, there are a few major differences between caustics and radiosity. The bounce of light with radiosity is very diffused, illuminating a wide area with reflected light. Caustics usually create very focused spots of reflected light. Light bounced by radiosity will pick up the surface's color. Caustics are only colored by the color of the light. Radiosity strength is only calculated for the attribute values for Diffuse and Luminosity. Caustics are affected by reflection and refraction.

How Caustics Are Created

Two things are necessary for a Caustic to appear in a rendered image. First, you need a caustic-enabled light, and you need an object surfaced with either reflective or refractive properties.

Caustics are created in one of two ways. If a surface has some value of reflection in its surface attribute, the surface will bounce off a caustic element. If a surface is transparent, a caustic will be created when the ray of light passes through the object. Transparent surfaces with an index of refraction value greater than 1.0 will cause the light to bend as it passes through the medium, either focusing it or spreading it. (If the transparent surface still has the default index of refraction of 1.0, the refractive value of air, the light theoretically goes straight through unaffected, but in practice will get distorted by the limitation of the caustic calculations.)

Caustics are generated by the light source. With the exception of the Distant light, any light can be enabled to generate caustics. In practice, the best results are achieved by using either a Point light or Spot light. Linear and Area lights have the ability to generate caustics but take much longer to render with little or no increase in quality.

To enable caustics for lights, open the Light Properties panel. Notice there is a check box for Affect Caustics (see Figure 5.10). This button on its own does not activate the caustic function; it enables caustics on a per-

FIGURE 5.10 The Affect Caustics selection on the Light Properties panel.

light basis. Click on the Global Illumination button to open the Global Illumination panel (Figure 5.11).

FIGURE 5.11 The Global Illumination panel.

The Caustics controls are located at the bottom of the Global Illumination panel. There are four basic controls: Cache Caustics, Intensity, Accuracy, and Softness. Because caustics can be very render-intensive, these settings help to manage the amount of calculation necessary.

When Cache Caustics are activated, the Caustics are only calculated on the first rendered frame, then that calculation is used on each

subsequent frame. This is fine if there is no movement of the light, the caustic generating surface, or any surface that the caustic light interacts with. This may work very well for things like still life scenes, which are architectural-type renderings where not much of anything is moving accept the camera, or where the caustics are being thrown toward a less active portion of the frame. However, when the caustic light or surface is in motion, or there is something in the scene that would move to block the light, the caustics would need to be recalculated. Cache Caustics should not be used in those circumstances.

The Intensity setting helps manage caustic visibility. Intensity is basically a volume control for the caustic speckles. The default is 100%, which is usually either too much or too little. The Intensity of the caustics should be set on a per-project basis. Notice that the intensity value has an E button to allow it to be enveloped.

The Accuracy setting helps control the consistency of the caustics from frame to frame. A caustic is pretty much just a blob of light, but if the Accuracy setting is set too low the blob of light will render slightly differently from frame to frame, causing it to appear jumpy when seen in an animation playback. If the Accuracy setting is set too high, the rendering times increase significantly. If the caustics are in constant motion, like light bouncing off rippling water, low accuracy will not matter. If the caustics are static and not moving, you can use the Cache Caustics function that will render the caustics exactly the same for every frame. Unfortunately, most cases fall between the two extremes and you must make a judgment call on the best Accuracy setting for the scene in question. The default for Accuracy is 100, but the range can go from as low as 1 to as high as 10,000.

The Softness setting controls the edge of the caustic blob of light. Unless an extremely high level of Accuracy is used, the caustic artifacts have a kind of spidery, grainy look. Splotches of caustic lights are typically expected to look softer and less defined. Softer also means you can get away with less accurate calculations. The default level is 20 with a range from 1 to 100. Calculating Softness for the caustics does add to the rendering time, but it is generally worth it. Once again, the level of softness needs to be determined on a per-project basis.

Shading Noise Reduction

The quality of the caustics is largely dependent on the settings in the Global Illumination panel. The quality of caustics are also affected by two other factors, Shading Noise Reduction and Motion Blur.

Shading Noise Reduction is a function available in the Global Illumination panel. Activating Shading Noise Reduction will slightly dither the areas illuminated by bounced light. This softens the caustic blobs of light, but often has the undesirable side effect of blurring surface texture details. Shading Noise Reduction should be used with discretion.

Ray Tracing and Caustics

All caustic effects happen through ray tracing, whether through reflection or refraction. The odd thing is that it is not necessary to activate Ray Tracing for reflection or refraction in the Rendering panel for caustics to work. With the Ray Trace Refraction and Ray Trace Reflection turned off in the Rendering panel, the caustic can still be generated.

A surface may have a high value of the reflection attribute but not appear to be reflective if Ray Trace Reflection is not turned on and no reflection map is used. As long as the surface has a reflective value, caustics will be calculated for it.

The caustic surface does not even need to be visible in the scene. In the following example, a reflective object has an object property of Unseen by Camera. Even though the object itself is not visible in the scene, the caustics it creates are visible.

TUTORIAL

ON THE CD

RENDERING A SCENE WITH CAUSTICS

STEP 1: LOADING THE CAUSTICS

The accompanying CD-ROM contains a sample LightWave scene to be used to explain the methods of applying caustics. In the Scenes directory go to the Lights folder and load the Caustic1.lws scene. This scene has a single Spot light shining on some basic objects in a room, all of which were given the default texture (see Figure 5.12).

STEP 2: MAKING SURFACES CAUSTIC CAPABLE

A requirement for Caustics is that the Surface needs to be either Reflective or Refractive. Click the Surface Editor button to open the Surface Editor panel. Hold down the Shift key and select both the Ball and Box surfaces. With both the Ball and Box surfaces selected, set the Reflection level to 100%. *Do not* adjust any of the Environmental settings that you normally would when working with Reflection, and *do not* activate Ray Trace Reflections.

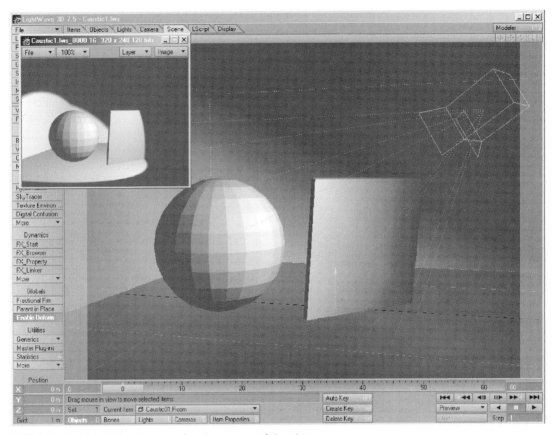

FIGURE 5.12 The default Caustics scene. Caustics are currently inactive.

STEP 3: SETTING UP THE LIGHT FOR CAUSTICS

The caustic functions of the light need to be activated. Select the light in the scene and click the Item Properties button to open the Light Properties panel. In the Light Properties panel, activate the Affect Caustics button.

Click the Global Illumination button to open the Global Illumination panel. Find the Caustics section at the bottom of the panel and activate Enable Caustics.

Render a frame and observe the rendered caustics (see Figure 5.13).

The caustics being thrown by the ball are square-ish and blocky because it is a faceted sphere. If Smoothing were turned on for the ball surface, the caustics would also appear to be smoothed. The caustic bouncing off the big square looks mostly square but is full of blotches. The blotches are due to the low Accuracy setting of the caustic. Because of the nature of the caustic arti-

FIGURE 5.13 The scene rendered with 100% reflective objects and default settings for reflection.

facts that LightWave renders, they will never be perfectly sharp and even. Fortunately, the uneven, smeared appearance looks natural on a caustic.

Other Aspects of Caustics

The previous exercise used the Reflection attribute to generate the caustics. The caustics appeared even, though there was no other evidence the surfaces were of a reflective nature. Caustics will also be generated if an object has Transparency turned on, and if the Transparency has a Refraction Index of something other than 1.0.

ON THE CD

To see this, from the Scenes folder on the CD-ROM, load the Caustic3.lws scene from the Lights directory. This is the same scene that was used in the previous exercise, but the objects are now transparent (see Figure 5.14).

Trace Shadows and Trace Refraction have been turned on in the Rendering panel to make the image look more visually pleasing. The caustics

FIGURE 5.14 Caustics rendered with refraction.

would have rendered with the Refractive properties even with the Ray Tracing turned on.

Notice that the Square object has some extra texture. A Bump map has been applied to the surface and both the index of refraction and the caustics respected the Bump mapping.

Caustics with Color

A question that often comes up is how to obtain *chromatic dispersion*, the rainbow effect of light passing through a prism. The only current method for creating rainbows is to fake it.

ON THE CD

The sample scenes, Caustic4.lws and Caustic5.lws, use three Spot lights of different colors that do nothing but generate caustics; they do not affect diffusion or specularity. A colored light will generate caustics of the same color. The illumination of the scene is accomplished by a fourth light. By slightly offsetting these colored lights, the caustics will also be offset, resulting in a fan of colors as the caustics are thrown from the object.

CONCLUSION

Lighting is one of the most underappreciated elements in image creation. Lighting alone can take a group of simple objects and reveal it as a striking work of art. This is true of all visual mediums, from computer renderings to oil paintings.

LightWave has a very good lighting kit in its tool box. There are still some limitations, particularly in the radiosity and caustics department, but as they keep improving and computers keep getting faster, the potential for getting true-to-life lighting solutions becomes more and more attainable.

6

ADVANCED TEXTURE TECHNIQUES

In This Chapter

- Image Maps As Textures
- Using Procedural Textures
- Numerical Values of Textures
- Texture Motion

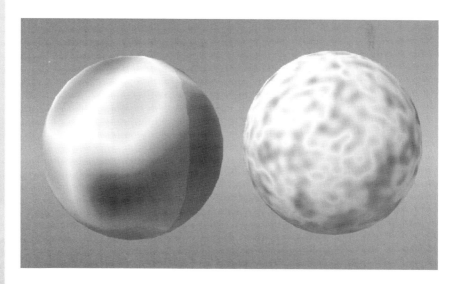

The previous chapters on surfacing covered the very basics of texturing an object, barely more than what can be seen in real time in the OpenGL display. To get more detail and realistic textures, it is necessary to understand some of the more advanced elements of the way surfaces work.

IMAGE MAPS AS TEXTURES

Images are often employed as a method of surfacing objects. An image can be a scan or photo of a real-world object, or it can be an image created in a paint program. The image might even have been created from a previous render. Image maps have many uses that may not be immediately apparent.

Layering Textures

Most surface attributes start with a base value, like having a solid color that covers all the polygons with that surface name or a single setting for the level of reflection or specularity. This type of mathematically perfect uniformity only exists inside the world of the computer. Any real-world texture will have some type of variation, transition, or flaw in some element of its surface. To introduce variations to the surfaces, we need to introduce textures.

Clicking the T button next to an attribute in the Surface Editor brings up the Texture Editor panel. There are three major tools in the Texture Editor to introduce variation to the texture attributes: Image Maps, Procedurals, and Gradients. These three texture types are similar in that they change the values of the attribute channel over the space of the area, yet they do so in very different ways.

Image Maps As Textures

An important part of texturing is the use of image maps. Image maps on an object surface have many applications that may not be immediately apparent. Nearly every texture attribute in the Surface Editor can make use of image maps. Image maps on their most basic level can be used to place a photograph in a picture frame of a scene. Using them to alter the diffuse, luminosity, or even reflective properties of a surface can also create natural-looking surfaces. Image maps are also used in compositing to

help marry the CGI element to the background plate by using the images to catch shadows and generate realistic reflections.

Images are mapped onto geometry in several different ways. Image maps can even be used to alter geometry through Displacement mapping, using the same texture mapping actions that happen in the Surface Editor (see Figure 6.1).

FIGURE 6.1 The Texture Editor with an image map of the earth's surface loaded.

Image Mapping Basics

Image maps can be applied various ways, but there are several common settings shared by the different modes. One important area is the Pixel Blending and the Texture Antialiasing options.

Frequently when an image is mapped onto a surface, it gets distorted or stretched beyond its original resolution. Normally when a digital image gets enlarged, it starts to look "bit-mappy" as the pixels become more apparent. Pixel Blending and Texture Antialiasing are intended to help

reduce this effect. This situation is a holdover from earlier days of computing when memory was scarce and hoarded. Image maps were made as small as possible to conserve system resources. Today it is much more feasible to use image maps that are several times the final rendered resolution of the image, which makes Pixel Blending and Texture Antialiasing less necessary. Many people make a habit of always turning off the Texture Antialiasing because it usually has the affect of softening the image and making it slightly blurry, especially when Enhanced Antialiasing is used on the final render. You can use antialiasing to your advantage, however, if you want the image to be a little blurry by setting the Texture Antialiasing level to 2, 5, or 10.

The Tile function is also used in several of the mapping modes. *Tiling* is the way an image is repeated over a surface when a single instance of that image does not cover it completely. There are several settings available for the Tile function: Reset, Repeat, Mirror, and Edge. Tiling modes can be set individually for both the horizontal and the vertical.

The usual Tile setting is Repeat. The image is repeated until it runs off the end of the surface, much like a floor tiled with linoleum squares. The *Reset* means the image is stamped down once. If you have the Height Tile set to Reset, and the Width Tile set to Repeat, it will make a ring around the surface.

The Mirror setting is similar to Repeat, except that the image flip-flops as it tiles the surface. Mirror is kind of a brute force way of making the tiles appear as a continuous image, since the mirrored edges of the image will always match up.

The Edge setting is kind of interesting. The Edge mode lays the image map down once, then takes the outside edge of the image map and stretches it to the end of the full surface. This is handy when you want the entire surface covered with the image map, but you do not want to enlarge it and think tiling it would be too obvious. See Figure 6.2 for examples of tiling methods.

Image Maps and Size

One of the most confusing aspects of mapping images onto geometry is how the size of the bitmap image relates to the size of the object being mapped. It is just a little complicated, but it is something helpful to learn right away.

Most of the Mapping modes have a button for Automatic Sizing. Automatic Sizing will scale the image so that it covers the entire surface with one instance of the image map. Keep in mind that Automatic Sizing assumes that it is a continuous surface. This is fine if you are mapping an

FIGURE 6.2 The same arrow map is applied to four different squares using different tiling methods.

image onto the face of a billboard, but not so good if it is for a surface like toenails, where the actual surface area is very small but spread over a larger area.

Here is one of the most difficult things to understand about image mapping in LightWave: all images come in the same size, one standard unit square. Whatever your default unit is set to in the General Options panel (it should be meters), an image is always treated as being 1 default unit square for mapping purposes. The image could be a postage stamp or a movie poster. Size does not matter for the purpose of mapping the image. The size of the image *does* matter for the quality of the image. But even if an image is exported and doubled in size, it will still be mapped with the same values.

Loading Images and Image Formats

Images can be loaded into LightWave in two different ways. When adding an Image Map texture in the Texture Editor, clicking in the image selection box allows you to select a currently loaded image, or load an

image by selecting Load Image. The second way to load an image is to use the Image Editor (see Figure 6.3).

FIGURE 6.3 The Image Editor.

The Image Editor will load an image into the scene but not specifically assign it to anything. The Image Editor also allows you to manipulate the image, create multiple instances of the image with different settings, and set limits and behaviors for sequences and animation files.

LightWave can use a wide variety of image and animation formats for image mapping—even Photoshop PSDs with layers—but they must be a form of bit-mapped image. LightWave cannot as yet use Vector or EPS files directly for image mapping.

LightWave can natively read just two image formats: Targas and IFF, which are written into LightWave's source code. The Input-Output plug that should already be installed allows LightWave to read most common image formats, including animation formats and 32-bit images with imbedded Alpha channels.

Viewing Images

Double-clicking on the thumbnail image in the Image Editor will display the full size image in its own window. Using the viewer's Save command can save the image in another format along with any changes or adjustments that may have been made.

If a QuickTime or AVI is loaded into the image editor, moving the scrub bar under the thumbnail image in the Image Editor panel can preview the sequence of the animation.

Basic Surface Mapping Types

There are six different ways to map an image on a surface. The first four are fairly easy to understand: Planar, Cylindrical, Spherical, and Cubic. They behave pretty much the way their names imply, and we will get to those in a moment.

Planar image mapping is the most straightforward. It simply applies the image flat onto the surface and projects it straight through the object. The direction that the planar map is applied is selected by the axis that is chosen. The Z axis maps the image flat on the front of the surface. Selecting the X axis puts the image on the side, and the Y axis drops it down from the top. Planar mapping projects the image map straight through on the axis, which means the other axes will only see the edge of the image and it will appear backwards when it comes out the other side.

The classic example of *Cylindrical mapping* is putting a label around a can. If you want to wrap a label around a can of beans, you use cylindrical wrapping using the Y axis. If you want the label to go around twice you choose a Wrap Width amount of 2. *Spherical mapping* is what you use to wrap a globe; it attempts to bend the image map to conform to a spherical shape.

Cubic mapping is similar to Planar mapping a sphere. It attempts to flatly put an image map on all three axes of an object.

It is important to note that these modes of image mapping describe how they work. It does not mean that this is how they must be used. You can use Cubic mapping on a cylinder, or Planar map a cube. It is up to you to decide the best mode for the situation at hand (see Figure 6.4).

A Word about OpenGL Textures

Surfaces can be seen in the Layout view if the Render Level is set to Texture Shaded Solid. OpenGL textures in the Display Options panel should also be enabled. Normally, only the first image map on the Color channel will be displayed in OpenGL,

FIGURE 6.4 Examples of various mapping types.

but there is a setting in the Display Options panel called Show Current Texture Editor Layer. When this is activated, image maps on any of the attributes channels can be seen in real-time in Layout.

Keep in mind that the way the images look in the OpenGL display are only an approximation of what they will look like when they are fully rendered. Things like falloff and other texture layers can affect the way the image maps will be rendered but will not show up in the OpenGL preview.

The Display Options panel allows you to set the resolution of the image maps in the OpenGL to conserve memory and speed up response time. The render resolution that is set in the Display Options panel has no effect at all on the image maps in the final render.

Image Mapping Coordinates, Scale, Position, and Rotation

When an image map is chosen as a Texture layer, four tabs appear at the bottom of the screen: Scale, Position, Rotation, and Falloff. (These tabs also appear when the Texture layer is a Procedural texture.) These tabs allow you to manipulate the position and size of the image map on the surface.

These coordinates work with images very much like they do when moving points around in objects. Just remember that every image comes in as a default 1-unit square, even if it is a rectangular image such as Leonardo DaVinci's *The Last Supper*. To give *The Last Supper* back its proper proportions, it is necessary to scale its height and width. If we wanted it to hang crooked on a wall, we would use rotation. To move it to a new place on the wall, you would use position. Think of manipulating an image map as if you have loaded a 1m square decal that you can stretch, tile, and place onto the object's surfaces.

T U T O R I A L

APPLYING AN IMAGE MAP TO A SURFACE

STEP 1: LOAD THE TEXTURE LAB SCENE

From the Surface folder of the Scene directory on the CD-ROM, load the TexLab01.lws. Activate Viper and render a single frame. Open the Surface Editor panel.

STEP 2: LOADING AN IMAGE

Click the Image Editor button at the upper left of the Layout screen to open the Image Editor panel. Click the Load button to load an image. Go to the Images directory and select the Earth image. In the Image Editor we can modify and pre-process the image, but for now we will leave it as is.

STEP 3: APPLYING THE IMAGE MAP TO A SURFACE

Return to the Surface Editor and select the Box surface. Click on the T button in the Color channel to open the Texture Editor. The default Texture type is Image Map; go to the image selection box and select the previously loaded Earth image. The image of the map of the earth should instantly appear on the front face of the Box object in the Viper window. Though the map looks normal on the front of the box, the edges of the image appear to be streaking down the sides of the box. The image is being Planar mapped through the length of the object.

STEP 4: ADJUSTING THE MAP

The problem with the earth map on the box is its projection type. The default projection type is Planar. Because the object being mapped is a box, the most obvious type of mapping to use would be Cubic. Click on the Projection Type selection and select Cubic. The earth map should now appear nicely mapped on all four sides of the Box object in the Viper window.

STEP 5: OTHER TYPES OF MAPPING

Just because the object is a cube does not mean you can only use Cubic mapping. With the Box surface still selected, change the Projection Type to Spherical. Spherical mapping will attempt to wrap a single instance of the image around the entire surface. Likewise, a Cubic map can be applied to a round object. Notice that a cubic map can look quite nice on a round object (see Figure 6.5).

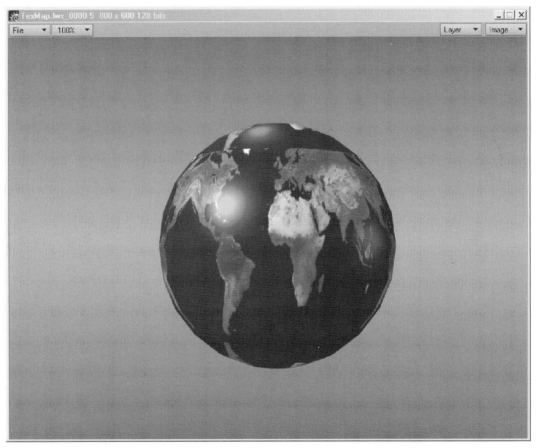

FIGURE 6.5 The Ball object with a cubic image map.

USING PROCEDURAL TEXTURES

A *Procedural texture* is a pattern created through a mathematical formula. A Procedural texture can be as complex as the never-ending fractal swirls that can go on to infinity, or as simple as the black and white squares of a chessboard. Procedural textures can be used to duplicate everything from the patterns of underwater ripples to the rough surface of sandstone (see Figure 6.6).

FIGURE 6.6 The Texture Editor and the list of Procedurals.

Advantages of Procedural Textures

Because a Procedural texture is mathematically derived, it is effectively resolution independent. You can zoom in by a factor of 1,000 on a surface created with Procedural textures and the image will not show any pixelating of the surface. The surface will also hold up when the camera zooms back. The Procedural texture goes on for infinity without ever

exactly repeating itself. Certain patterns will emerge, just as they do in natural textures, but there will not be the obvious tiling we see with image maps.

Procedural textures take virtually no memory, but they do take time to calculate. The more the amount of detail a texture has, the more calculations are necessary. This is particularly noticeable when anything involving ray tracing interacts with a textured surface.

The Procedurals supplied with LightWave give instant access to many natural-looking textures. Most of the Procedurals are available in all the texture attribute channels, and many can even be used as displacement maps to physically change the shape of an object.

Some of the listed textures exist in true 3D space. Even though we usually see just where the texture intersects with the object surface, that texture exists on all three axes, like the rings inside a block of wood, or the fudge layer inside chocolate swirl ice cream. As the texture center is shifted, the texture will change as it moves through the surface. Textures can be given velocity so that they actually move through a surface, leading to some interesting effects (see Figure 6.7).

Procedural Scale

Strictly speaking, Procedural textures are resolution independent. If an image map is enlarged too far from its original resolution, it will no longer look like the original image and will display the individual pixels that made it. A Procedural texture has no pixels. The texture is mathematically calculated at a sub-pixel level, so there is never any pixelating. (However, the "jaggies" can still appear on straight lines if no antialiasing is used). Procedurals do, however, have a specific useful range.

Early computer animation used recursive fractal algorithms that created never-ending multicolored swirls. The Procedural textures in LightWave do not work that way. The difference can be illustrated by the checkerboard pattern. If the scale of the checkerboard procedural is set to High, a single square will fill the screen and be effectively a single value. If the checkerboard scale is set to Small, the individual squares will shrink to microscopic dots, creating a halftone blend of the checked squares. This also happens in real-world textures. Distinctive textures like wood or marble patterns when enlarged or reduced 100 times would not easily be recognized.

Most Procedural textures have a range where they are most useful, but there are often secondary considerations when dealing with texture scale. Many Procedurals have settings for the amount of detail to add to textures. Some of each texture's level of detail is controlled by the

FIGURE 6.7 The Ripple texture applied to all the surfaces of the object. Notice the full 3D nature of the texture.

number of frequencies used and by something called *Small Value* (see Figure 6.8).

Uses of Procedurals

Some Procedurals have familiar sounding names, like Wood and Marble, and others have names that suggest their appearance, like Crumple and Ripples. Do not take these names too seriously. The procedural textures were named by their programmers on a whim, sometimes with a goal in mind and sometimes not. The Wood procedural can be made to resemble actual wood, but it does take a bit of work. Realistic surfaces are usually the results of several layers of attributes and textures working together.

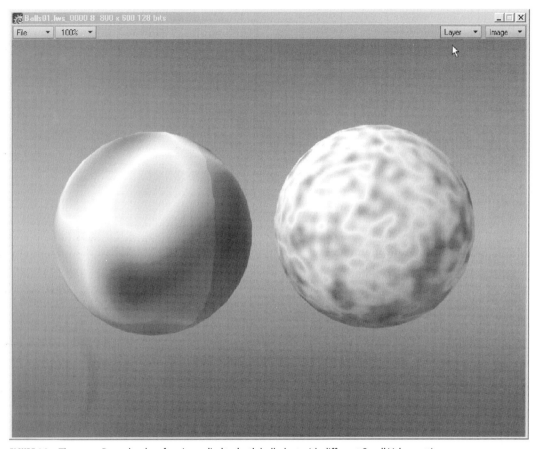

FIGURE 6.8 The same Procedural surface is applied to both balls, but with different Small Value settings.

Procedurals are excellent for producing irregular yet uniform surfaces—the subtle bumps of writing paper, for instance, or the crisscrossing of veins. The same Procedural texture can be used simultaneously on different texture channels, like making the reflective area also transparent to obtain more natural effects. Using different procedurals on separate channels multiplies the complexity of the texture.

TUTORIAL APPLYING PROCEDURALS TO A SURFACE

STEP 1: LOAD THE TEXTURE LAB SCENE

From the Surface folder of the Scene directory, load the file TexLab01.lws. Activate Viper and render a single frame. Open the Surface Editor panel.

ON THE CD

STEP 2: APPLYING PROCEDURALS TO THE ROOM

Once a frame has been rendered and appears in the Viper window, select the Room surface. Go to the Color channel and click on the T button to open the Texture Editor. Click the button for Layer Type and select Procedural Texture.

The default Procedural texture is Turbulence. The default color is almost exactly the same shade of gray as the base color for the wall, so there will appear to be no immediate effect on the walls of the Room object in the Viper window.

STEP 3: CHANGING THE TEXTURE VALUES

To make the Procedural texture Turbulence stand out, it needs to be a different color than the background base color. The Procedural has its own Color channel, which works the same way as the Color channel in the Basic tab of the Surface Editor. Change the color to something drastically different like solid blue.

As soon as the color is changed in the Texture Editor, the selected surface should be updated in the Viper window. Turbulence has a kind of wispy appearance. The underlying light color suggests clouds over a blue sky. Changing the settings for Frequencies, Contrast, and Small Power can further alter the look of the Turbulence texture. Contrast controls the edge softness, which can be set to negative values. Any changes you make to the texture setting should immediately be displayed in the Viper window.

STEP 4: COPYING THE PROCEDURAL TO A DIFFERENT CHANNEL

The Copy and Paste buttons at the upper left of the Texture Editor allow you to easily copy textures and paste them into other channels. With the Turbulence procedural currently selected, click the Copy button and select Copy Current Layer.

Close the Texture Editor panel for color and open the Texture Editor for the Bump channel. In the Texture Editor for Bump, click on the Paste button and select Replace Current Layer.

The Turbulence texture will now be pasted into the Bump channel with all the settings that it had in the Color channel, but nothing will appear to have happened. Notice that in the settings for the Turbulence texture where the color information had been, a setting for Texture Value now appears. Texture Value is currently at 0, so the Turbulence texture has no effect on the Bump level. Enter a setting of 100 for the Texture Value and notice the effect it has on the surface of the Room object in the Viper window (see Figure 6.9).

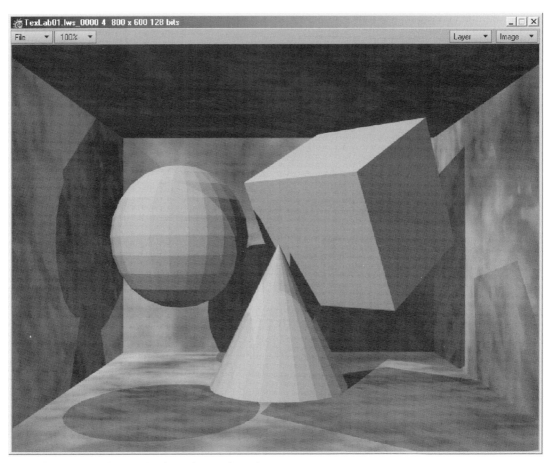

FIGURE 6.9 The Room object with Color and Bump channels.

The Bumps of the Bump channel happen at the same place as the blue color from the Color channel, with the same level of intensity.

This tutorial showed a very simple example, but it illustrates the process of combining different attribute channels with the same procedural textures.

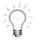 *Closing the Texture Editor*

There are two ways to close the Texture Editor panel: by clicking the X in the top right-hand corner of the window, or clicking the Use Texture button at the bottom of the window. Next to that button is the Remove Texture button. It is, unfortunately, far too easy to hit the Remove Texture button by mistake. The Remove Tex-

*ture button will delete that texture and all its settings from the attributes channel,
and there is no way to get them back.*

Using Gradients

Gradients are a brand new way to put a texture onto a surface. A Gradient
uses some type of outside control to apply texture values to a surface. The
Gradient is a group of values that are spaced out over the surface accord-
ing to the input parameter (see Figure 6.10).

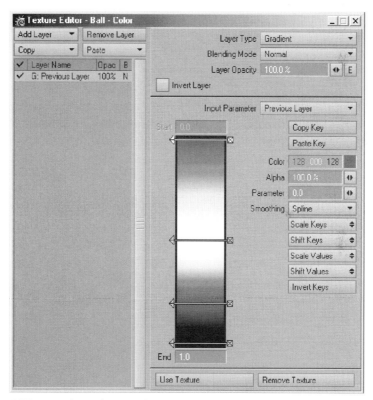

FIGURE 6.10 The Gradient panel.

The white bar in the center of the Gradient layer is called the *swatch*.
Inside the swatch are control points called *keys*, which look like small
golden arrows. A Key is created when the mouse is clicked inside the
swatch. The key contains several pieces of data: its position in the swatch,
the attributes value at that key, and the Alpha value for that key. The po-
sition in the swatch reflects whatever is being used as an input parameter,

be it distance or angle. The key value is the value for that attribute. The alpha value controls the transparency of the attribute at that key. A Gradient can be controlled by a large number of input parameters. It can also be controlled by other textures, by distances to objects, and by angles.

The Gradient defaults to using the previous texture layer as the Input Parameter. The strength of the texture below it controls the keys in the swatch. The other texture parameter is the Bump channel. Using the Bump channel as an input parameter is particularly useful because the bumpy texture of a surface is often related to other aspects of the surface.

An important input parameter is the Incidence Angle. The Incidence Angle is the angle of the surface to the camera. Many surface attributes change their values depending on the angle at which they are viewed. The windows in many office buildings, for example, are transparent when viewed straight on to the camera, but when they are angled away from the viewer they take on much more reflective qualities. This changing of surface attributes based on angle of view is known as the Fresnel Effect.

TUTORIAL

ON THE CD

USING THE GRADIENT TO CREATE A FRESNEL EFFECT

STEP 1: LOAD THE TEXTURE LAB SCENE

From the Surface folder of the Scene directory, load the TexLab01.lws scene. Activate Viper and render a single frame. Open the Surface Editor panel.

STEP 2: APPLYING A GRADIENT TEXTURE TO THE BALL SURFACE

We will be applying a Gradient to the Color channel using the Incidence Angle as the input parameter. In the Surface Editor panel, select the Ball surface. Activate Smoothing for the Ball surface and render a frame so that Viper updates the Ball surface with smoothing applied.

Click on the T button in the Color channel to open the Texture Editor for the Ball Surface. Under Layer Type, select Gradient.

STEP 3: ADJUSTING THE GRADIENT TEXTURE

The default settings for the Gradient texture do very little to the surface. We must change the input parameters and add some colorful keys to the white swatch. Click on Input Parameter and select Incidence Angle. Nothing will happen yet because the Gradient has only the initial starting key.

Create a new key for the Gradient by clicking the mouse inside the white rectangle of the Gradient swatch. A new key will appear looking like a little gold arrow. Click and drag the new arrow key to the bottom of the Gradient box. With the new key still selected, go to the color box and change the color from the default white to a bright red. The effect should be apparent immediately in the Viper window (see Figure 6.11).

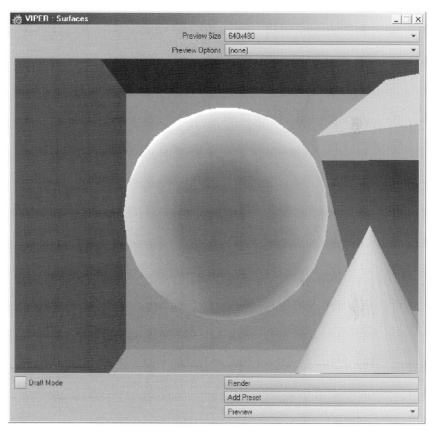

FIGURE 6.11 The Ball object with Gradient shading.

The first key in the Gradient box is at 0 degrees. That means the polygons of the surface have no angle to the camera (see the sides of the Ball object in this scene). When the key that was added was dragged to the bottom of the box, the parameter of that key became 90 degrees. A parameter of 90 degrees means that the polygon is facing directly into the camera, in this case the center of the ball facing toward the camera. This is the range of the Incidence Angle input parameter, facing into the camera at 90 degrees and facing

perpendicular to the camera at 0 degrees. Any keys that are added fall between these two extremes.

STEP 4: ADDING ADDITIONAL KEYS

Currently one color key is at full strength and pointing directly into the camera. That color fades into the color of the original key that is around the edge of the Ball object facing away from the camera. Additional keys can be added to add more color values.

Click the Gradient box to add additional keys. Give each key a different color and note the effect in the Viper window. A rainbow spread of colors now covers the surface of the Ball object.

STEP 5: TRYING DIFFERENT INPUT PARAMETERS

The Incidence Angle input parameter is useful for duplicating the optical properties of the Fresnel Effect, but there are also other input parameters based on angle and distance that can be useful.

Change the input parameter to Slope. Slope is similar to Incidence Angle, except that it works from the top down and is not affected by the camera position or angle. The Slope is calculated from the object's rest position, the position it is in when it is first loaded into Layout. If the object has been keyframed into an upside-down position, the slope will stick to the object and also appear upside down.

Change the input parameter to Light Incidence. One of the lights in the scene will also need to be selected so that the Gradient knows which light to reference. Once again, this result is very similar to the Incidence Angle with the camera, but here the selected light can be repositioned and animated in the scene. The light rotation makes no difference to the Gradient; the important aspect is its angular relationship to the surface of the object. The light can be turned off completely and it will still affect the Gradient when Light Incidence is used as an input parameter.

Several of the input parameters concern distance, such as the distance to the object and the distance to the camera. These settings are useful when you want the action in the scene to affect surface attributes of an object. When one of the distance-based input parameters is chosen, a number appears at the bottom of the Gradient swatch, which tells you the current scale of the swatch. The default value is 10 meters, meaning that a key at the bottom of the box determines what happens to the sur-

face when it is 10m from the surface. This scale value can be changed. If the object and the surface never get more the 100mm apart, the scale can be set to 100mm. That setting does not actually do anything. It just scales the view in the Gradient swatch box.

NUMERICAL VALUES OF TEXTURES

Both Procedural textures and image maps are heavily dependent on the numerical coordinates in the Texture Editor. The numerical coordinates specify the Scale, Position, Rotation, and Falloff of the textures (see Figure 6.12). Not only do these coordinate settings give us control over the placement, size, and the rotation of the textures, the Falloff setting lets us specify how far the textures will reach.

FIGURE 6.12 The Coordinate tabs.

Because objects made in the 3D world are virtual, the units of measurement used are a matter of preference. The metric system was arbitrarily chosen for convenience. Because there is no real distance inside the computer, the units of scale could be anything you want to call them. However, it is important to have a standard of reference for the geometry and for the textures.

LightWave in general likes to work its math close to the neighborhood of one default unit. Beginners have the habit of not paying attention to the scale when they are first building objects, working in whatever level of magnification they happen to be in when they start. This is sloppy modeling and will cause problems down the road. While you can work with models scaled in kilometers or microns, most tools and functions are set to work in the 1m range. Another potential problem occurs when you want to combine objects of drastically different scales in

the same scene, and come up with such things as a one-inch coffee cup on a mile high table.

The strongest argument for keeping your geometry within the same order of magnitude is for surfacing. Keeping objects in the same scale makes it easier to develop surfacing skills. If all your objects are of the same size, the surfaces will translate well when copied from one object to another.

Sizing an Image Map

All image maps enter into LightWave at the relative size of 1m square, regardless of its original size and aspect ratio. LightWave uses 1m because the standard default unit set in the General Options panel is meters. If the default unit has been changed to something else, like feet or microns, the image will be treated as a one default unit square of what ever has been selected.

While it may be confusing at first to treat every incoming image as being the same size, it is actually quite useful. Image maps come in a variety of resolutions, from high-resolution scans several thousand pixels across, to images of just a few pixels. Images with the same aspect ratio but different resolutions can be swapped out in a texture without the need to readjust the any of the coordinate settings.

In the Texture Editor for Image Maps is a button for Automatic Sizing. Automatic Sizing will take the image map and stretch it like a bed sheet to exactly cover the selected surface. One copy of the image will cover every polygon of the object that has that surface name. It will treat the surface as if it is continuous, even if it is not. The image map will be sized so that the edges of the image meet the farthest points of the surface.

TUTORIAL

ON THE CD

AUTOMATIC SIZING

STEP 1: LOAD THE TEXTURE LAB SCENE

From the Surface folder of the Scene directory, load the file TexLab01.lws. Activate Viper and render a single frame. Open the Surface Editor panel.

STEP 2: MAPPING AN IMAGE ONTO THE WALL

Select the Wall surface and click on the T button for the Color channel. Click on the Image box and select Load Image. Load any image you want. When the

image is loaded it will appear in the Viper window on the walls of the Room object.

STEP 3: ADJUSTING THE IMAGE MAP

Currently the image is using a Planar map. Change the Projection Type setting from Planar to Cubic. The image is now mapped flat on all four walls. Because the walls of the object are greater than 1m square, the image is repeated several times on each wall.

Click the Automatic Sizing button and observe the results. There is now a single instance of the image map on each wall, stretching from corner to corner. The numbers appearing in the Scale tab are also the same size of the Room object.

Measuring an Object with Automatic Sizing

When Automatic Sizing is used to scale the image to a surface, the values in the Scale tab are the X-Y-Z values for the polygons of that surface. If you are unsure of the scale of the object in question, using Automatic Sizing in the Texture Editor gives you an instant measurement.

Scaling a Procedural Texture

Sizing an image map to a surface is a fairly easy concept to understand; you either want one image to cover the entire surface or you want the image to be smaller than the surface and tiled. Procedural textures go on forever, but they still need to be given a proper scale.

A good rule of thumb for scaling textures is to start with a scale value about one-tenth of the size of the surface being textured. If the surface covers two meters, give the Procedural a starting scale of 200 millimeters. More often than not, this gets you in the ball park for a good scale of the Procedural, and you can move it up or down from there.

When using Procedurals, whatever settings get the job done are the right ones to use. If Procedurals are too small they can take on the appearance of repeating almost as if they were an image map—they really are not but look like they do. Also, tiny Procedural textures may look fine in a still frame but have a tendency to look like they are "crawling" or "buzzing" when viewed in an animation, especially in video on video monitors. A few things that can be done to reduce the problems are lowering the detail and reducing the small power of the procedural, using a

higher level of antialiasing, or even running a very slight blur filter over the animation sequence as a post-production process.

Adjusting the Sample Sphere Scale

The Texture Editor panel has a thumbnail texture sample. The default display here is a 1m sphere. Clicking on the Options button next to the texture sample window allows you to change the display to what may be more useful to the current section. If you are texturing wing nuts or hot-air balloons that you have built to scale, you can reset the sample window to a similar scale. Some surfaces look quite different on a curved surface than they do on a flat one, so we also have the option to view the sample mapped onto a cube.

One of the most useful options of the sample window is the ability to use a background. The default background is black, which is not very useful if you are texturing an object with black edges. The background can be either the backdrop color or a checkerboard. Both are handy when surfaces have reflective, refractive, and transparent qualities.

The options for the texture sample window will return to the default settings when LightWave is shut down.

Texture Numerical Values

Image maps and Procedural textures have coordinate values much like objects in Layout. These coordinates are laid out in four different tabs at the bottom of the Texture Editor panel (see Figure 6.13).

FIGURE 6.13 The numeric tabs for image maps and Procedural textures.

The first three settings, Scale, Position, and Rotation, work exactly the same way on textures as they do on objects in Layout. The textures are, in effect, parented to the objects, so that when the objects move, the textures stick to them. The values are entered directly into the associated boxes. Notice that there is an E button next to every value, indicating that the values can be enveloped.

T U T O R I A L

APPLYING AND MODIFYING A PROCEDURAL TEXTURE

In this tutorial a procedural texture is used to demonstrate the effects of the Texture Editor's coordinate values.

STEP 1: LOAD THE TEXTURE LAB SCENE

ON THE CD

From the Surface folder of the Scene directory, load the file TexLab01.lws. Activate Viper and render a single frame. Open the Surface Editor panel.

STEP 2: SELECTING ALL THE SURFACES AND APPLYING THE GRID PROCEDURAL TEXTURE

The Grid texture will be applied to the entire scene to display the effects of the Procedural on all the objects. In the Surface Editor, select the first listed surface. While holding down the Shift key on the keyboard, select the last surface in the list. This should result in all the surfaces in the Surface Editor being selected. Any adjustments made in the Surface Editor will be applied to all the selected surfaces.

Go to the Color channel and click on the T button to open the Texture Editor. Select Procedural Texture as the Texture Type. For Procedural Type select Grid.

Because the default color of the Grid is the same as the base color, there will be no change immediately apparent in the Viper window.

STEP 3: ADJUSTING THE GRID SETTINGS

The first thing to do is to make the Grid visible by changing its color. Change the Grid color to red to make it easily visible in the Viper window (see Figure 6.14, page 224).

The current size of the Grid texture is one default unit, which is 1m. To change the size of the Grid, new values need to be entered into the Scale tab. To make the Grid smaller, enter the following values:

X = 500mm
Y = 500mm
Z = 500mm

Notice that as you type in the values into the boxes and press Return, the effects of the new size are instantly shown in the Viper window. The Grid is now half its previous size because the values are half the original settings.

To increase the size of the Grid, enter the following larger values for the Scale setting:

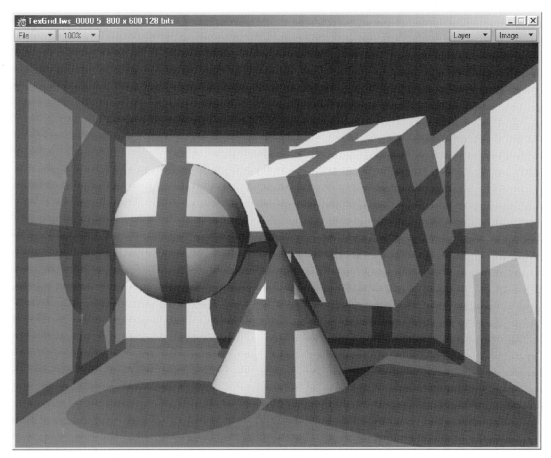

FIGURE 6.14 The Grid Procedural on all the objects in the scene.

X = 2m
Y = 2m
Z = 2m

The Grid is now twice the size of its original setting. It is not necessary to make uniform scale changes; each axis can have a unique and separate value.

STEP 4: ALTERING TEXTURE POSITION

The second coordinate tab is Position. A texture's Position is its starting reference point. The 0 position for the texture is the same point as the axis of the object to which the polygon with the surface belongs, not necessarily the center of the surface. In the Texture Lab scene, the 0 point of the surface for the

Ball and the Cube object happen to also be the center of the object, but that is just how they were created. You can see this with the Grid texture; X marks the spot for the center.

You may have noticed when resizing the Grid that some of the Grid lines ran parallel to the polygons of the square objects. This results in the Grid texture appearing as a solid sheet of color. Fix this by moving the Grid texture so it is not parallel to the polygons.

In the Position tab, click on the incremental arrows in the data boxes and change the position a few millimeters either way. Notice how the X, Y, and Z coordinates for the Texture position behave much the same way as when you move an object on the same axis in Layout.

STEP 5: ALTERING TEXTURE ROTATION

The Grid texture is perfectly in line with all the square edges of the scene. However, you may not always want a texture that is perfectly square. The Rotate tab allows you to rotate the texture. Keep in mind that the texture will rotate around the center of the object, and that the center can be offset with the Position settings.

The Rotate functions for textures can be a bit confusing. Although they are the same as the Layout rotations, you do not have the advantage of seeing the results as you move the mouse. You can see the effect of changes in the Viper window. Change the H rotation value by clicking on the up/down arrow next to the H rotation value box and view the result in the Viper window. Return the rotation values to 0 before proceeding to the next step.

Falloff Settings

Falloff is the act of a texture fading away over distance. The texture begins at 100 percent strength at the center of the texture and falls away to 0. How quickly it falls away is determined by the Falloff setting.

Calculating the Falloff setting is perhaps the most confusing aspect of using falloff, but the basic premise is fairly simple. When Falloff is used, it means that the texture is at full strength at the beginning and will eventually drop to nothing. This drop-off rate is determined by the default unit, usually 1m. A Falloff setting of 100% means that a texture will fade away completely exactly 1m from the center. A Falloff setting of 50% will take two meters to fade away. A 200% Falloff setting will fade away the texture in half a meter.

Using the Grid texture example from the previous tutorial, set the Falloff on the X axis for 100%. You will see in the Viper window that

texture fades away as it reaches the right and left edges of the objects in the room. Because they are all 1m in scale means that the edges are only half a meter from the center. But the Room, which is bigger than 1m, shows the texture falling off completely. Setting a Falloff of 500% shows the texture very clearly fading from the smaller objects in the room (see Figure 6.15).

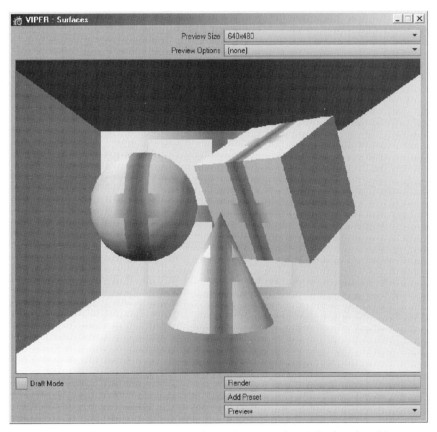

FIGURE 6.15 The Falloff on Room is 100% for the Grid texture and 500% for the other objects.

Because the setting was on the X axis, the Falloff took place horizontally. Falloff can also be set for the Y and Z axes as well. The default setting for Falloff is Cubic, which gives you the classic square- or diamond-shaped falloff. The other settings are Spherical and Linear.

The Spherical setting for Falloff means that the edge of the falloff area will be round instead of square, which can be more useful than the Cubic setting in many cases. Linear falloff indicates falloff in only one direction. Linear falloff will have the texture at full strength until the center of the

texture and then start fading away. To reverse the direction of the Linear falloff, use a falloff with a negative value.

TEXTURE MOTION

Most people think of textures as fixed to the surface of an object, like paint or decals on real-world objects. In computer animation, the textures themselves can become animated. The entire texture can travel across the object surface, or just specific values of the texture can be made to change over time.

Giving a Texture Motion with Envelopes

Textures can be given motion in much the same way as objects. In the co-ordinate settings for the texture, each value has an E button indicating that the value can use an envelope to change its value over time. The Scale, Position, and Rotation settings can all be keyframed and animated.

TUTORIAL

MAKING A TEXTURE ROTATE

In this tutorial we will use the same Grid texture as in the previous tutorial, but this time an envelope will be applied to the texture's B rotation channel.

STEP 1: LOAD THE TEXTURE LAB SCENE

ON THE CD

From the Surfaces folder of the Scene directory, load the file TexLab01.lws. Activate Viper and render a single frame. Open the Surface Editor panel.

STEP 2: SELECTING ALL THE SURFACES AND APPLY THE GRID PROCEDURAL TEXTURE

The Grid texture will be applied to the entire scene to display the effects of the Procedural on all the objects. In the Surface Editor, select the first listed surface. While holding down the Shift key, select the last surface in the list. This should select all the surfaces in the Surface Editor. Go to the Color channel and click on the T button to open the Texture Editor. Select Procedural Texture Grid as the Texture Type. Change the color of the Grid texture to something more visible, like bright red.

STEP 3: CREATING AN ENVELOPE FOR ROTATION

In the Texture Editor panel, go to the Rotation tab for the Grid texture. Click on the E button for the B (Bank) channel of rotation. The Bank rotation rotates around the object's center like the hands of a clock. Clicking the E button opens the Graph Editor panel. This is the same Graph Editor panel that is used throughout Layout, and all the tools work the same way (see Figure 6.16).

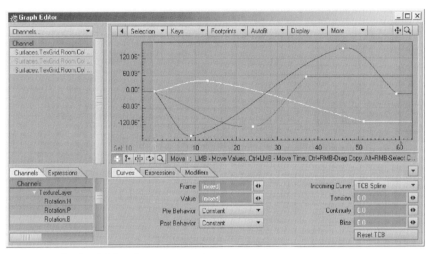

FIGURE 6.16 The Graph Editor for texture rotation.

Clicking the E button for any of the Rotation channels opens the Graph Editor for all three rotation channels, but whichever channel was clicked will be selected when the Graph Editor opens. We want the Grid texture to rotate 90 degrees over the 60 frames of the current scene.

The Graph Editor currently contains a single keyframe, the texture rotation's current resting position. We need to add a second keyframe with a different value to create rotation. Select the Create Key tool (the second of the five boxes just below the Grid in the Graph Editor) and click in the graph space to create a new keyframe. With the new keyframe still selected, enter these values for the second key:

Frame = 60
Value = 90

STEP 4: RENDERING A VIPER PREVIEW

The Viper window should show all the objects in the scene with the Grid texture. In the Viper panel, select Preview>Make Preview. Viper will now render an

animation showing the rotation of the texture. Note that there is no change in the position of the objects in the Viper animation. Viper renders its best guess as to what the new texture settings would look like had they been in place when the first sample frame was rendered.

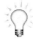

Viper Preview Length

When Viper renders a preview, it uses the start and stop frames that are currently specified in Layout. To lengthen or shorten the preview in Viper, change the in and out points that are to the right and left of the Layout scrub bar.

Because the nature of the Grid texture is basically a perfect square, rotating it 90 degrees on its axis gives it the appearance of a continuous loop. Most textures require a full 360-degree rotation for a continuous loop.

This example works well because it is quite easy to see the effects of the keyframed rotation on the texture. All the other coordinates can be keyframed in a similar manner for Procedurals and for image maps.

Animating Other Texture Values

Some of the Procedural textures have settings that can be animated. Take a look at the Procedural texture called Dented (see Figure 6.17).

The Dented Procedural texture has five different parameters that can be keyframed. Each of these parameters controls a certain aspect of how the Dented texture will appear on the surface. The setting for Scale in conjunction with the setting for Power controls how much of the surface will be covered with the Dented texture. Experimenting with the values and watching the results in the Viper window helps you to zero in on the maximum and minimum levels you want to have in the surface. Once you have determined the range of the settings for the texture, those settings can be entered as keyframes. Once an envelope has been created, the result can be seen by rendering a preview in the Viper window.

The Viper window will render its sample based on the current frame in Layout. Whatever the value of the Envelope at that frame are the values that will be used.

Self-Motivating Textures

There are a few Procedural textures that come with built-in motion and will be animated without the use of keyframes: Ripples, Underwater, and

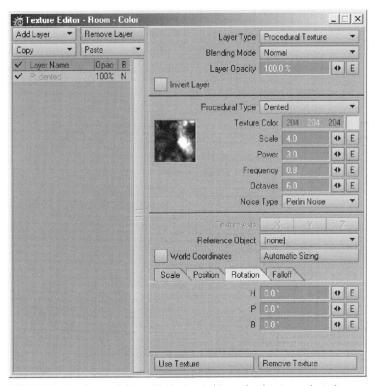

FIGURE 6.17 The Texture Editor with the Dented Procedural texture selected.

Smokey textures. The three textures, Ripples, Ripples2, and Underwater, begin moving as soon as they are selected. Both the Ripples and Underwater textures can be made to loop by dividing the Wave Length value by the number of frames in the scene to get the proper Wave Speed. If Wave Length is 0.5 and there are 60 frames in the scene, enter the equation 0.5/60 into the box for Wave Speed, then press Enter. LightWave will do the necessary math and give you the number 0.0083. Render a preview of the Ripple texture with these values in the Viper window and you should see a seamless loop.

The three versions of the Smokey texture, Smokey 1, 2, and 3, start off static but begin to move when they have a Turbulence value of greater than 1. The Smokey Procedural resembles the whorls that vapor makes when seen in a shaft of light. The texture can look quite different depending on the value of the Turbulence. An interesting thing about the Smokey textures is that they can be looped. A Turbulence value of 1.0 makes the texture loop at exactly 188 frames. A Turbulence value of 2.0 will cause it to loop at 94 frames. To see them move, render a Viper preview.

Using a Reference Object

Procedural and image mapped textures can be animated through the use of keyframes in the Texture Editor, but sometimes it is more convenient to use a *reference object*. A reference object can be any object in Layout, although in most cases it is a null object brought into the scene for the sole purpose of controlling the texture. A reference object provides an easy way to keyframe the scale, position, and rotation of a texture.

When a reference object is used for a texture, the coordinate values of the reference object are added to the coordinate values already in the Texture Editor. For instance, if the X position of the reference object is 2m, and the X value for the position in the Texture Editor is 3m, the texture itself will be moved a total of 5m.

The biggest advantage of using a reference object is the ease in which you can animate a texture. The reference object can be moved interactively and keyframed in Layout much more intuitively than when working in a Graph Editor. The reference object can also be manipulated by other forces in Layout that will then affect the texture.

Reference objects can be used for both Procedural textures and image maps. The resulting motion can be seen by rendering a preview in Viper. On some systems, when Layout has Texture Mapping activated, you can view the movement of the image on the surface in real time as the reference object is moved.

Layering Textures

Even within a single attribute channel, it is possible to have several layers of texturing. Procedural, image mapped, and Gradient textures can be combined in various ways to achieve complex textures.

Blending Modes

Layers of textures are combined in different ways using Blending Mode. Blending Mode is selected at the top of the Texture Editor menu (see Figure 6.18).

Blending Modes determine how the layer will affect the current surface and how it will react to other layers. The different modes are similar to the painting modes you might find in a paint program.

The two most important Blending Modes are Normal and Alpha. The Normal mode simply lays the texture layer over the current surface. If there are any "holes" in the texture, the previous surface will be seen through it.

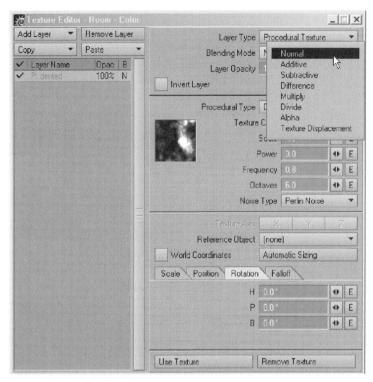

FIGURE 6.18 Blending Mode types.

When the Blending Mode is set to Alpha, the Alpha layer becomes sort of a cookie cutter for the layer directly below it. Anywhere the texture would have normally fallen, the mode removes that part of the underlying texture.

TUTORIAL

CREATING A MULTI-LAYERED TEXTURE

Several texture layers can be combined in the Color channel for a more detailed surface.

STEP 1: LOAD THE TEXTURE LAB SCENE

ON THE CD

From the Surfaces folder of the Scene directory, load the file TexLab01.lws. Activate Viper and render a single frame. Open the Surface Editor panel.

STEP 2: APPLYING THE FIRST TEXTURE TO THE ROOM

Select the Room surface and click on the T button for the Color channel to open the Texture Editor. Select Procedural Texture as the Texture Type and the Checkerboard texture for the Procedural. Change the color of the Checkerboard texture to blue so that its effect can be seen in the Viper window.

Notice that the Checkerboard texture lays down a checkerboard of blue squares. The area not covered by the blue squares reveals the underlying surface color.

STEP 3: ADDING A SECOND PROCEDURAL TEXTURE

While still in the Texture Editor for the Color channel, click on the Add Layer button at the top left of the panel and select Procedural. Use the default Procedural texture of Turbulence. To see the Turbulence texture more clearly, change its color to bright green.

The Turbulence texture puts a wispy, cloud-like texture over both the Checkerboard texture and the original surface.

STEP 4: SWAPPING TEXTURE LAYERS

Currently, the Turbulence layer is on top of the Checkerboard layer. To swap these two layers, click on the layer name listing in the Layers box, and drag the Turbulence layer under the Checkerboard listing. The Checkerboard pattern should now be solid blue squares with the wispy Turbulence layer beneath it.

STEP 5: USING A LAYER AS AN ALPHA CHANNEL

So far both these layers have used the Normal blending mode. Using the Alpha blending mode makes that layer a transparency map for the previous layer.

Move the Turbulence layer back to the top of the stack so that it covers the Checkerboard. Change the Blending Mode for the Turbulence layer to Alpha. Once the Turbulence Procedural has been changed to an Alpha layer, the Turbulence texture "erases" the parts of the previous layer where the Turbulence would have been adding a color.

Alpha channels are extremely useful in creating textures. The Layer Type can be mixed any combination. A Procedural, image map, or Gradient texture can be used as an Alpha channel for whatever the previous layer is. You can even use an Alpha channel on another Alpha channel.

Temporarily Disabling Textures

Using many layers of textures can sometimes become confusing and it can be difficult to remember how each layer is contributing to the texture. To temporarily remove that layer, deactivate it by clicking on the little checkmark next to the layer listing in the Texture Editor's layer listings. The Texture layer will remember all its settings even though the Texture layer is disabled. The Texture layer will still remember the settings even when the object is saved and loaded at a later time, which is much handier than removing the layer and losing all the settings.

CONCLUSION

LightWave has a huge arsenal of texturing tools; just a few applications were touched on in this chapter. As you spend more time building textures in LightWave, you will find yourself spending more time examining the textures in your own environment, taking apart the elements and examining why things look the way they do. The more you understand the complex interaction of light and shadow, the better equipped you will be to create your own textures and surfaces.

SUBDIVISION SURFACES AND DISPLACEMENT

In This Chapter

- Subdivision Surfaces
- Simple Applications for a Single SubPatched Plane

I n this chapter you will learn how to create and manipulate SubPatch objects.

Subdivision Surfaces

Subdivision Surfaces (also referred to as *Sub-D* and *SubPatches*), is a very sophisticated object modeling format that is surprisingly easy to use. Simply put, you turn it on and it makes things smooth in a flexible and controllable way. There are certain rules, however, that must be followed for it to work correctly.

TUTORIAL

A Quick Introduction to Subdivision Surfaces

Step 1: Creating a Box

Use any setting you want and make a Box object.

Step 2: Activating Subdivision Surfaces

Under the Construct tab, click the SubPatch button. This converts the standard polygon object to a Subdivision Surfaces object. (The shortcut is the Tab key on the keyboard; get used to using it now because you will use it often.)

Step 3: Viewing Your Work

In other words, you make an object and press the Tab key, and watch Light-Wave smooth it. The result can be saved with Subdivision Surfaces active, and rendered that way in Layout.

What Is Subdivision Surfaces?

Subdivision Surfaces is a more advanced form of the Smooth Subdivide modeling tool. When a normal polygon object is converted into a Sub-Patch object, a smoothing cage forms around it. The power of Subdivision Surfaces is that it is a virtual smoothing action. It does not need to be frozen into a standard polygon mesh to load into Layout to be rendered. The advantage of this is that you can specify the amount of subdivision at any time prior to rendering.

The level of subdivisions for an object can range from no subdivision (no effect on the original geometry) to hundreds of subdivisions. Each level of subdivision multiplies the number of polygons that will be rendered for that object by a factor of four. The more subdivisions there are, the higher the resolution of the rendered model. Although the higher resolution model will render much more smoothly, a model with tens of thousands of polygons takes longer to render than one consisting of a few hundred polygons, and all those polygons take up more memory.

Adjusting Levels of Subdivision

When an object is converted into a SubPatch object, it is really just an on or off process. The object is either a Subdivision Surfaces object or it is not. The level of subdivision can be set at any time.

In Modeler, there is a single level for the subdivision, which is set in the General Options panel (see Figure 7.1).

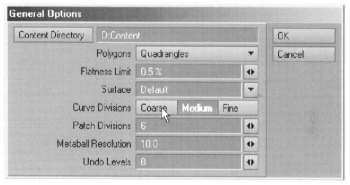

FIGURE 7.1 The General Options panel.

The default level is 6, which is the same as taking an object and running Smooth Subdivide on it 6 times. (This setting is provided only for visual reference when working on SubPatch objects.) The level of subdivision in Modeler has no effect on the level of subdivision when it is loaded into Layout.

In Layout, the default level of subdivision is 3, half as much as the default in Modeler. The change in the level of detail from Modeler to Layout can be disconcerting at first. Under the Objects tab in Layout is a setting for SubPatch Level. Changing the SubPatch Level to 6 will make the object look exactly the same as it did in Modeler.

The SubPatch Level in Layout has two settings, one for display and one for rendering. This configuration makes the best use of your system's resources. Normally, you would have a low setting for display (for visual reference as you set up the scene) and a higher level to use when the object is rendered. This helps keep your real-time display working smoothly.

The level of subdivision can be set on a per-object basis. You can have clones of the same object in a scene with different levels of subdivision. For example, suppose you had a scene that contained a group of identical characters, such as ants. The ant object close to the camera can have a SubPatch level of 10 or more, and the one far away can have a SubPatch Level of 1 or 2. This saves system resources and does not burden the processor unnecessarily.

The Subdivision Level for any object in Layout or Modeler can be changed at any time. The Subdivision Level is saved in the scene file, not in the object file.

Rules for Using Subdivision Surfaces

There is really only one rule for using Subdivision Surfaces, but it is a big one. Only three- and four-point polygons can be converted into SubPatch objects. You will be reminded of this every time you try to SubPatch an object with inappropriate polygons with a warning window (see Figure 7.2).

FIGURE 7.2 The warning window called if you try to SubPatch objects with inappropriate polygons.

In this case, all polygons with three or four points will be transformed into Subdivision Surfaces, but the inappropriate polygons will be left as they are.

Activating Subdivision Surfaces

As stated at the beginning of this chapter, all that is required to convert a normal polygon model into a SubPatch object is to hit the Tab key. The actual button is in the Convert section of the Construct tab, but you will find yourself toggling the Subdivision Surfaces on and off so frequently that the Tab shortcut will save much time.

You can have a single object that has both normal and Subdivision Surfaces simultaneously; many objects are a combination of angular and smooth surfaces. To create only part of an object, have those polygons selected when Subdivision Surfaces are activated. Only those selected polygons will be converted into SubPatch objects.

You will sometimes have a situation were some of the polygons are SubPatches and some are not, and you will want to toggle the SubPatches on and off. If some polygons are SubPatches and you hit the Tab key, the SubPatch polygons will return to normal, but the normal ones will become SubPatched. The best way to control this feature is with the Statistics panel. The Statistics panel will display the number of polygons that are SubPatched and allow you to select them. When the SubPatches are selected and the Tab key is pressed, only they will be affected.

Working with SubPatch Objects and Geometry

When an object is first converted into Sub-D geometry, it often has a very lumpy appearance. All the sharp edges are smoothed, making most things look like they are built from malformed potatoes. This is because each polygon of the object is divided the same number of times. Subdivision Surfaces does not subdivide based on the amount of area the polygon covers; it divides each polygon the same amount.

Beveling Surfaces

To give these soft organic shapes more definition, we need to add more geometry. This can be done a number of ways: with beveling, using the Knife tool, or by subdividing the object. You can add geometry while the Subdivision Surfaces are either on or off.

TUTORIAL

USING THE BEVEL TOOL ON A SUBPATCH OBJECT

STEP 1: CREATING A BOX

Use any setting you want and make a Box object.

STEP 2: ACTIVATING SUBDIVISION SURFACES

Turn on the SubPatch by hitting the Tab key. The box should now look like a square-ish ball.

STEP 3: BEVELING THE OBJECT

Select two polygons on opposite ends of the box. Under the Multiply tab, click the bevel key (or use the shortcut *b* key on the keyboard). Click on one of the viewports and drag the mouse cursor to see the effect the interactive bevel has on the SubPatch geometry (see Figure 7.3).

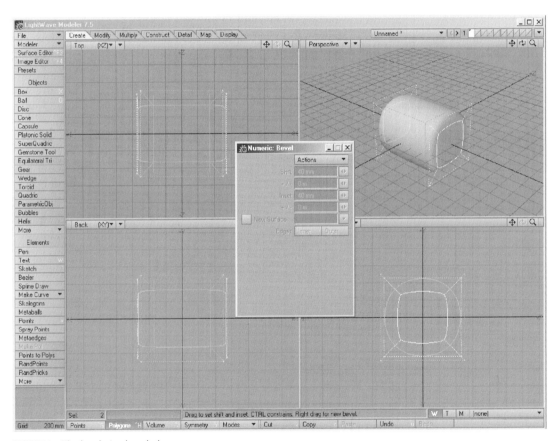

FIGURE 7.3 The box being beveled.

Notice the effect this has on the SubPatch box object. The selected ends being beveled have a harder edge, giving the object a tubular shape. The smaller the amount of the bevel, the sharper the edge is. Complete the bevel action by turning off the Bevel tool, and toggle Subdivision Surfaces on and off to see what the beveled box looks like.

Using the Knife Tool

The Knife tool is very useful for adding detail to SubPatch objects. You must be careful because it is possible to create polygons with the Knife tool that have more than four polygons, making them unusable as Subdivision Surfaces. (The Bevel tool, in contrast, always generates four-point polygons.)

For an example of how the Knife tool can be used, start with the basic box and turn on Subdivision Surfaces by pressing the Tab key. Under the Construct tab, click the Knife button to activate the Knife tool. Draw the Knife tool across the center of the Sub-D box. You will see how the additional geometry effects the object. You can move the cutting line of the Knife tool by grabbing it in its center, or twist it around by grabbing its end points.

By moving the Knife tool's edge around the object, you can see how the location of the cuts affect the smoothing properties of the SubPatch object. When the generated points are closer together, the edges become harder. When the new points are more spread out, the shape retains most of its roundness.

At some point in moving the Knife tool around the SubPatch object, the Subdivision Surface will fail. This is because the Knife tool is cutting across a polygon in a way that is creating polygons greater than four points (see Figure 7.4).

Subdividing a SubPatch Object

Sometimes the easiest way to give a SubPatch object more form is to simply do one level of subdivision on it. One level of subdivision, using either the faceted or smooth options, will double the number of points in the original object. This gives you more points to move around and model. Many times you start with a low polygon object to model the basic shape of a model. As you progress, you subdivide the model to give you more points so you can add detail.

Start with the 1m box and turn on Subdivision Surfaces. The box appears as a square-ish lump. Under the Construct tab, click the Subdivide button and select the Faceted option. The box still has rounded edges, but looks more box-like. Click the Subdivide button again and run the faceted subdivide a second time. The corners and edges of the object become even more defined. Hit the Tab key to see what the geometry really looks like. After two applications of faceted subdivide, the

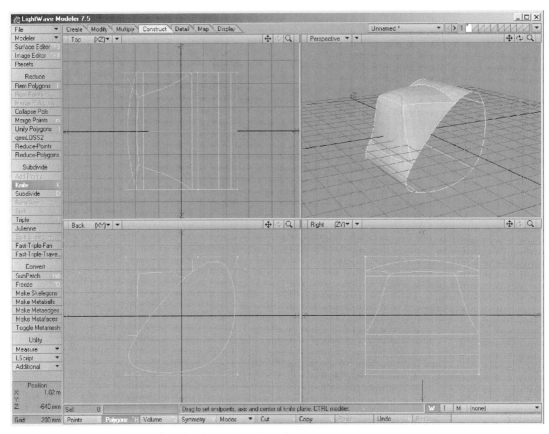

FIGURE 7.4 The Sub-D box with Knife tool making a five-point polygon.

walls of the box should consist of a four-by-four grid of squares (see Figure 7.5).

Changing Default Subdivision Settings

In Modeler, the default setting for Subdivision Surfaces is 6. This is a nice level, but at times you will want to match the Modeler level of subdivision to that of the intended render level. Conversely, there are times when dealing with a high polygon object with 6 levels of subdivision bogs down the system and you will need to reduce the level.

By selecting Modeler>Options>General Options from the pull-down menu, you can bring up the General Options panel. The setting for Patch Divisions sets the Subdivision Level for the SubPatch objects display. It is important to understand that this setting is only for the Modeler display; it has no effect on the object when saved as a SubPatch object.

FIGURE 7.5 The SubPatch cubes with increasing levels of subdivision.

The exception to this rule occurs when a SubPatch object has the Freeze command applied to it. The Freeze command, under the Construct tab, will convert the current SubPatch object into a normal polygon object with all the subdivision in place. It will use the level of subdivision specified in the general options panel and freeze the SubPatch object. This is sometimes used to export LightWave models to other programs that do not support the LightWave SubPatch system (see Figure 7.6).

In Layout we have two settings for subdivision, the Display setting and the Render setting. Display sets the amount of subdivision seen only in the Layout viewport and has no effect on the final render. The Render setting is the level of subdivision that is used in the final render. The default for both settings is a SubPatch Level of 3 (see Figure 7.7).

The SubPatch level can be changed at any time. The SubPatch level is set on an individual basis for each object. The level can be set either by

FIGURE 7.6 The Sub-D object as a SubPatch object, and the same object once it has been frozen into a standard polygon object.

FIGURE 7.7 The SubPatch Level box.

clicking on the SubPatch Level button under the Objects tab in Layout, or in the Geometry section of the Objects Properties panel.

SIMPLE APPLICATIONS FOR A SINGLE SUBPATCHED PLANE

Subdivision surfaces have been a great boon to high-end 3D character animation, but it has much simpler applications as well. Through the use

of Subdivision Surfaces, even a simple four-point polygon can result in some very complex structures.

When a polygon has been converted into a SubPatch object, it has nearly unlimited potential. The object can be taken into Layout and distorted in ways that would completely ruin a normal polygon object.

CREATING A SINGLE SUBPATCH POLYGON

Creating a single four-point polygon is about as simple as modeling gets. This polygon will then be converted into a SubPatch object that will be manipulated in Layout. The easiest way is to start with a box object.

STEP 1: CREATING A BOX

In Modeler open the Numeric panel and click the Box button to activate the Make Box tool. In the Numeric panel for Box, select Reset and then Activate. Click the Box button again to deactivate the Box tool and to freeze the Box object.

STEP 2: MAKING IT A PLANE

We want just the top polygon from this box. Select the bottom and the side polygons of the box and then press the Delete key. There should be nothing left except the top polygon floating half a meter in the air. The Modify tab in the Move section of the Tools menu contains a command for Center Data. Use this command to center the last remaining polygon.

STEP 3: CONVERTING AND SAVING

Convert the polygon into a SubPatch object by pressing the Tab key. The square polygon should then look like a pancake. Save the object as SubPlane.lwo. (This process of creating a plane from a box and converting it takes much longer to read than to actually do.)

Leave Modeler and open Layout. Load the SubPlane object. The SubPlane object will look almost invisible in the Camera view because we are looking at a paper-thin object edge on. To get a better view of the object, switch to Perspective mode. This will also make it more convenient to scoot around the object as we deform it in Layout (see Figure 7.8).

Notice that the SubPlane object looks less smooth in Layout than it did in Modeler. This is because the default Subdivision Level in Modeler is 6, and the

FIGURE 7.8 The plane in perspective mode.

default Subdivision Level in Layout is 3. Click on the SubPatch Level button and set both settings to 10 for now.

Displacement Textures on SubPatch Objects

The shape of an object can be modified in Layout through the use of Texture Displacement. Texture Displacement can be found in the Object Properties panel in the Displacement section. Clicking on the T for Displacement Map opens the Texture Editor panel for Displacement. This panel is very much the same as the Texture Editor for surfaces.

The first thing we will add is an image map. From the Images folder of the book's CD-ROM, load the ARROW.tga image. Select the Texture Axis as Y. You should immediately see the effect the image has on the SubPlane object (see Figure 7.9).

ON THE CD

FIGURE 7.9 The SubPlane object deformed by the arrow map.

The image of the arrow is displacing the SubPlane object in a very rough arrow shape. To get a more accurate representation of the arrow image on the SubPlane object, there needs to be a higher level of subdivision. Try setting the Subdivision Level to 50 (see Figure 7.10).

With a higher level of Subdivision, The SubPlane object has many more polygons to work with. It also takes much more memory and longer to render. You may already notice that the viewport update is slower.

Even at a SubPatch Level of 50, the edges still do not look very smooth. The arrow image is not the best application for a SubPatch displacement texture. The whole point of using Subdivision Surfaces is to get smooth flowing curves. The arrow shape seen here would have been accomplished much more effectively if the arrow were simply created in Modeler.

Ripples

Instead of an image map with hard lines, we will now switch to using Procedurals. In the Displacement Texture Editor, change the Layer type to Procedural and select the Procedural Type as Ripples2. The Ripples2 texture will deform the SubPlane object into a ripple shape. In Layout, hit the Play button for the real-time preview; you can see the ripples in action as they deform the SubPlane object (see Figure 7.11).

If the SubPlane object keeps blinking out as you move around in Layout, the Bounding Box Threshold may be set too low, and often defaults to 0. Open the Display Options panel and check the level for the Bounding Box Threshold. Change the Bounding Box Threshold to at least 20,000. This will keep the object in view as a solid, rendered object in the Layout viewport.

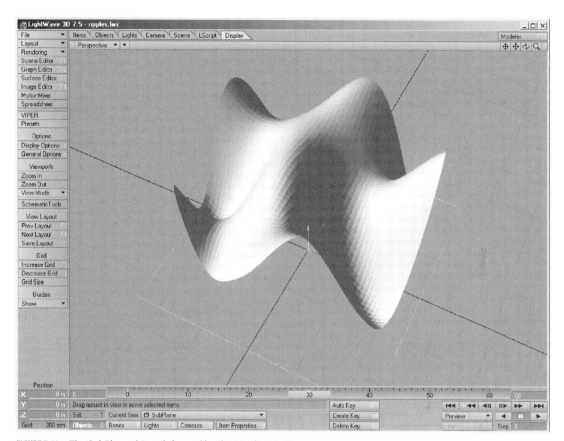

FIGURE 7.11 The SubPlane object deformed by the Ripples2 texture.

The amount of displacement can be changed by either adjusting the Layer Opacity or the Texture value. Any changes made to the settings in the Displacement Texture Editor will instantly be seen in the Layout viewport. Try changing the Position settings for the Ripple2 Texture. When ripple texture is first applied to the object, it starts at the center of the SubPlane object. By moving the Position away from the center you get a more natural rippling effect.

There are a few other textures that have built-in motion that can be applied as a Displacement map. LightWave has two Ripple textures, a related texture called Underwater, and groups of textures called Smokey. The Smokey textures will be animated if they have a Turbulence value of greater or less than 0. A value of 2 is a good place to start; you can adjust the setting to your own taste by watching the changes in real time.

Animating Static Textures

Textures that do not have built-in movement can still be animated using envelopes. Many textures have settings with values that can be enveloped. Moving a texture on the X and Z axes will cause the same displacement to shift around on the surface, but moving it through the SubPlane object will cause the surface to constantly evolve as the Procedural moves through the Y plane.

Saving Transformed

While you are deforming an object, the object might take on a very interesting shape. You can freeze the object by going to the File pull-down menu and selecting Save Transformed. This will allow you to save the object in its current shape under a new name. When that object is then loaded into Layout, it will look the same way but without the need for Displacement mapping.

Mountain Range

SubPatch planes work very well for creating scenery. You may have already spotted the way some of the displacement resembles mountain ranges.

TUTORIAL

MAKING A MOUNTAIN WITH SUBPLANE OBJECT

STEP 1: SETTING UP THE SCENE

Starting with a clear scene, load the SubPlane object. For now, use the Perspective view. With the SubPlane object selected, click the Item Properties button to open the Object Properties. A SubPatch level of 3 will be too low for what we are doing, so set the Display level to 50, and the Render level to 100.

STEP 2: APPLYING THE DISPLACEMENT TEXTURE

Under the Deform tab of the Object Properties panel, click on the T to open the Displacement Texture panel. Set the Type to Procedural and the Procedural Type to Crumple. This will instantly change the SubPlane object into a big crumpled mess.

STEP 3: APPLYING FALLOFF TO THE CRUMPLE TEXTURE

In the Displacement Texture panel for Crumple, go to the Falloff tab. We want the Crumple texture to fall off completely by the time it gets to the end of the

1m polygon. The texture that starts at the middle of the edge of the polygon is half a meter away, so the Falloff needs to be set to 200.

We want the Falloff to happen on the X and the Z axes, so enter 200 for the Falloff for both of those (see Figure 7.12). We can see that this results in a squared-off texture, the classic diamond shape falloff. To fix this, change the Falloff type from the default Cubic to Spherical. The Falloff now creates a circle around the texture.

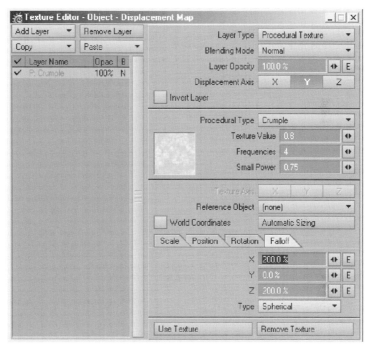

FIGURE 7.12 The Falloff tab in the Texture Editor for the Displacement.

STEP 3: ADJUSTING THE CAMERA

Now that the mountain has taken shape, it is time to adjust the camera. Switch to Camera view and keyframe the camera so that it has a good view of the Sub-Plane object in all of its displacement glory as you can see in Figure 7.13.

Render a frame. Notice how the SubPlane object looks different in the render than it does in Layout, because the rendered version uses more polygons.

STEP 4: COLORING THE MOUNTAIN

Now that the Mountain has been built, it is time to color it in. There are several ways to approach surfacing this object; we will start with something basic.

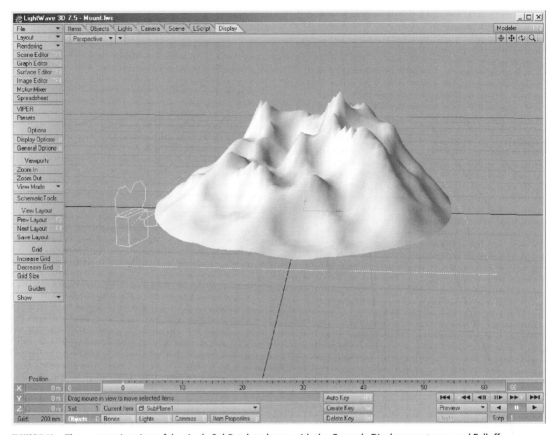

FIGURE 7.13 The perspective view of the single SubPatch polygon with the Crumple Displacement map and Falloff.

Close the Object Properties panel and open the Surface Editor. Click on the T button for the Color channel to open the Color channel Texture Editor. We are going to start with two layers, a Procedural and a Gradient. The Procedural will be the same Crumple texture that was used to displace the SubPlane object, and the Gradient will use that as its input parameter.

In the Texture Editor, change the Texture Type to Procedural, and select the Procedural type as Crumple. Do not make any other changes to the Crumple setting. Except for the falloff, these are the same settings that were used for the Displacement texture.

Click on Add Layer and select Gradient. The Gradient Layer should be on top of the Procedural Crumple texture. The Default Input Parameter should be left at Previous Layer. (If you have not already done so, activate Viper and render a frame so you can observe the results of the settings.)

Click on the Gradient box to add a second key; they should both currently be white. Go to the top key and change the color to dark green. You should see

a smooth transition from the green to the white appear on the surface of the SubPlane object in the Viper window. Add a third key by clicking between the two existing keys, and make that one brown. Move the arrows around and view the results in the Viper window.

The Gradient is being controlled by the same Procedural that is displacing the SubPlane object. The more intense the areas of the Gradient, the more the SubPlane object is displaced and the higher the Gradient. Move the Gradient Keys around by clicking on the pointed arrow part of the key and dragging it up and down. The white key represents snow, the green key foliage, and the brown one in the middle looks like earth. You can add keys and squeeze them together for more realistic shading (see Figure 7.14).

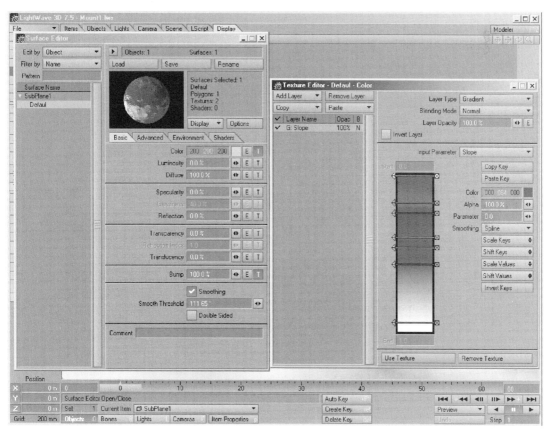

FIGURE 7.14 The Gradient panel as a texture layer from the Mountain surface. You can see how the Bumps and ridges change color using the Slope control on the Gradient textures color swatch.

STEP 5: ADDITIONAL TEXTURING

The Crumple texture was added without alteration to make the point that the same Procedural was being used in two different places to get results that complemented each other. Return to the Crumple texture and try changing both the Small Value and the number of frequencies used. The Crumple texture still follows the basic lines of the original texture, but it allows for some natural looking variation.

The mountain is also too smooth and needs some Bump mapping. Click on the T button for the Bump channel. Select Procedural as Texture type and leave the default texture Turbulence selected. Currently the Turbulence texture is too big to do much good. We know that the SubPlane object is 1m square, so by using the 10 percent rule of Procedurals (scale procedural size to one-tenth of the surface), enter a scale value of 10mm for the X, Y, and Z Scale values. The view in the Viper window in Figure 7.15 shows that this seems to work pretty well.

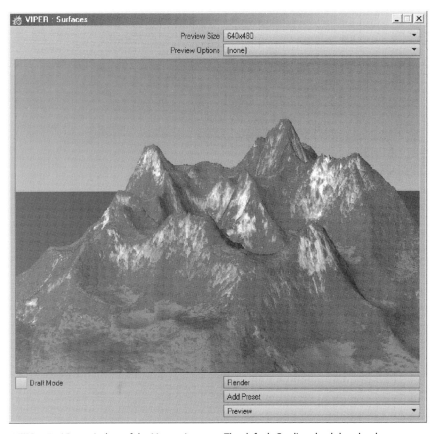

FIGURE 7.15 Viper window of the Mountain scene. The default Gradient backdrop has been activated to give it a skyline.

CONCLUSION

Subdivision Surfaces and SubPatch objects are very powerful tools. They do not necessarily need to be reserved for complicated setups and complex objects. By knowing a few simple rules, anyone can start using Subdivision Surfaces in their modeling and animation rendering.

ANIMATION OF OBJECT DEFORMATION

In This Chapter

- How Bones Work
- Object Morphing

I f all we had to animate with were keyframes, all computer animation would look very mechanical. All the objects would appear to be bolted together and could only move, rotate, and change in size.

Not everything moves like a machine. We need the ability to stretch and bend. We want characters with big rubbery faces, and sails that billow in the wind.

To get this kind of organic shape changing, we need ways to animate the very shape of the objects. We need ways to pull, twist, and stretch the points. In other words, we need to deform the very shape of the objects. LightWave gives us several ways to reform the objects and keyframe their changes.

HOW BONES WORK

The Bone function is one of the most powerful tools in Layout. Bones have very specific ways of operating and rules of operation that must be followed precisely. Once these rules are understood, bones in an animation are quite easy to use.

What Are Bones?

Bones are Layout items that can be added to an object to affect its shape. A bone is like a very strong magnet that pulls the points of an object. There are many controls that can be adjusted on a bone. A bone can be instructed to affect the whole object, a limited range, or just a specified group of points in an object. Bones can be keyframed and parented just like any other Layout item.

Bones are used heavily in character animation, allowing you to manipulate portions of an object, like fingers, feet, and facial features. Bones are also used in industrial and business graphics, for animating logos and text. They are used any time the geometry being animated needs to be bent or twisted.

How Bones Work

Bones only work within objects. Bones can be added once an object is loaded into Layout. After the bones are keyframed into the rest positions and activated, they can be moved, rotated, and scaled. The object the bones are parented to move along with the bones. They act like magnets, pulling the points with it as it moves. The points can be under the influ-

ence of several bones at once. Generally the nearest bones will have the greatest affect on points.

Bones have evolved considerably since their introduction to Light-Wave. LightWave has a large number of settings for precise control over how and where the bones effect the points of an object (see Figure 8.1). The most important thing to remember is to set up the bones properly from the beginning by following the basic bone-usage rules.

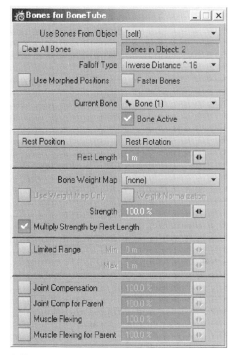

FIGURE 8.1 Bones properties panel.

The Rules of Bone Usage

When using bones in LightWave, follow these three rules:

1. The bones must be keyframed into the rest position before being activated.
2. If the bones need to be resized, they must be adjusted using the Rest Length function, not the Scale or Stretch functions.
3. Once the bones are in the desired rest position and keyframed in place, they must be activated.

A new term here is *rest position*. When a bone is added to an object, it is not yet activated and has no effect at all on the object. You must move

the unactivated bone to the desired part of the object and create a keyframe to keep it there. When that bone becomes activated it initializes the bone and locks all the points into place. That keyframe becomes the rest position of that bone. When the bone is in its rest position, it does not exert any influence over the points under its control. All the points are at rest, not being tugged in any direction by the bone.

When the bone is keyframed into its proper rest position, it is then activated, which can be done in two ways. The most expedient way is to simply press the *r* shortcut key, for Record Rest Position. Or, go to the Objects tab and click the Rec Rest Pos button. Recording the rest position also turns on the magnetic effect of the bone. When the bone is off its outline is a dotted line. When it is active the bone is outlined with solid lines.

TUTORIAL

ADDING BONES TO AN OBJECT

STEP 1: LOADING AN OBJECT

Starting with a cleared scene in Layout, load the BoneText object. Using the Camera view, the BoneText object should appear nicely centered and resting on the ground grid.

STEP 2: LOADING AND POSITIONING A BONE

With the BoneText object selected, click the Add button and select Add>Bones>Add Bone. This will assign an un-activated bone to the BoneText object. The bone first appears at the object's pivot point. Move the bone 1m to the left and keyframe it with these values:

X = –1m
Y = 0
Z = 0

STEP 3: ADDING A SECOND BONE

Once again, click the Add button and select Add>Bones>Add Bone and add a second bone. This time move the bone 1m to the right and keyframe it into the following position:

X = 1m
Y = 0
Z = 0

The BoneText object now has two un-active bones, one on the far left and one on the right. Neither bone is having any effect on the object.

STEP 4: ACTIVATING THE BONES

Select the left bone, which should be named bone(1), and press the *r* key on the keyboard. The outline of the bone changes from a dotted to a solid line. If the active bone is moved now, it will move the entire object because all the points are affected equally by the influence of the bone and no opposing force is present.

Select the second bone, bone(2), and activate it by pressing the *r* key. Now try moving and rotating the bones.

With two active bones the object becomes much more interesting. One bone anchors one end while the other twists and strains. Though not strictly necessary, it is generally good practice to have all your bones in place before you start activating them. Bones can be added to an existing bone setup, but it can sometimes cause unpredictable results.

Bone Active vs. Activating Bones

When a bone is activated using the r *key it automatically locks in the current keyframe as the rest position, as does the Rec Rest Pos button. The Bone Active button is intended to turn a bone on and off after it has been activated. A brand new bone can be activated with the Bone Active button, but it will have a 0 value for all position and rotation coordinates and not the values of the keyframed rest position.*

T U T O R I A L

USING A SINGLE BONE

There are many ways to use bones and many settings to control them. The following tutorial demonstrates the use of a limited region of bones.

STEP 1: LOADING THE BONETEXT OBJECT

As with the previous tutorial, load the BoneText object into a cleared scene. Leave it centered on the screen in the Camera view.

STEP 2: ADDING A BONE TO THE TEXT OBJECT

Click the Add button and select Add>Bones>Add Bone. This time, leave the bone in the original position. Activate the bone by pressing the *r* key. When

the bone is moved, the entire object moves with it, because the bone is acting with equal strength on every point of the object and has no other force to oppose it.

STEP 3: ADJUSTING THE LIMITED REGION FOR THE BONE

With the bone selected, click the Item Properties button to bring up the Bone properties menu. Toward the bottom of the Bones properties panel are the settings for Limited Range. Activate Limited Range by clicking on the box so that a checkmark appears.

Once Limited Range is activated, two dotted ovals will appear around the bone indicating the maximum range of the bone's influence. The maximum range determines the point at which the bone influence drops off completely. The Minimum setting is the point were the bone strength is at full power. The default setting for the minimum range is 0, meaning that the influence of the bone starts dropping immediately as it moves away from the center, which is good if you want things to bend in a gentle curve. Sometimes you want portions of an object bent by a bone to appear more solid and bend only at the edge of the bone influence. In this case, you would increase the minimum range so that strength falloff is bunched up at the end.

Joint Compensation and Muscle Flexing

Bones are an indispensable component in character animation. Several tools have been added to the Bone properties panel to make bones even more useful, but they must be applied properly to work.

When a bone is used to bend a limb of a character, it often carries the undesirable effect of the joint flattening out like a hose being crimped. This problem is due to the points being stretched around an angle (see Figure 8.2).

To help combat this effect, the Bones properties panel has a setting for Joint Compensation. Joint Compensation causes the limb to swell out at the rotation point of the bone, offsetting the crimping effect.

TUTORIAL

BENDING A TUBE

This tutorial covers the correct way to set up a bone chain to use Joint Compression.

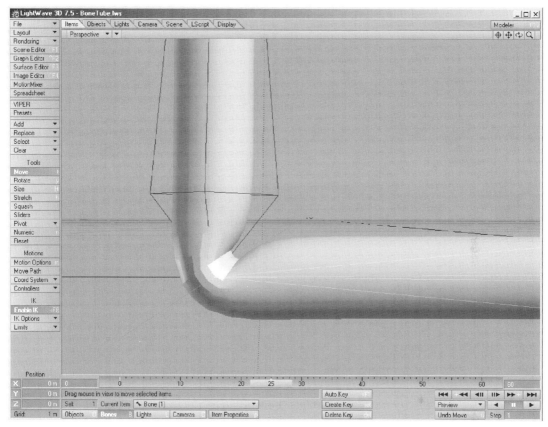

FIGURE 8.2 Crimped geometry.

STEP 1: LOADING THE BONETUBE OBJECT

ON THE CD

Load the BoneTube object from the Bones folder in the Objects directory on the companion CD-ROM. This is a 2m tube with lots of segments that allow it to bend. Select the Perspective view to allow you to easily zoom around the object.

STEP 2: ADDING PARENT AND CHILD BONES

With the BoneTube object selected, click the Add button and select Add>Bones>Add Bone. This first bone should appear at the base of the tube and reach halfway down it.

Add a child bone to the first bone by clicking the Add button and selecting Add>Bones>Add Child Bone. This will automatically place a second bone at the tip of the first bone and parent it. Activate both the parent and the child bones by selecting them and pressing the *r* key.

Create a keyframe for the child bone with these values:

Frame 30
Rotation P = −90 degrees

This gives the BoneTube object a typical arm-pumping action. Notice the crimping effect that rotating the child bone has on the object.

STEP 3: ACTIVATING JOINT COMPRESSION

Select the child bone and open the Items Properties panel. Click on Joint Compensation to activate it. Manipulate the Layout view and the Bone properties panel so that you can see the bent BoneTube object as you activate the Joint Compression function (Figure 8.3).

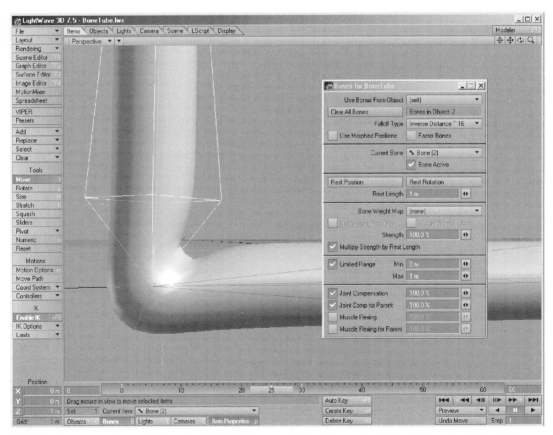

FIGURE 8.3 Bone properties panel shows that the Joint Compensation has been activated for the bones in the bent tube.

As you click Joint Compensation on and off, you can see its effect on the geometry of the bent tube. With Joint Compensation on, the crease of the bent tube becomes a bit less crimped and more filled out. To increase the compensation effect, set the level of joint compensation to greater than 100%. Levels of 200% or 300% are still within the useful range.

STEP 4: ACTIVATING JOINT COMPENSATION FOR THE PARENT

As the name implies, Joint Compensation for the parent helps minimize the crimping effect of the bone rotation of the child for the points that are influenced by the parent bone. The best way to understand this is to view the effect in action. Advance to frame 30, where the child bone is bending the BoneTube object and watch what happens when Joint Compensation is toggled on and off.

STEP 5: USING MUSCLE FLEXING

The Muscle Flexing option works much like Joint Compensation, but rather than bulging the object at the rotation point of the bone, the object bulges it toward the middle of the bone. This is very useful for animating the bending of limbs on a character and having them "make a muscle" as their arms flex.

Important! Joint Compensation and Muscle Flexing only work on the P (Pitch) axis. Rotation of the bone on the H or B axes will not activate Joint Compensation or Muscle Flexing.

OBJECT MORPHING

A 3D object is made up of polygons strung together by points. The positions of these points and polygons give the object its form. LightWave objects have the ability to form more than one shape. A mathematical description of an object is a "map" of the X-Y-Z coordinates of every point in the object. An object can be instructed to look at an alternative "map" of the points' positions in the object and form a completely different shape. The act of taking a point from its original position and directing it to another location within the object is known as *object morphing*. Object morphing is different from the 2D image morphing effect in that it actually alters the shape of the objects in three-dimensional space.

Uses of Morphing

Morphing has many uses that may not be immediately apparent. The most obvious use is for character and facial animation. Once a basic face has been built, variations can be created for different expressions and mouth shapes. Muscles can bulge and cheeks can puff. By varying the morph over time the face can smoothly transition from one extreme to another.

Morphing has uses beyond character animation. Morphing can give you very precise control over an object's shape, and allow you to easily keyframe its transformation independent of the Move, Rotate, or Scale channels in Layout. Morphing is an excellent way to introduce complex secondary animation to a scene. The animation can be something as complex as an interlocking mechanism inside a machine, or something as simple as individual letters that squash and stretch in a logo.

Traditional Morphing vs. Endomorphs

There are two ways to perform an object morph in LightWave. The traditional way requires two objects, a source and a target. The source object is selected, and in the Object Properties panel under the Deformations tab, a morph target and morph level is chosen (Figure 8.4).

FIGURE 8.4 Object Properties panel for morphs.

There are some very strict rules governing this type of object morphing. The source object and the target object are required to have the exact same number of points. The order of the points are also very important. The object morph matches up the points, moving the point on the source object to the position the match point holds on the target object.

For example, you could start with a sphere, which may represent a baseball, and use that object as the source object. The sphere object is then reshaped to resemble a football, then saved under a different name to be used as a target object. Both objects are loaded into Layout. The baseball-shaped source object is positioned in front of the camera. The football-shaped target object is typically moved out of view of the camera. In the Object Properties panel Source and Target is selected, and usually an envelope is used to create the morph transition over time.

You can also set up a chain of morph targets. The target object for the source object can have its own target object. To the previous example of the baseball source object and the football target object, a third variation of the same geometry could be created to look like a hockey puck. To see a transition of all three states of the original geometry, the baseball source object would need a morph envelope with a target of the football. After the baseball transforms into a football, the football uses the hockey puck as its target and conforms to the hockey puck shape. Because the original source copies the shape of the football target, when the football changes shape, so does the original source.

ON THE CD

T U T O R I A L

SETTING UP A TRADITIONAL MORPH

STEP 1: LOADING THE OBJECTS

Starting with a cleared scene in Layout, load these three objects from the Objects>Morph directory of the CD-ROM.

Source.lwo
Target1.lwo
Target2.lwo

The source object is a white sphere, Target1 is a football-shaped object, and Target2 looks like a hockey puck. Keyframe the target objects so they are off to the side of the Camera view (Figure 8.5).

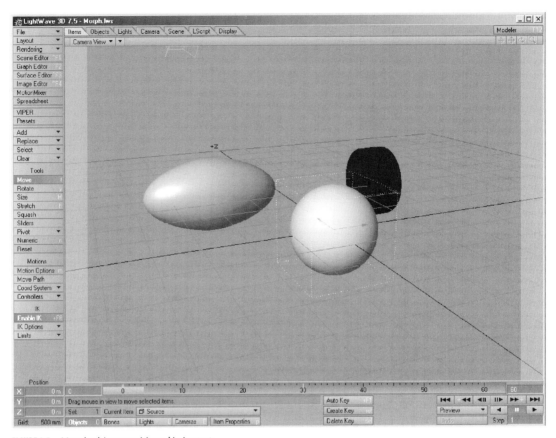

FIGURE 8.5 Morph objects positioned in Layout.

STEP 2: ASSIGNING SOURCES AND TARGETS

With the source object selected, open the Object Properties panel. Go to the Deformations tab and click on the box for Morph Target and select Target1.

Above the Morph Target selection is the Morph Amount box. Click on the scrub arrows for Morph Amount and watch how the sphere-shaped source object in Layout transforms into the football shape of the target object. Click on the E button for Morph Amount and create an envelope with two keyframes and the following values:

Keyframe 1
 Frame = 0
 Value = 0%
Keyframe2
 Frame = 30
 Value = 100%

Previewing the animation in Layout should show the sphere transforming into the football over 30 frames.

STEP 3: ADDING A SECONDARY MORPH

The next step is to make Target1, the football, conform to the shape of Target2, the hockey puck.

Select the football object, Target1, and go to the Deformation tab of the Object Properties panel. Select the Target2 object as the Morph Target. Click on the E button and create an envelope for the morph with two keyframes and these values:

Keyframe 1
 Frame = 30
 Value = 0%
Keyframe2
 Frame = 60
 Value = 100%

Previewing the animation in Layout should show the sphere-shaped source object transforming into the football shape of Target1 in the first 30 frames. From frame 30 to frame 60, both the source object and the Target1 object both transform into the hockey puck shape of Target2.

STEP 4: MORPHING SURFACES

The surface of the source object is white and Target1 is brown. With the source object currently selected, activate Morph Surfaces in the Deformation tab of the Object Properties panel. The change of the surface texture will only appear in a rendered frame. It will not show up in the OpenGL display.

 If Morph Surfaces is selected for the secondary morph, Target1 to Target2, it will only affect the surface of Target2. Even though the source object is conforming to the hockey puck shape, it does not adopt its texture.

It should be quite obvious that setting up multiple targets using traditional morphing can become quite a complicated mess quite quickly. There is also the problem of keeping all the points in order. With traditional morphing once the primary source object is saved, no points can be added or deleted without the danger of rearranging the way the points are aligned in an object. A copy-and-paste function performed on a target object may cause point 6 at the tip of the nose in the source object to

change to point 27. The points do not know any better; they simply get their name and assignments and go where they are told.

Endomorphs are a new aspect of the LightWave object format that address nearly all the limitations associated with object morphing. Rather than having a separate source object and target object, there is just a single object. The object has its "base" shape, but also can have several variations of the shape. These imbedded morph targets are called *endomorphs* and are referred to as Morph Maps. An endomorph is simply an alternate set of locations to where each point in the object is expected to go. By storing alternate location data for each of the points in an object, endomorphs eliminate the need for multiple objects to reference the morph.

Endomorphs are created for an object as a Morph Map in Modeler. Once the object is saved and loaded into Layout, the plug-in Morph Mixer is added to the Deformations tab of the Object Properties panel. The Morph Mixer provides a set of sliders that allow you to mix various amounts of each of the Morph Maps to the base object. The results of moving the sliders can be viewed in the OpenGL display. Moving the sliders of the Morph Mix automatically creates a keyframe for that slider on the current frame. The sequence and actions of the Morph Mix can be adjusted by advancing the scrub bar and moving the sliders, or can be adjusted directly in the Graph Editor.

Endomorphs are considerably more convenient and flexible than the traditional source/target type morphing, although endomorphs have one limitation. With two-object source/target morphing you have an option to morph surfaces. With Morph Surfaces activated, as the object morphs and takes on the shape of the target object it will also adopt the target's surface attributes. The term Morph Surfaces is a bit misleading; what actually happens is that the surface texture of the source object will do a cross fade to the surface texture of the target. Unfortunately, there is no interpretation between the two surfaces, just a fade from one to the other. Morph Surfaces are also limited to one level of morph. It is possible to morph the baseball to a football in both texture and geometry, but if the football is morphed to a third target, the surface texture of the third object will not be transferred back to the original baseball source object.

The Morphing Process

The most important thing to understand about object morphing is that the points of the transforming object always move in a straight line. Each point has its start point and moves to its destination in a straight line, which is not always a good thing.

Imagine an open hand morphing into a fist. You would want the fingertips to move in arc to fold into the hand. With a morph, the tips and knuckles of the fingers will move in a straight line, collapsing into the hand and passing through it in a very unnatural fashion.

When LightWave looks at a morph, it compares the source/base object with the target/endomorph and calculates the difference between the point locations. When a morph is at 100 percent, the source is exactly the same shape as the target. When the morph is at 50 percent, it is half its original shape and half the target shape. What is interesting is that because LightWave is interpolating the difference of the points' locations, a morph can have a value of greater than 100 percent or even a negative value. Morph values of greater than 100 percent will exaggerate the difference between source and target, and negative values move the points in opposite directions to the target object.

A big advantage of endomorphs is that endomorphs are much more friendly to adding points and polygons to an object even after morphs have been created. This advantage occurs because you are always dealing with a single object. Polygons of the base object can be beveled and subdivided, and LightWave will do its best to appropriately apply the new geometry to the Morph Maps.

Morphing can also take advantage of Subdivision Surfaces. Both types of morphing treat Subdivision Surfaces the same way. The Subdivision Order function provides an option as to whether the subdivided polygon mesh gets frozen before or after the morph deformation. In most cases, you want the object to be deformed by the morph first, then subdivided for rendering. If the subdivision takes place first, the morphing deformation may overextend the polygons. If you see polygons appear to tear in a morphed object, that phenomenon occurs because the polygon was subdivided in the morphing.

Working with Endomorphs

ON THE CD

Endomorphs are created in Modeler. To examine an endomorph object in Modeler, load Objects>Morph>Sample.lwo from the companion CD-ROM.

The Sample object at first appears to be just a sphere. Indeed, that is how this object began. Click on the M button at the bottom right of the Modeler screen to tell Modeler we will be working with the Morph Maps.

Just to the right of the M button is the name for the currently selected map. What you see first is the (base) designation. This indicates that the normal shape of the object, its resting state, is currently selected. The (base) shape is the reference shape for all the other Morph Maps.

Click on the Morph Map listing (base) and scroll down to the next listing, which should be Cube. This is a Morph Map of the original sphere object. All the points are the same; They have just been rearranged into a cube shape (see Figure 8.6).

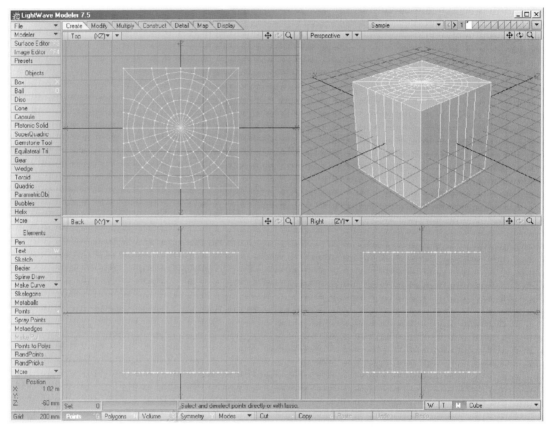

FIGURE 8.6 The Cube layer of one of the Morph Maps that are inside the sample ball-shaped object. The overhead view of the cube shape shows evidence of its spherical origin.

It is important to understand that the cube is not a separate object. It is still the original spherical object with its points repositioned. The base object is still there in its original shape. Scroll down to see the other Morph Map, the one labeled Plug. This is the original sphere shaped into a cylinder.

This is an Endomorph. The base object has two Morph Maps, Cube and Plug, two alternative sets of positions for each point in the sample object.

TUTORIAL

ON THE CD

SETTING UP AN ENDOMORPH

STEP 1: LOADING THE OBJECT

Starting with a cleared scene in Layout, load the Balls.lwo object from the Objects>Morph directory of the CD-ROM. The object will be fine when left in its original loaded position in the center of the screen.

STEP 2: APPLYING MORPH MIXER

With the Balls object selected, open the Object Properties panel and go to the Deformations tab. Click on the Add Displacement bar and scroll down to select the Morph Mixer plug-in, which should be labeled "Mixing 2 Morphs in 1 Group". The two Morph Maps in the Balls object are Football and Puck.

Double-click on the Morph Mixer plug-in listing to bring up the Endomorph Mixer with the slider controls. Click and drag on the sliders to mix various amounts of the Morph Map into the base object. Changes to the base object can be observed in real time in the Layout OpenGL display.

Once the Endomorph panel is open with the sliders, you can close the Item Properties panel. The slider panel will remain, making it easier to view the morph while moving the sliders.

STEP 3: ANIMATING THE MORPH

The sliders in the Endomorph Mixer panel can be animated in two ways. When a slider is moved, it automatically creates a keyframe on the current frame. Advance the scrub bar to frame 30 and move the scrub bar; a keyframe will automatically be created at frame 30 for that slider at whatever value it was left. This is indicated by the key symbol that appears in the little box between the two arrows at the right of the slider. (Clicking on the arrows will take you to the next and previous keyframe of that slider.)

The alternative way of animating the morphs is by using the Graph Editor. Clicking on the Graph Editor button brings up a Graph Editor with the Morph Maps of the endomorph object appearing as channels.

The Graph Editor gives you direct and independent control over each of the Morph Maps in the endomorph object. The sliders give you convenient and intuitive control over the mix of the morph. There is no reason why you cannot use both methods when setting up a morph of an object.

Outrageous Morph Values

It is sometimes useful to have morph values that are greater than 100 percent or with a negative value, but the sliders on the Endomorph Mixer only go from 0 to 100. To get values outside that range, type in the value manually and press Return. The number you keyed in will become the keyframed value.

The previous tutorial uses the Balls.lwo object as an endomorph to transform the sphere into both a football shape and a hockey puck. The geometry of the endomorph is identical to the source and target morph used earlier. The advantage of using an endomorph and Morph Maps in this case is that it is a much simpler setup and easier to animate. The disadvantage is that the endomorphs cannot even morph one level of surface texture. A workaround would be to create envelopes for the textures, possibly using channel followers, to make the surface attributes change values as the morphs take place.

Endomorphs and Facial Animation

Endomorphs are very well suited for character animation, especially for facial expressions. Endomorphs also allow you to create groups of sliders that control certain parts of the entire object. When creating Morph Maps for a head, for example, it is common to create separate banks of sliders for the eyes and lips, and even the nose and cheeks.

The way that separate banks of sliders are created for an endomorph is rather crude. When naming a new morph, the name is separated by a period. The first part of the Morph Map name becomes the *group name*; the period indicates it will be put in a *bank*. For example, if the Morph Map is named mouth.closed and the next Morph Map is named mouth.open, both those Morph Maps will be grouped when they show up in the Morph Mixer in Layout.

TUTORIAL

CREATING GROUPS OF ENDOMORPHS

In this tutorial we will add groups of endomorphs to a Head object.

STEP 1: LOADING THE HEAD OBJECT INTO MODELER

ON THE CD

The Morph Maps of the endomorph are created in Modeler. From the CD-ROM, load the file MorfFace.lwo from the Objects>Morph directory. This is a generic Head object created with Subdivision Surfaces activated to make it smooth.

STEP 2: CREATING A MOUTH GROUP

Now we will create a Morph Map group. Click on the M button at the bottom right of the screen to select the Morph Maps. Click on the word (base) and scroll down to select (new). When the name requester pops up, enter Mouth.closed for the morph map (see Figure 8.7).

 It is very important that you have the group name, a period, then the name.

FIGURE 8.7 Morph Map name.

STEP 3: MODIFYING THE MORPH MAP

The current Morph Map is now Mouth.closed and is an exact duplicate of the base object. (Do not leave the Morph Map layer without performing some action on the Morph Map; if you do not change the Morph Map in some way before leaving the layer it will disappear.)

Because we have prefixed this morph group with the word *Mouth*, that is the area we should work on. The polygons of the face should be manipulated so that the mouth is closed. There are several ways to do this, as follows.

Under the Modify tab, select the Drag tool, and turn on the Symmetry function. The drag tool allows you to grab and move points around one at a time without selecting them first.

The Symmetry function mirrors on the left of the screen any action done on the right side of the screen, forcing the expression to be symmetrical.

 To prevent accidentally moving points on the back of the head while working on the mouth, lasso the points around the mouth area so then only the selected points will be grabbed by the drag tool.

STEP 4: ADDING ADDITIONAL MORPHS TO THE GROUP

Now we will create a second Morph Map for the Mouth group. This time we will use the New Endomorph interface button found at the bottom left of the Map tab. Click the New Endomorph button to generate a new Morph Map. When the Create Endomorph requester comes up, give it the name Mouth.open.

Once again, using the Symmetry and the Drag tool, modify the face so that the mouth is closed.

STEP 5: ADDING AN EYELID MORPH GROUP

The next step is to add a group of morphs for the eyelids. Create a new endomorph and name it Lid.closed.

On this Morph Map, grab the polygons around the eye and move them closer together so it appears that the eye is closing. The Drag tool works well for this, or you could simply select the top and bottom polygon by the eyes and use the Stretch tool to shrink them together.

Add a second morph to the Lid group and name this one Lid.up. For this morph, grab the polygons around the eye near the nose and move them up so that the face takes on a surprised expression.

STEP 6: MOVING THE EYES

In this particular head model, the eyes are built into the geometry. Though this makes for a simpler setup, it limits the amount of animation the eyes can have. We need to set up a separate morph group just for the eyes.

Name the elements in the Eye morph group as follows:

Eye.right
Eye.left
Eye.down
Eye.up

The names for the Morph Maps are pretty self-explanatory. The easiest way to modify the model is as follows.

Turn off the Symmetry. Mouth shapes are often symmetrical, such as in a smile, but eye movements are usually parallel. If Symmetry is active it will make the eyes move in opposite directions.

Select just the center polygon of the eye; that polygon is named EyePupil. Move it to the position that corresponds to its name on the Morph Map.

We should now have three groups of Morph Maps in the MorfFace object under a new name of your choosing. Proceed to Layout.

STEP 7: ANIMATING THE FACE IN LAYOUT

Load the newly remodeled MorfFace into Layout. With the face object selected, open the Object Properties panel. Under the Deform tab, click Add Displacement and select the Morph Mixer plug-in. Once it is selected it should show "Mixing 10 MORFs in 3 Groups".

Double-click on the Morph Mixer listing to bring up the slider panel (see Figure 8.8).

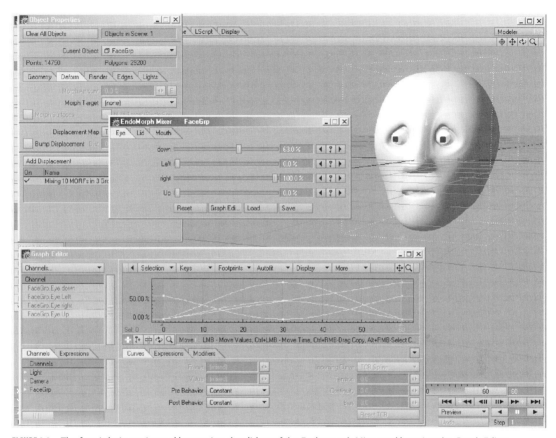

FIGURE 8.8 The face is being animated by moving the sliders of the Endomorph Mixer and by using the Graph Editor.

See how we now have three tabs of sliders? The tabs are separated purely for housekeeping purposes. A complex character can have several dozen Morph Maps, so grouping them into categories is a good idea.

CONCLUSION

As you can see, there is a multitude of ways to deform objects in Layout. The methods applied depend on the desired results. The mixing of

endomorphs is an art in itself, and the art of boning a character may well take a lifetime to master.

Both Bone deformation and the new Endomorph technologies are constantly being improved and updated to make them both more powerful and easier to use. Just when you think you have it all figured out, a new function will be released that opens a whole new world of possibilities.

COMPOSITING

In This Chapter

- Introduction to Compositing
- Front Projection Mapping
- Advance Compositing Techniques

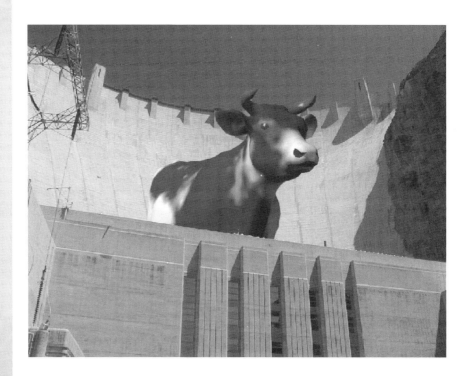

▌n this chapter we cover the ways to combine 3D elements into pre-existing imagery.

INTRODUCTION TO COMPOSITING

Compositing is the art of combining several graphic elements together in a single image. It is important to achieve the correct balance and tone in all the elements so that they blend well into a single image.

LightWave has the power to create elements that fit into pre-existing imagery, or to render animations in separate layers so that each element can be processed independently. Having different elements of the animation as separate layers allows you to make changes in post-production. *Post-production* refers to changes made after the initial renderings. Adjusting the image brightness and contrast, color correction, and adding glows and blurs are typically done in post-production. Post-production manipulation of frame sequences are usually done in an editing or special effects program. The paint and animation program Aura, from Newtek, combines separate layers very well.

The Alpha Channel

The heart of all compositing is the *Alpha channel*. The Alpha channel is a grayscale image usually imbedded in the color image that acts as a transparency map, although an Alpha channel can also be imported from a separate file. This black and white image acts as a cookie cutter for the element in the frame.

Many image formats support the imbedded Alpha channel, which are referred to as Red, Green, Blue, and Alpha (RGBA) or as 32-bit files. The files are 32 bits because the standard measure for full color is 8 bits per color channel. Adding those (8 + 8 + 8 = 24), and then adding another 8 bits for the transparency channel (24 bits of RGB + 8 bits Alpha) gives you 32 bits. (Recent developments are pushing toward more of the 8 bits of color space per channel.) In the examples in Figures 9.1, 9.2, and 9.3, an apple is rendered as a 32-bit image.

In the first image, nothing is in the background, and it appears a solid black in the LightWave Image Viewer. The second image shows only the Alpha channel. (The Image View has a nice selector in the upper-right corner that allows you to view either the RGB image or the Alpha.) The white area, the outline of the rendered apple, is the section of the image that will be kept. The third image is the rendered apple over a

FIGURE 9.1 Screenshot of Layout.

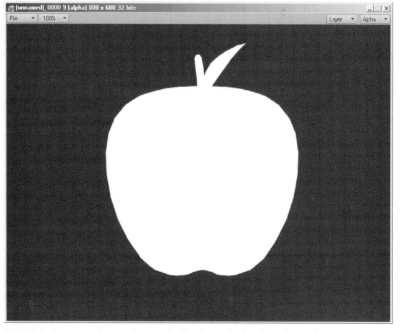

FIGURE 9.2 The same image of an apple showing only the Alpha channel.

FIGURE 9.3 Image of the apple composited on a background.

background. The image was not re-rendered; it was taken into Aura and placed over another image (see Figure 9.4).

The image in Figure 9.4 shows how the rendered image can be manipulated in post-production. The apple element was rendered only once. The file was saved in a 32-bit format, then manipulated in post-production. Sometimes it is more efficient to do things with 2D manipulation than to try to render everything in 3D.

The Compositing Panel

In LightWave, we have some rudimentary Compositing tools. Click the Compositing button under the Scene tab. The Compositing panel is one of the submenus in the Effects panel (see Figure 9.5).

FIGURE 9.4 The various processed apples over a background.

FIGURE 9.5 The Compositing panel.

The properties of the Compositing panel has remained virtually untouched since the early days of LightWave. Notice that although you have the option of loading an image file directly, the Compositing panel has no Edit Image button, which all the other components of LightWave that use images have. To edit the images that appear in the Compositing panel, it is necessary to click the Image Editor button to bring up the Image Editor menu. All but the most basic compositing will require an external program with more sophisticated compositing features.

The Compositing panel serves mostly to sandwich the rendered elements in the scene between two pre-existing images.

The Background Image

The first section of the Compositing tab of the Effects panel is the Background Image. This section of the Compositing tab gets the most use. Any image that is loaded in as a Background Image will appear behind any objects that get rendered in the scene.

Be aware that the Background Image is not really in the scene. It is composited in after the entire rendering is complete. The Background Image is not affected by any lighting, shadows, or camera moves. The Background Image by itself will not respect the reflective or refractive properties of surfaces, although it can be made to appear so by using the same image as reflective and refractive spherical maps.

Foreground Images and Alpha Channels

In the Compositing tab, the background layer places the Background Image behind all the rendered elements in the scene. The Foreground Image places the image in front of all the elements in the scene. Anything in the scene, even Lens Flares, will be covered by the Foreground Image.

The Foreground Image requires an Alpha channel. Unfortunately, the foreground layer that requires an Alpha channel, to be of any use at all, does not have the capacity to use the Alpha channel imbedded in a 32-bit image. Without an Alpha channel, even a 32-bit image file will completely fill the screen with the Foreground Image so that none of the rendered elements or the Background Image can be seen.

An appropriate Alpha channel image may be extracted from a 32-bit image file by using the Image Editor panel. The original 32-bit image is duplicated, and the clone has the Alpha channel set to Alpha Only. This leaves us with a black and white image that can be loaded into the Foreground Alpha section of the Compositing tab.

Image Issues

When an image file is loaded as either a foreground or background layer, the image is stretched to fill the screen. If the original image is larger than the current camera settings, the image will be shrunk to the correct proportions. If the background image is smaller than the resolution set for the current camera, the image will be enlarged to fit the screen. If the image is much smaller than the intended rendered output, magnifying the layer may result in the image looking pixilated.

Single images and image sequences used in compositing are the same as elsewhere in LightWave. A sequence of images is treated as a single item, whether it is a numbered sequence or an animation file.

TUTORIAL

BUILDING A THREE-LAYER COMPOSITE

Here we will load an object and render it layered between a foreground and a background image.

STEP 1: LOADING THE BACKGROUND IMAGE

ON THE CD

This tutorial will make use of several prepared images on the book's accompanying CD-ROM. Go to the Scene tab and click on the Compositing button to bring up the Compositing menu. Click Background Image and choose Load Image. From the Images folder on the CD-ROM, load the BigDam.jpg image. This is a digital still of the Hoover Dam.

STEP 2: LOADING THE COW OBJECT

The background image needs to have something in front of it, and the Cow object will work nicely. From the Objects directory in LightWave, load the Cow object. Rotate it and keyframe it so that it faces the camera at an angle.

Render a single frame. The effect we now have looks exactly like a rendering of a cow over a picture of a dam.

STEP 3: ADJUSTING THE BACKGROUND DISPLAY

It is often very handy to be able to see the background image when setting up the scene. The Display options contains a setting for Camera View Background. Select the Camera View Background as Background. Whatever image is selected as the Background Image in the Compositing panel will now appear as a

background image in Layout. The image in Layout may not be at full resolution, but that is much better than not being there at all. Note that the Camera view in Layout looks very much like the rendered image (see Figure 9.6).

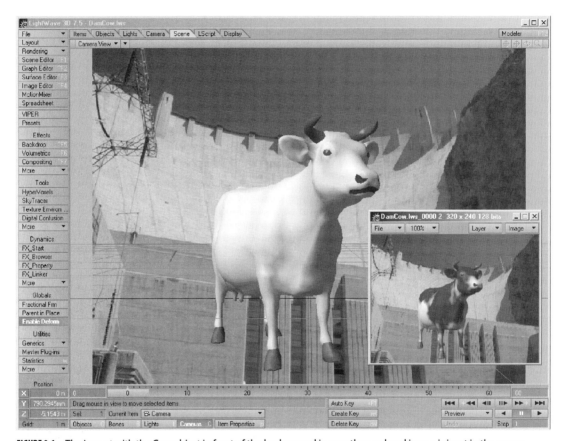

FIGURE 9.6 The Layout with the Cow object in front of the background image; the rendered image is inset in the corner.

STEP 4: LOADING THE FOREGROUND IMAGE

The foreground image will be a second image of the Hoover Dam, but the foreground image has had the portion of the image that appears above the front of the wall cut out. Click the Image Editor button to open the Image Editor panel. In the Image Editor panel, click Load and load the DamFront.tga image from the CD-ROM.

ON THE CD

If this image is loaded directly as a foreground image, the empty space in the image will fill the screen with black. We need to extract the Alpha channel from the image so we can use it as a foreground Alpha mask.

In the Image Editor, select the listing for the DamFront.tga image, click the Clone button and select Instance. There should now be two listings for the same image, DamFront.tga and DamFront.tga{1}.

Select the second listing, DamFront.tga{1}. In the Options for Alpha Channel select Alpha Only. The thumbnail preview of the image should now appear in black and white.

STEP 5: ASSIGNING THE IMAGES TO THE FOREGROUND

Open the Compositing tab and load the foreground images. The Foreground Image should be the unaltered DamFront.tga image. The Foreground Alpha should be the cloned DamFront.tga{1}image that appears in black and white. The white areas of the Alpha image will retain the original foreground image, and the black areas of the foreground image will filter out the rest.

Render the image. The Cow object should now appear stuck inside the walls of the Hoover Dam. You can use the background image in Layout to adjust the Cow object to the most effective angle (see Figure 9.7).

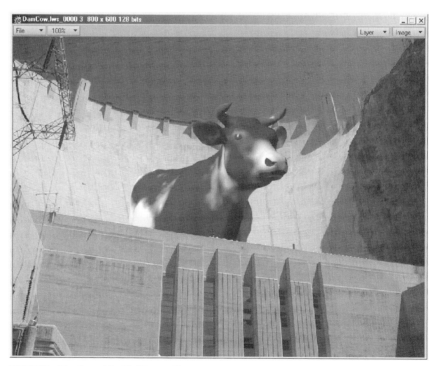

FIGURE 9.7 The Cow object in Hoover Dam.

The tutorial demonstrated the crudest form of compositing, sandwiching elements together with very little finesse. A successful composite requires a careful balancing of light, color, and image quality. While this composite technically has all the basics, a rendered element between a background and a foreground, a lot more is needed to marry all the elements successfully.

FRONT PROJECTION MAPPING

Ideally, the separate elements in a composite should appear to interact somehow. Having elements of different layers appear to cast shadows or reflections gives the eye visual cues that all the elements belong in the same space. To get this kind of interaction requires using objects to stand in for things that appear in the background plate.

Front Projection Mapping as an Image Texture

Objects used as stand-ins are roughly similar in shape and position to the background elements that they mimic. The most common use of stand-ins is to have a background image of a real location, and a stand-in object used as a "shadow catcher." Because the stand-in object has a shape similar to that in the background, the shadows cast from the other objects in the scene will look like they are falling on objects that exist in the background plate.

For these stand-in objects to act as shadow catchers in the LightWave scene, they need to be mapped with the same image that is in the background plate. To facilitate this, LightWave provides a method of mapping known as Front Projection. Front Projection mapping locks the image that is being mapped onto a polygon surface as if it were in the background plate. A Front Projection map is always perfectly aligned with the background image. Even if the object with the Front Projection surface is moving around in the scene, the image is still locked in place. Nothing done to the object will affect the position or scale of the Front Projection map.

TUTORIAL

USING FRONT PROJECTION MAPPING TO PUT A UFO IN THE DESERT

Not all shadow-catching geometry needs to be complex. This next tutorial uses a simple square plane.

STEP 1: CREATING A BACKGROUND PLATE

The background plate is nothing more than a 1m square polygon. Create it any way you wish. Save the object as Bgplate and load it into Modeler.

STEP 2: PREPARING LAYOUT

Next we will load the image into Layout. Go to the Scene tab and click the Compositing button to bring up the Compositing panel. Click on the Background Image selector and choose Load Image. From the Images file on the companion CD-ROM, load the Valley.jpg image.

ON THE CD

If you have not already done so, make the background image visible in Layout. Open the Display Options panel and select Background Image as the Camera View Background. The Layout should now display the background image in the camera view with the 1m polygon partially blocking our view.

STEP 3: SURFACING THE BGPLATE OBJECT

The BGplate object needs to have the Front Projection surface applied to it. Click on the Surface Editor button to open the Surface Editor panel. The BGplate surface should be active because it is currently the only surface in the scene. Click on the T button for the Color channel to open the Texture Editor.

In the Texture Editor, give the BGplate surface the following values:

Layer Type	Image Map
Blending Mode	Normal
Projection	Front
Image	Valley.jpg
Pixel Blending	Off
Texture Antialiasing	Off

Once the Valley.jpg image has been place on the BGplate object surface as a Front Projection map, you may see the image on the BGplate object in Layout. (This depends on the Display Options settings and the display capabilities of the system you are using.) Pixel Blending and Texture Antialiasing should be turned off because they alter the look of the original image. We need the image to match the background.

STEP 4: POSITIONING THE BGPLATE OBJECT

The BGplate object is to stand in for the ground plane object. The BGplate object needs to be rotated and positioned so that it approximates the floor of the valley as it appears in the background image. The best way to do this is to ro-

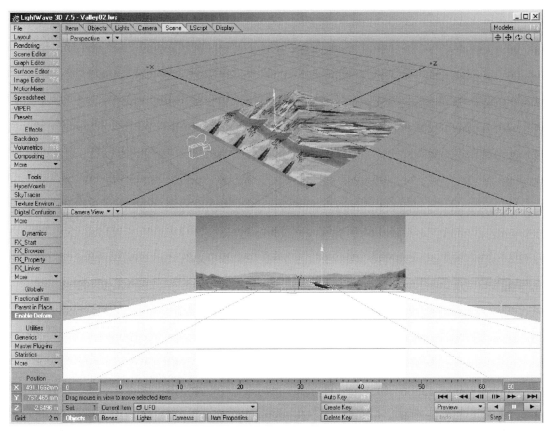

FIGURE 9.8 The LightWave ground plane positioned so that the BGplate object is aligned.

tate the BGplate object back 90 degrees so that the BGplate object is resting on the Layout grid's ground plane. Then position and angle the camera so that the LightWave grid's ground plane aligns with the ground plane of the background image (see Figure 9.8).

Once the object and the camera have been aligned, you will need to increase the size of the BGplate object. With the BGplate object selected, click the Size button and increase the size of the BGplate object about 10 times. The resizing of the object is not technically necessary, but will serve to keep things in comparable scale.

STEP 5: LOADING A UFO

We will add the UFO object to the scene. From the Comp directory of the Objects directory, load the UFO object. Keyframe the UFO object in about the center of the scene, above the BGplate object.

STEP 6: ADJUSTING THE LIGHT

The scene has just one default light. This is fine for the nature of the background image, illumination from the sun and bounced ambient light. We just need to attempt to match the angle of the default Distant light with the angle in which the sunlight appears in the image.

Judging from the shadows that appear in the background picture of the valley, the sunlight seems to be coming almost straight down, tilting just slightly to the left. Start keyframing the light so it points straight down.

Activate the Ray Trace Shadows option and do a test render. The shadow of the UFO should fall somewhere on the BGplate object plane. If the shadow is not visible, check the position of the UFO, BGplate, and the angle of the light. Switching to Perspective view is sometimes helpful in visualizing how the rays will fall in the scene (see Figure 9.9).

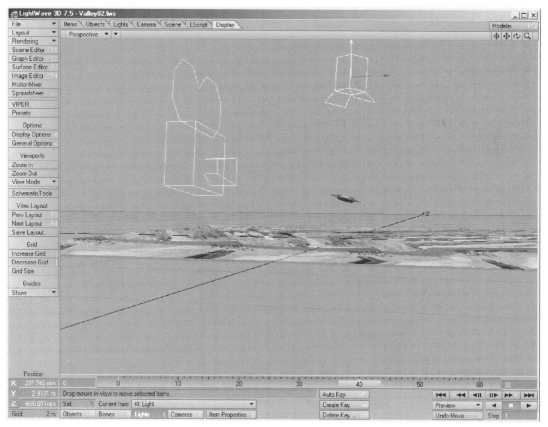

FIGURE 9.9 A scene in Perspective view.

It is also helpful sometimes to use the Light View option in one of the Layout viewports. Keep in mind that using Light View for a Distant light can sometimes be misleading because it refers to the position of the light, and position is inconsequential to the effects of a Distant light (see Figure 9.10).

FIGURE 9.10 The rendered scene showing the UFO casting a shadow on the valley floor.

This is a very simple shadow-catching type of composite. A single plane with a Front Projection map is used to catch the shadow of the rendered object. You will notice that while the shadow works well when it falls on the flat areas like the road, it looks very odd when the shadow remains perfectly flat when it falls on the trees and houses. To fix that requires more detail on the shadow-catching object.

The shadow of the UFO also looks different than those cast by the real objects in the picture. The real shadows are actually darker and harsher than the ones rendered by LightWave. There is also a curious edge where the BGplate object ends and the background image picks up. These are all issues that need to be addressed through adjusting the lighting and the surface textures in the scene.

Balancing Front Projection Mapping with the Background Image

When an image is applied to a surface using Front Projection mapping, it is addressing only one channel of all the attributes of the surface. Front Projection mapping is primarily applied to the Color channel (though it is sometimes applied to other channels as well). All the other surface attribute channels are still in effect.

When using Front Projection mapping to catch shadows, you must strike a balance between the surface attributes and the lighting to get the object to blend seamlessly with the background. The background is the image in its original form. There is no shading or illumination. To match that perfectly with an image mapped onto geometry, the surface needs to be illuminated at exactly 100%. This could be done by setting the Diffuse to 100% and aiming a single light directly at it, and also setting the ambient light to 0%. This would illuminate the surface exactly 100% and match perfectly with the background. The problem here is that you must have perfectly flat surfaces and a light always pointed directly down for your composite to work.

Another option is to set Luminosity to 100% and Diffuse to 0% so that the surface is completely self-illuminated. The problem with this approach is that by being self-illuminated, the image will show no shadows.

Seamlessly mixing a surface with the background takes careful blending of the Diffuse and Luminosity values to balance the amount of light in the scene. A good place to start is to have the Luminosity and the Diffuse values total 100%. The more Luminosity a surface has, the lighter the shadow will be. Ambient light will also add illumination to the shadowed areas, making the shadows darker. Remember also that when light strikes a surface at an angle, it does not hit the surface at full strength. The weaker strength of the angled light will have to be compensated for by increasing the Diffuse and Luminosity values.

In the tutorial starting on page 288, the object that was acting as the ground plane was overlit. It looked a little brighter than the background image and a line can be seen where the polygon edge ends. In addition, the edges of the shadow look unnaturally harsh. A couple of things can be done to fix these problems.

Figure 9.11 shows the same UFO valley scene with a few things added. The most noticeable addition is a big mirrored ball. The mirrored ball is using both ray traced reflections and spherical map reflections. The spherical reflection map being used is the same valley image being used as the Front Projection map on the ground plane. The big mirrored ball appears to be rolling down the road. Notice the reflection in the ball. It correctly corresponds to the section of the road. This is pretty amazing considering the road really isn't there. Notice also that both the UFO and its shadows are also in the mirrored ball's reflection, and that the sky appears behind the UFO in the reflection. How amazing is that?

FIGURE 9.11 The rendered image of the ball with the UFO. Spot lights with Shadow Map shadows are used for soft edges.

The lighting and the surfacing have also been adjusted in Figure 9.11. The one light in the scene has been changed from a Distant light to a Spot

light so that we can use shadow maps for shadows with a softer edge. The light needed to be repositioned so that its cone completely encircled the entire ground plane with the full strength of the light. The surface was too brightly lit, so Diffuse was set to 80% and Luminosity was set to 10%. These levels seem to balance the illumination properly to match the background image.

Last, a second light was added to the scene to light the objects from below. In an environment like the one pictured, the strong harsh light of the sun would bounce back a considerable amount of illumination. A Distant light is added at 50% intensity pointing straight up from below the ground plane. Shadow Type for this bounce light is set to Off. (If not, it would not make it past the ground plane.) Affect Specular is also turned off, as most bounced or ambient light would not contribute a specular highlight to a surface.

With these few changes, the scene becomes much more believable. We have still more tools available. For example, you can use the Light Exclusion function in the Light Properties panel to give you more options on how the rendered object is to be lit. The beauty lights can light the main object and all but the shadow-casting object will be excluded from the shadow-catching object.

Using Clip Mapping with Front Projection Mapping

Clip maps are much like transparency maps, except that they have a much harsher edge and they work on a per-object rather than per-surface basis. They do render much faster and more cleanly than transparency maps. When a portion of an object is cut out by a Clip map, it is completely gone.

Clip maps are part of the Item Properties for Objects (see Figure 9.12).

The Clip map is based on the brightness of the image. Any image should be treated as if it were a two-toned black and white image. The white parts of the image completely remove that part of the object as if it were cut away by an X-acto knife. The black parts of the image remain untouched. There is no antialiasing or feathering of the dividing line; it is either in or it is out.

Smoother Clip Maps

The edge of a Clip map region sometimes has a jagged edge due to the yes/no method of operation, because you are seeing each pixel of the map without any an-

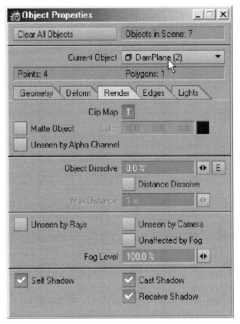

FIGURE 9.12 The Clip Map selection in the Object Properties panel.

tialiasing. To get a smoother edge, use larger images as Clip maps. The more pixels in the cutoff line, the smoother the line will be. You can scale up the original Clip map images and run a smooth filter over them. (Save them as 2-bit files if you can and want to save memory. Clip mapping only sees black or white.)

TUTORIAL TWO LAYERS OF DAM WITH PLANES AND CLIP MAPS

In this tutorial we will use Front Projection mapping on planes to create the foreground and the background. Clip mapping will be used to remove part of the foreground element to allow the geometry between the two plates to be seen. As with the earlier example using the foreground layer in the Compositing panel, we will pull an Alpha channel from an existing 32-bit image.

STEP 1: LOADING A 1M PLANE INTO LAYOUT

This plane will be the canvas for the BigDam picture. This object will be used twice—once for the background and again for the foreground. The foreground plane will have a Clip map applied to it that will remove the area above the retaining wall. Call this 1m square DamPlane.

STEP 2: SURFACING THE DAMPLANE

The DamPlane object will have the BigDam image applied to it as a Front Pro-jection color map. Click the Surface Editor button to open the Surface Editor. Click on the Color channel T to open the Texture Editor. Load the BigDam image as the texture map and select Front and Projection Type. Turn off the Pixel Blending and Texture Antialiasing options, because these will just serve to degrade the image in this situation.

In this tutorial, the background plate will eventually completely fill the screen. None of the backdrop will be seen. Because the Front Projected surfaces do not need to match the background plate, there is much more flexibility for setting the surface attributes and the lighting in the scene.

STEP 3: CLONING AND POSITIONING THE DAMPLANE

We want the DamPlane object to fill the screen. Select the DamPlane object and use the Size function to scale the DamPlane object to larger than the frame size. The edges of the DamPlane should go beyond the frame. This will not affect the image in the render (though odd things may happen in some OpenGL previews) because Front Projection mapping always maps the image as if it was loaded as a backdrop layer.

There needs to be two planes with the BigDam image, one in front and one in back. With the DamPlane object selected, click the Add button and se-lect Clone Current Item to get a second DamPlane object.

Select the new object, DamPlane(2), and move it forward. Do not worry about resizing the object; the image will always stay where it is. You may need to use the Perspective view to judge the distance between the two planes (see Figure 9.13).

STEP 4: PULLING OUT A CLIP MAP

We are going to be doing a bit of juggling to pull a Clip map from a different image. Click on the Image Editor button to open the Image Editor panel. From the Images directory of the content disk, load the image DamFront. This is the original BigDam picture that has had the top portion of the Dam removed. In this situation we only want the Alpha channel of the image, so select Alpha Only under the Alpha channel options (see Figure 9.14).

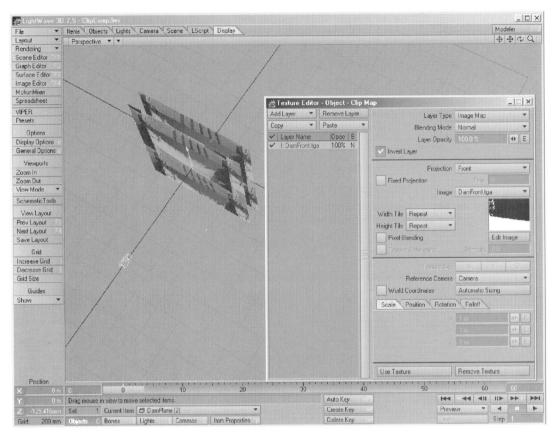

FIGURE 9.13 The two planes spaced in the Perspective view.

FIGURE 9.14 The Clip Map Texture Editor.

STEP 5: APPLYING THE CLIP MAP

The Clip map will be applied to the front DamPlane polygon. With the front-most area, DamPlane(2), selected click the Item Properties button to bring up the Object Properties panel. In the Object Properties panel, click the Rendering tab to bring up the submenu that contains the Clip map options. Click on the T button for Clip map to bring up the Texture Editor for Clip mapping.

In the Texture Editor for the Clip map, the DamFront image's Alpha will be applied as a Front Projection map. The only problem is that Clip maps remove the white areas and leave the black, the exact opposite of what we need here. This is quickly fixed by selecting Invert Layer.

To confirm that the layer is doing what it is intended, click on the Rendering button and select Render Selected Objects. You should see just the front of the dam with the top area blank. Rendering the full frame will look exactly like the image was loaded as a backdrop layer. The difference now is that these planes will react to shadows, light, and can have objects move between them.

STEP 6: ADDING OTHER OBJECTS

The point of this tutorial is to add other elements to the image. In the pictured example, a group of mirrored balls are seen rising from inside the dam structure and moving forward. Any item you want to slide between the two planes will work. If necessary, you can reposition the planes to accommodate the incoming object.

STEP 7 (OPTIONAL): OTHER THINGS THAT CAN BE DONE WITH THIS SETUP

This scene currently has two planes, the background and the foreground. In the Images folder on the companion CD-ROM there is an image available called DamMid that has the sky removed from the original BigDam picture. You can extract the Alpha from the DamMid picture and apply it to the background plate. You are now free to add a new sky to the scene.

To add a new sky, under the Scene tab click the Backdrop button to open the Effects panel. In the Backdrop section, click the Add Environment button and select SkyTracer2. This will render a new sky that can be seen through the empty area of the background plane that had the original sky removed. (For the best skies, open the SkyTracer2 Options panel by double-clicking on the SkyTracer2 listing, and activate some of the Cloud options.)

We can also alter the original lighting. Because the geometry that holds the images completely filled the screen, they do not necessarily need to match the original brightness. You can change the apparent time of day in the background shots by changing the amount of light used. By using lower-intensity

light, you can make the scene look as though it takes place in the evening. You can even use tinted lights to change the mood.

ADVANCE COMPOSITING TECHNIQUES

The compositing techniques covered so far in this chapter have been single-pass renders with all the effects done in camera. Some situations call for more extensive manipulation of the images, often requiring several passes or additional mapping.

Rendering in Multiple Passes

Even scenes that are completely created inside LightWave are better off rendered in sections. Frequently, special processes are desired for selected elements in a scene. Other times, it is more cost effective to render elements separately. For example, take a typical scene with two characters talking inside a room. A good cinematographer will compose the scene with depth of field in mind so that the main point of interest, the character that is speaking, is the point of focus and the background is slightly blurred. LightWave has the ability to render depth of field effects, but this normally requires huge amounts of antialiasing to get it to render at an acceptable quality, which equals a lot of extra time invested just to make something look blurry.

Splitting the render into separate foreground and background renders can be much more resource efficient. Here is a breakdown of a typical scene rendered in several layers (see Figure 9.15).

This scene contains a character in an environment. The viewer is not sure where to focus attention because all is equally in focus. The scene is broken into two parts, the background layer (see Figure 9.16) and the foreground element (see Figure 9.17).

The background and the foreground elements must be rendered separately. Because the background is intended to be blurred anyway, we will render it at a low resolution with little antialiasing. The foreground element will be rendered at full resolution with a higher level of antialiasing.

We applied a paint program filter to the background image to give it the effect of a camera depth of field blur. Because this is being done in a paint program, we have a high degree of control over the look of the blur. The background image also has its color and saturation muted. We apply a much softer blur filter to the foreground image, and a bloom filter to

FIGURE 9.15 The robot still.

FIGURE 9.16 The background layer of the robot scene.

302 The LightWave 7.5 Primer

FIGURE 9.17 The foreground element of the robot scene.

snaz it up a bit. Figure 9.18 shows the results after the two layers were composited.

The advantages of splitting the render are that you have much more control over the look of the final image. You also often gain time because processing images in post-production often is much quicker than doing it in LightWave. These examples used stills, but the same holds true for full sequences of images.

There are several ways to split up a LightWave scene for multi-player rendering. The most straightforward way is to save the scene in versions, an A version and a B version, deleting the unwanted objects. This can sometimes lead to trouble, because you can accidentally delete something. You also have the option of replacing an unwanted item with a null object, which will retain the integrity of any parenting.

The best way to divide a scene is with the Scene Editor (see Figure 9.19).

The Scene Editor lists every item in the scene, with a checkmark after each item. That checkmark indicates that the item is active in the scene. If you click on that checkmark, the checkmark disappears and effectively removes that item from the render engine. The item will remain in the scene, but it will have no visible effect on the final image. Objects will not

FIGURE 9.18　The final composite.

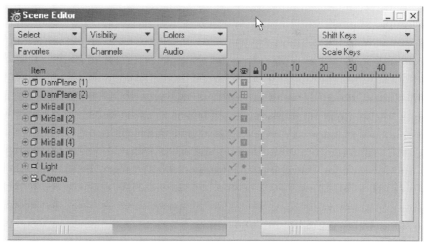

FIGURE 9.19　A close-up of the scene elements in Scene Editor.

be visible, cast a shadow, or show up in a reflection. Lights will in effect be turned off. What is great about this is that clicking again in the space and putting the checkmark back can reactivate these items any time.

Creating a Reflection

Other than receiving a shadow, the stand-in objects have not been affected by the added elements in the scene. Previous examples in this chapter showed that the additional elements can be tricked into reflecting things in the background image, but the background image can also be made to appear as if it is reflecting the rendered elements.

The setup for reflections is not that much different than that used for catching shadows. A Front Projection map is applied to the Color channel as before, but now we add some reflection to the stand-in object. In most cases only a portion of the background image will be reflective, such as the example of some reflective windows on a house in Figure 9.20.

FIGURE 9.20 The window picture.

The original picture was brought into a paint program and used as a reference to create a texture map for the reflection channel. Wherever there was a reflective surface in the original image, that area was painted

white. In this case the windows are partially reflective so white rectangles are painted to match them.

In Layout, we loaded a polygon and positioned it to match the angle of the wall and scaled it to cover all of the window area. We loaded the original image into the background to serve as a reference. The window reflection map texture was mapped on to the polygon using Front Projection mapping in the Reflection channel. The white areas of the texture map will make those areas of the polygon 100% reflective, and the black areas will cause it to have no reflective properties at all (see Figure 9.21).

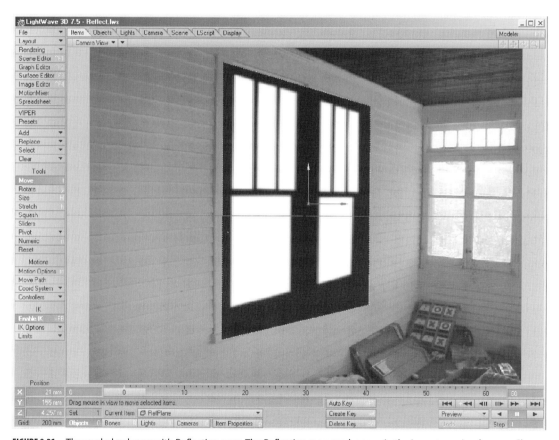

FIGURE 9.21 The angled polygon with Reflection map. The Reflection map can be seen in the Layout preview because Show Current Active Map has been activated in the Display options.

The polygon must be 100% transparent, which seems to makes no sense, but it works. Reflections still show up in a transparent object. By making the polygon 100% transparent, only the reflections will appear on the polygon surface during the rendering.

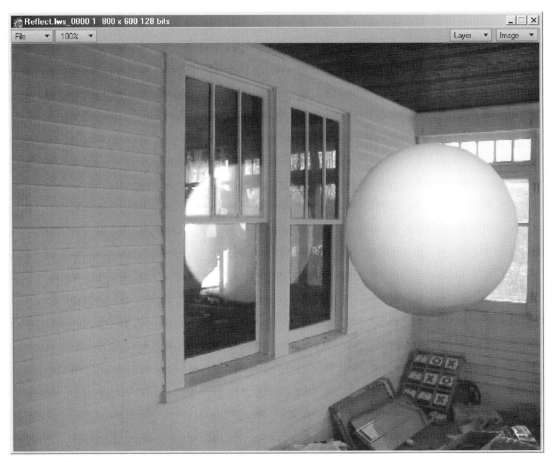

FIGURE 9.22 The reflected ball.

In the example scene, a large yellow ball has been introduced to display the effects of this composite reflection (see Figures 9.22 and 9.23).

You can plainly see that the ball appears to be reflected in the windows. Upon closer examination you can see that there are some problems with the reflection. Objects that should be blocked by the presence of the ball (if it was really there) can be seen showing through the ball's reflection. To fix this would require that the reflection pass be rendered separately, and then composited later. Rendering the reflection as a separate pass also gives you the opportunity to make adjustments to the brightness and the color of the reflection element.

On the other hand, this is one of those elements of compositing that should be done very subtly. The reflections should not call attention to

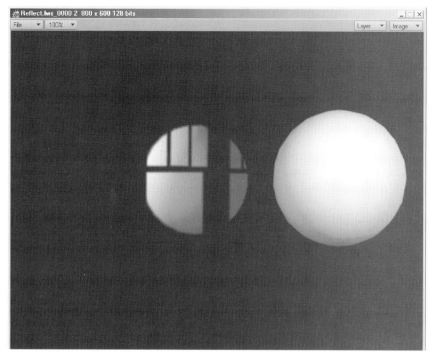

FIGURE 9.23 The ball without the background.

themselves; they should be an extra subliminal visual cue that ties the added element to the background image.

Shadow Density

Through compositing, we can obtain shadows without compromising the background image. The Alpha channel has an option called Shadow Density in the Advanced tab of the Surface Editor (see Figure 9.24).

Shadow Density is one those things that only works in the computer 3D world and therefore is a little hard to visualize. Shadow Density is intended to be applied to the surface of the shadow-catching object. Shadow Density makes the entire surface transparent except for where the shadow falls. The shadow-catching surface should be black, and Shadow Density must be selected for the Alpha channel options in the Advanced tab. When the frame is rendered, you will see the main object rendered over a field of black. When you look at the Alpha channel of the rendered frame, you will see a solid white area for the object (assuming the object has no transparent surfaces) and a dimmer white area where

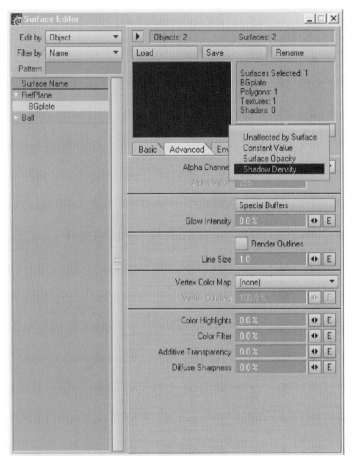

FIGURE 9.24 The Advanced tab with Shadow Density selected.

the shadow of the object would fall on the shadow-catching object. This is the Shadow Alpha, which will cause the black from the frame to be mixed in with the composited background layer.

Here is a typical example of how Shadow Alpha is used. In Figure 9.25, an object has been built that roughly resembles the dam that we see in the DamBig image. This is the shadow-catching object. The object is positioned in the scene so that it aligns with the corresponding object in the background layer. The view has temporarily been switched to Wire Frame render so that the background image can be seen.

When a shadow falls on the nooks and crannies of the shadow-catching objects, the shadows will shape themselves to the geometry. As the object moves, the shadow will slide along the surface of the stand-in

FIGURE 9.25 The Wire Frame shadow-catching object aligned with background image.

object similarly to the way it would on the object in the background image.

The surface of the background image should be solid black, but for display purposes it has been made a dark gray so it can be seen. The UFO object has been added to the scene, as well as a second light (see Figure 9.26).

Both lights are Spot lights using Shadow Map shadows and are slightly tinted. They also have a soft-edged falloff around the cone (see Figures 9.27 and 9.28). In normal Front Projection compositing, that kind of lighting would give you fits. When compositing shadows in several passes using Shadow Density, it does not matter.

The rendered image shows only the main object, including the gray surface of the shadow-catching object. The Alpha channel shows us an outline of the UFO object, and the various densities of the shadow. If this

FIGURE 9.26 The scene setup with the UFO.

FIGURE 9.27 The rendered image. It appears to be only the UFO over a black background.

FIGURE 9.28 The Alpha channel of the same image, showing the area of the UFO and a gray area that shows where the shadow is falling on the geometry standing in for the dam.

image were brought into a compositing package, the gray of the shadow-catching object would be mixed in, which is why the shadow-catching object should be black (see Figures 9.29 and 9.30).

Figure 9.30 shows how the 32-bit image of the render looks when it is brought into Aura. You can clearly see the effect that the Shadow Alpha has on the image. This 32-bit image can be dropped directly over the background layer.

To give even more flexibility, you can render the shadow sequence all by itself. In the Item Properties panel, select Unseen by Camera in the Rendering panel. The object will not show up in the final render, but it will still cast a shadow. (You will then need to do a third layer with only the object and without the shadow catching-object.)

FIGURE 9.29 The render over a checkerboard background.

The advantage of rendering the shadow as its own layer is that you have many more options for the look of the shadow. A shadow is basically a black spot that moves over the scenery. You can soften the edges of the shadow by running it through a blur filter, or you can make it a lighter shadow by increasing its transparency. Matching shadows is a very important part of creating a seamless composite, and it deserves much attention.

CONCLUSION

LightWave has many tools dedicated to the compositing process. Compositing may be done entirely within the LightWave environment, in a paint program, or in dedicated compositing software. Sometimes compositing involves combining real-life and computer-generated images; at other times completely computer-generated scenes are rendered as different elements and composited together. Compositing is a powerful technique and well worth taking the time to learn.

FIGURE 9.30 The render over the background.

10

PARTICLES, HYPERVOXELS, AND SASQUATCH

In This Chapter

- Particle Effects
- HyperVoxels
- Sasquatch Lite

Once considered the domain of expensive third-party software, particle animation is now an integral part of LightWave. Particle animation is the effect of moving groups of points around the 3D environment freely within a set of constraints. Particles have many uses. For the most part they are used to mimic acts of nature. Vapors, liquids, even billowing leaves are all candidates for particle type animation.

To compliment the particle engine is a closely linked function called *HyperVoxels*. HyperVoxels is a method of rendering a volume of space rather than geometry. Though it can sometimes be time consuming, HyperVoxels provide a more efficient way of creating such elements as smoke and mist that are composed of millions of specks of particulate matter suspended in air. HyperVoxels is also used to create surfaces of flowing and viscous natures, like water and lava. Sometimes the points used are from a Particle Emitter; sometimes the particles are part of an object.

The Sasquatch Lite plug-in works in a similar way as HyperVoxels. It uses geometry in the LightWave scene to render a volume of hair. Modeling and rendering millions of strands of hair, and calculating their interaction both physically and visually, would be quite a task for any computer. Sasquatch offers us a way simulate the effects of hair and fur with surprisingly reasonable render times.

PARTICLE EFFECTS

Particle systems allow you to deal with groups of points in a loose rather than a rigid construction of solid objects. Particles can be used to create such natural phenomenon as swarms of insects, dust clouds, and falling sparks.

Anatomy of a Particle System

Most particle systems, regardless of the 3D software used, are of a similar nature. There are three important aspects in a particle's life: the Emitter, the Modifiers, and the Collision. The important thing to understand about the Particle Effects in LightWave is that Particle tools become Layout items when they are added to the scene and can be treated as such. The Particle items can be moved, parented, and keyframed.

The Emitter is the birthplace of the particles. The Emitter has a range of settings that can be of any shape or size. The particles may spit out from the Emitter at high speed, or they may simply pop into existence

inside the Emitter's space and sit there motionless. The Emitters themselves can have motion, throwing off particles as they fly by. Emitters can spray thousands of particles per frame or just dribble them out one at a time.

After the Emitter has generated particles, they can be acted on by outside forces called the *Modifiers*. A Modifier changes the path of the particle in some way, and can be anything from gravity to donut-shaped turbulence.

Collision is an important aspect of particle animation. Technically, collision could be considered another Modifier, but Collision is such an important part of particle animation it deserves separate mention. As the name suggests, collision occurs when a particle hits something and reacts. The collision object can be one of LightWave's built-in primitives, or it can be a properly constructed LightWave object that has been given particle collision properties. (In most cases, the built-in primitive objects will serve as collision objects, and will normally perform much more quickly and more accurately than polygonal objects.)

Particle, Partigons, and Layout Items

There are two types of Emitters that can be introduced into Layout, an HV Emitter and a Partigon Emitter. An HV Emitter has particles that are points, basically null objects. They have no surface and are intended to be use as HyperVoxel reference points. The Partigon Emitter, on the other hand, creates particles that are single-point polygons.

A *Partigon* is a single-point polygon, and can be seen in a normal LightWave render. A single-point polygon will normally render as a 1-pixel dot, regardless of its distance from the camera. The size of the Partigon can be changed in the Rendering tab of the Object Properties panel. The Particle/Line Thickness setting allows you to specify the size in pixels that you want the single-point polygons to render.

If neither HyperVoxels nor Partigons will do, the Emitter can also emit other Layout items. By using the FX Linker function, other objects can be used in place of the particles flowing from the Emitter.

Activating Particle Devices

The most convenient way to access the ParticleFX functions is with the FX Browser. Under the Scene tab in Layout is a section for Dynamics. This section contains a button for the FX Browser. Clicking on the button brings up a free-floating menu labeled the ParticleFX Browser (see Figure 10.1).

FIGURE 10.1 The ParticleFX Browser.

The ParticleFX Browser allows you to add Particle Emitters, Modifiers, and Collision objects directly into the scene. To add a Particle Emitter to the scene, click on the button to the right of "Add in the ParticleFX Browser" and select Particle Emitter. The act of selecting Partigon Emitter will put a Partigon Emitter in Layout. It will appear as a 1m bounding box with a few points inside it (see Figure 10.2).

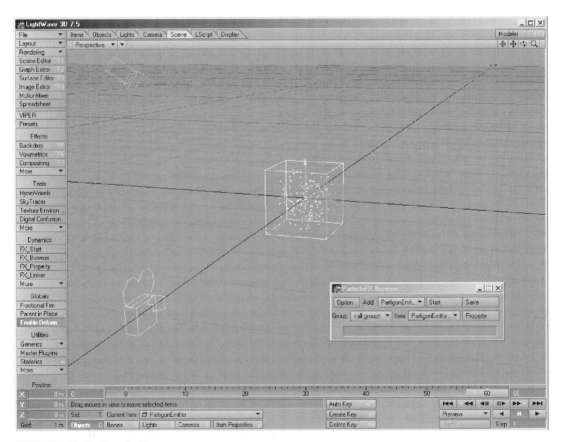

FIGURE 10.2 The Partigon Emitter.

Click the Play Preview button in Layout to see the Partigons pop into existence. Without any forces acting upon them, the Partigons are content to stay put. Objects at rest, as they say.

Select the Particle Emitter and keyframe it at frame 60 about 2m to the right. Watch what happens to the particles in the preview. The points are being thrown off like water droplets from a dog. The particles are inheriting the motion of the Emitter.

TUTORIAL ## A PARTICLE PINWHEEL

Particle Emitters can be treated just like any other Layout function, including parenting.

STEP 1: ADDING A PARTIGON EMITTER

If you have not already done so, click the FX Browser button to open the ParticleFX Browser. In the Add section, select Partigon Emitter.

STEP 2: ADDING A NULL OBJECT FOR THE PARENT

Add a Null object to the scene by going to the Items tab of Layout and selecting Add>Objects>Add Null. Select the Partigon Emitter and select the Null object as its parent.

STEP 3: POSITIONING THE PARTIGON EMITTER

Select the Partigon Emitter and keyframe frame 0 at X = 1m. This offsets the Partigon Emitter from the center.

STEP 4: KEYFRAMING THE ROTATION OF THE PARENT NULL OBJECT

Select the Null object and keyframe it to make two complete rotations. Give the Null object a value of B = 0 at frame 0, and B = 720 degrees at frame 60.

Watch a preview of the animation. Use the Perspective view so you can zoom around the action. As the Null object rotates, it spins the Emitter around in a circle and the particles fly off because of the rotational forces.

Modifying Emitter Properties

Much of the character of Particle Animation comes from the way the particles are emitted. The ParticleFX Browser contains a button labeled Property. Clicking the button opens a properties panel for whatever current item is selected in the ParticleFX Browser (see Figure 10.3).

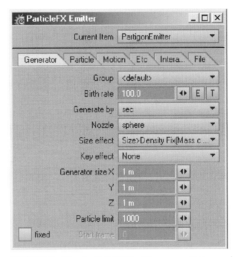

FIGURE 10.3 The ParticleFX Emitter properties panel.

Rather than going over all the Emitter settings in detail, here are a few of the less obvious but important settings.

The first tab, Generator, has a Birth rate setting. This is the speed at which the particles are created. Toward the bottom is a setting for Particle Limit, which is the maximum number of particles that will be created. Because each particle in its way is its own separate object, it is less taxing on the system to recycle particles that have previously been created and have died off than it is to continuously create fresh particles. If the Birth rate is too high and the life span of the particles is too long, you may run out of particles if the Particle Limit setting is too low.

The next tab, Particle, contains two important settings you should be aware of: Particle Resistance and Lifetime. *Particle Resistance* can be thought of as air friction, the drag on an object moving through the air. *Lifetime* is literally how many frames the particle will be active in Layout before returning to the recycle bin. Notice that both these settings have both T (Texture) and E (Envelope) buttons to give you more control over their actions. Notice also that these settings have a plus/minus button.

The plus/minus allows you to specify the allowable amount of variations to the settings, which gives particles a controllable amount of randomness, which can be desirable in particle animation.

The next tab is Motion. The settings here will give particles motion the moment they are created. The Vector settings can be combined to shoot the particles in a specific direction as they come out of the Emitter. The Explosion and Vibration settings give the particles a random direction and velocity as they appear in the Emitter space.

In the Ect tab has the setting everyone is looking for, Gravity. The realistic setting for Gravity is Y = –9.8, the gravitational constant for the earth, but in most cases scientific accuracy usually gets replaced with whatever setting looks best for the scene. The other important setting in the Ect panel is Parent Motion. Parent Motion is the amount of inertia the particles inherit from the movement of the Emitter. If the Parent Motion is set to 0, the particles will not take on the motion of the Particle Emitter, often making the particle trail look as if it is being painted in as the Emitter moves across the scene.

Notice that most of these important settings include the plus/minus option to vary the initial settings, and many have T and E buttons to change the effects with Textures and Envelopes. You also have the option of keyframing the ParticleFX elements as Layout items.

Other ParticleFX Items

When clicking the Add section of the ParticleFX Browser, you will notice a number of Modifiers listed. These settings control the path of the particles once they leave the Emitter (see Figure 10.4).

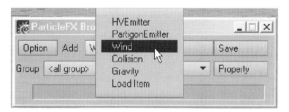

FIGURE 10.4 The ParticleFX Add drop-down menu.

When one of these Modifiers is selected, it appears in the Layout view as a Layout item. For the particles to be affected by these Modifiers, they must be within the Modifiers' range of influence. The range of the Modifiers' influence can be seen by their appearance in Layout.

 Notice that a Gravity Modifier is listed. The Gravity Modifier operates slightly different from the Gravity setting in the Emitter panel. This gravity is localized and can be keyframed with motion.

Each of these Modifiers has its own set of controls that can be accessed by having that item selected in the ParticleFX Browser and clicking the Property button.

TUTORIAL · MOVING PARTICLES WITH GRAVITY AND WIND

STEP 1: ADDING A PARTIGON EMITTER

Start with a freshly cleared scene. Set the scene length to 300 frames by entering the number 300 in the frame number box to the right of the scrub bar in Layout. If you have not already done so, click the FX Browser button to open the ParticleFX Browser. In the Add section, select HV Emitter to add one to the scene.

STEP 2: ADJUSTING THE EMITTER PROPERTIES

Click the Property button in the ParticleFX Browser to open the Particle Properties panel. We will give the particles gravity and increase their lifespan.

In the Particle tab of the ParticleFX Emitter panel, set the Lifetime [frame] to 150. The particles will now exist for 150 frames.

In the Ect tab, set Gravity to Y = –0.5. This gives a gentle gravitational tug to the particles to bring them down to earth.

Preview the animation. You should see the particle popping into existence then slowly falling down.

STEP 3: MAKING WIND

To give these particles more interesting paths, we introduce a Wind modifier into the scene. In the Add section of the ParticleFX Browser, select Wind. This places a Wind element in the scene, directly on top of the previously introduced Particle Emitter. Click on the Property button in the ParticleFX Browser to open the ParticleFX Wind panel.

In the ParticleFX Wind panel, change the Wind Mode to doughnut. Leave all the other Wind settings at the defaults.

Notice that adding the Wind modifier has an immediate effect on the particles, as does entering changes into the settings. Currently the Wind and the Gravity settings are at odds, both exerting forces upon the particles.

STEP 4: MOVING THE WIND

The real power of having the Wind modifier accessible in Layout is that it can be keyframed. Here we will animate the movement of the wind so that it causes the particles to swirl and dance.

In Layout, select the Wind item. Create two keys for the Wind item that will cause it to move through the center of the HV Emitter while rotating. Give the keys the following settings:

Keyframe at Frame 0
 X = 1m
 Y = 0
 Z = 0
 H = 0
 P = 0
 B = 0

Keyframe Frame 300
 X = −1m
 Y = 0
 Z = 0
 H = 0
 P = 360
 B = 360

Preview the effect of these keyframes on the Wind item. The Wind item will now move through the Emitter. As it does the particles will get caught up in the wind and be swirled around.

Save this scene to use in the section with HyperVoxels.

STEP 5: ADDING A COLLISION OBJECT

Putting a collision object in the scene will give the particles something to collide with and react to. In the Add section of the ParticleFX Browser, select Collision to add a collision object to the scene. The collision object defaults to a 1m sphere; you should instantly see the effects that it has on the particles in the scene.

Click on the Property button in the ParticleFX Browser to bring up the Properties panel for the collision object. Change the Type to Plane. (This is an infinite plane. Although it only shows a 1m square, the collision effect of the plane reaches from horizon to horizon. To get a limited flat plane for collision, you need to use the box collision shape.)

The Plane collision object is offset 1m up in the air because that is the default size of a collision object. In Layout, select the collision object and move it down two meters so that Y = −2m.

Run a preview. The wind object should swirl the particles around, but they never go beneath the ground level presented by the collision object (see Figure 10.5).

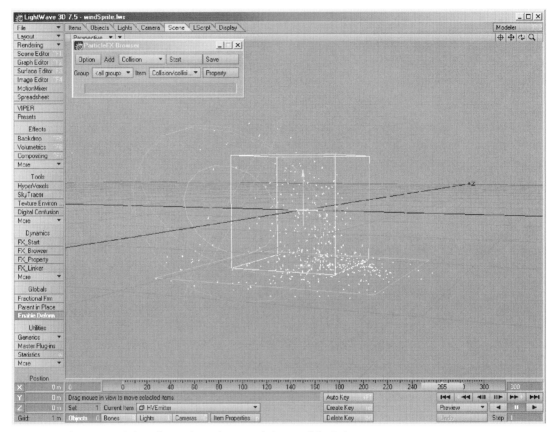

FIGURE 10.5 The scene with the collision object, the ground plane, and the Emitter.

T U T O R I A L

REPLACING PARTICLES WITH AN OBJECT

Sometimes particles and HyperVoxels just are not enough; sometimes you need the Emitter to toss out actual objects. By using the FX Linker button, the Particles from the Emitters can be replaced with standard LightWave objects.

STEP 1: SETTING UP A PARTICLE EMITTER

Before objects can be spewed from a Particle Emitter, an Emitter must be put in place and adjusted. Click on the FX Browser button to open the ParticleFX

Browser. In the Add section of the ParticleFX browser, select HV Emitter to add a Particle Emitter to the scene. Click on the Property button and change the settings to the following values:

Generator Tab
 Birth Rate 25
 Particle Limit 100
Particle Tab
 Life Time 150
Motion Tab
 Vector $Y = 2m$
 Explosion 2.0
Ect Tab
 Gravity $Y = -2.0$

In Layout, set the scene length to 150 frames. Run a preview. You should see particles spraying upward then falling down.

STEP 2: LOADING REPLACEMENT OBJECT

You will now load an object to replace the current particles. It is a good idea to start with a fairly low polygon object because that object will be cloned once for each particle created by the Emitter. Even in this simple example the object will be multiplied 100 times.

ON THE CD

In the Objects directory of the accompanying CD-ROM is a directory called Particle. From the Particle directory load the Flake.lwo object. This is a snowflake-shaped object that will be used to replace the particles from the Emitter.

STEP 3: ACTIVATING THE FX LINKER

In the Dynamics section a little below the FX Browser button is the FX Linker button. Click the FX Linker button to open the ParticleFX Linker panel (see Figure 10.6).

There are quite a number of controls for the ParticleFX Linker. Most of them assist in altering the size and rotation of the linked object. Because a particle usually consists of a single point size, rotation has no meaning; however, rotation will be used when the point is replaced with an object of size.

There are three important settings in the ParticleFX Linker menu, and only one of them really needs to be changed. The Particles section is the Emitter that will be used, and the Replace Object is the item that is going to be replacing the particles, in this case the Flake object. The third important setting is the Copy setting. If you want all the points to be replaced with the new object, the

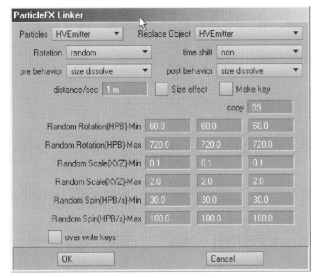

FIGURE 10.6 The ParticleFX Linker panel.

number of objects must equal the number of points in the Emitter. The Emitter has a particle limit of 100, so we need to copy the originally loaded object 99 times to give us a total of 100 objects to perfectly match the number of points.

Enter the values seen in the image to give the new Flake objects some variation of size and rotation, then click on OK to replace the particles.

STEP 4: ADJUSTING THE FLAKE EMITTER

Watching a preview of the animation now should show the Flake objects being spit out by the Emitter. What is really impressive is that the settings of the Emitter can be altered but will still emit the objects as particles with the new values.

Try increasing the Explosion or Vibration value to 5 in the Motion tab of the ParticleFX Emitter panel, or reducing the size of the Generator. See how the Flake objects now follow different paths? You can even add Wind or collision to affect the path of these objects.

HYPERVOXELS

HyperVoxels (HV) is a method of rendering a volume of space rather than rendering planes of geometry. HyperVoxels range from gooey too wispy,

with every variation in between. HV can be used for fire, water, rock, and smoke. All these variations can be made with just a few clicks of the mouse. With all this power, it is important to a have a firm grasp on the way HyperVoxels operate.

Introduction to HyperVoxels

HyperVoxels are a Volumetric Effect that requires reference points in Layout. The reference point can be as simple as a single null object or the points on an existing object, or as complex as a cloud of colliding particles.

You find HyperVoxels by going to the Scene tab and clicking the Volumetric button to bring up the Effects Menu with the Volumetrics section active. Click the Add Volumetric button and select HyperVoxels Filter. Double-click the listing for HyperVoxels to bring up the HyperVoxels panel (see Figure 10.7).

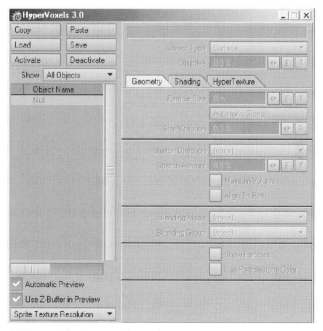

FIGURE 10.7 The HyperVoxels panel.

HyperVoxels work as follows. The HyperVoxel Filter is assigned to a Layout item that contains points. The HyperVoxel Filter then does a volumetric render around each of the points. The points act as a kind of framework for the HyperVoxels.

T U T O R I A L **USING A NULL FOR HYPERVOXELS**

Some HyperVoxel applications require thousands of points, but sometimes you only need a single null.

STEP 1: ADDING A NULL TO THE SCENE

Start with a clear scene in Layout. Under the Items tab, click the Add button and select Add>Objects>Add Null to put a single Null object in the scene. The Name the Null object requester will appear, but leave the name Null for now. Select the Camera view, which should point the Null object into the very center of the screen.

STEP 2: LOADING THE HYPERVOXEL FILTER

The HyperVoxel Filter needs to be added to the scene. Under the Scene tab, click the Volumetrics button to bring up the Effects panel. In the Volumetric section of the Effects panel, click on the Add Volumetric button and select HyperVoxel Filter. Double-click on the listing for HyperVoxels to open the Hyper-Voxel panel.

STEP 3: APPLYING HYPERVOXELS TO THE NULL

Currently only one item in the scene contains a point, the Null object. On the left side of the HyperVoxel panel is an object list that shows all the objects available for HyperVoxels. The only item showing is the Null object, and the Null is appearing semi-ghosted, because although it is available, it is not active as a HyperVoxel.

If you have not already done so, activate the Viper window. When working with HyperVoxels, it is not necessary to render a frame first.

The Null can be activated as a HyperVoxel either by double-clicking on the Null Listing in the HyperVoxel panel, or by selecting the Null listing with a single click, and then clicking the Activate button directly above the list of objects (see Figure 10.8).

STEP 4: CHANGING HYPERVOXEL OBJECT TYPE

The Default HyperVoxel looks very much like a solid white ball. By changing the object type the Null object will look completely different. In the Object

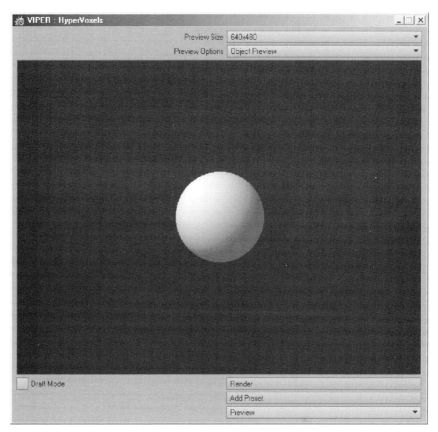

FIGURE 10.8 The Null object with default HyperVoxel setting.

Type box of the HyperVoxel panel (top-right corner), change the Object Type from Surface to Volume. The ball shape is replaced by a cloudy mass. Now change the Object Type from Volume to Sprite and observe the difference. Although the Sprite looks a bit similar to the Volume, it has much less detail and renders much more quickly, even in the Viper window.

STEP 5: LOADING HYPERVOXEL SETTINGS

Once the Null has been activated as a HyperVoxel, it should appear in the Viper window as a solid white sphere. This is the initial default setting. Notice that the default size setting is 1m, the standard LightWave unit. The 1m size is the spherical volume that will be rendered around that point. Most of the Presets are based on a Null being 1m. Size and scale have a major affect on the way HyperVoxels look.

With the HyperVoxel menu currently active, click on the Presets button to open the HyperVoxel Presets panel. There are several banks of Presets for HyperVoxels that display the staggering array of looks that can be achieved with HyperVoxels. Double-clicking on the thumbnail image of the sample presets allows you to copy the settings onto the active object. Once the Preset has been placed on the active object, you should see the results immediately in the Viper window.

Flavors of HyperVoxels

HyperVoxels render using three different methods, the Object Types: Surface, Volume, and Sprite. Although these Object Types are related, each one has its own set of properties and advantages.

Surface

The Surface Object Type is used to create flowing masses with a continuous surface, mostly liquids and near liquids. As you see in the Presets, Surface can also be used to create some elaborate organic shapes like rock and snow. It can also be textured much as you would texture a polygon object of the same size.

Volume

Volume is the most sophisticated HyperVoxel, and also the most expensive in terms of rendering time. Volume is used to create air-type effects such as clouds, smoke, and fire. With the Volume setting, vaporous volume is actually created in three dimensions. Objects and cameras can fly through the Volume, Volume can cast and receive shadows, and it can even be seen in reflections. LightWave will behave as if the scene truly contains a big billowy cloud mass. Using Volume of course comes with a huge rendering penalty. Any time you have your camera inside a HyperVoxel Volume, expect the rendering times to increase substantially.

Sprites

The third type of HyperVoxel is the Sprite. Sprites can be made to look very much like HyperVoxels in the Volume mode, but Sprites render much more quickly. They render more quickly because they only render a 2D slice of the full volume, but because that slice is facing the camera, it looks much like the full volume.

The Sprite mode is the only mode that can be seen represented in Layout. Selecting the Show Particles option under the Geometry tab in the HyperVoxel panel will render an approximation of the Sprite HyperVoxel in Layout. Many of the Sprite attributes will not be correctly rendered in Layout; the Viper window comes much closer to showing the full render. Still using the Show Particles option is very helpful in setting up the scene. It is also useful to temporarily switch to Sprite mode when using Surface or Volume modes so you can reference the particles in Layout.

One of the more interesting things to do in Sprite mode is to load an image map. The image will be applied to each HyperVoxel particle, taking on the other attributes (size, surface values, and so on) of that particle. The image map Sprite can be rendered in Layout view.

Although Sprite mode does not have all the controls and flexibility found in the Volume mode, its quick rendering time and ability to give you a visual representation in Layout makes it extremely popular.

Important HyperVoxel Settings

Most of the attribute settings in the HyperVoxel panel are very delicate. Small changes sometimes make big differences in the way the HyperVoxels are rendered. Another complication is that names of many of the settings are not very descriptive, and many of the settings interact with other attributes. All of this can be frustrating when trying to dial in a particular look that you have in mind. To begin to understand how HyperVoxels operate, there are a few concepts that you must learn.

HyperVoxels render around selected points that exist in Layout. The amount of space that is enclosed is specified by the Particle Size setting under the HyperVoxels Geometry tab. Variation of the size and stretch directions can be added, but everything starts with the Particle Size setting.

A HyperVoxel can be a single point, or a group of points. The group of points can be the points of a normal LightWave object, or it can be a spray of particles from an Emitter. Points in a group can interact while in Surface mode, like flowing drops of mercury.

The biggest effect on the way a HyperVoxel looks, other than its size, is the HyperTexture. HyperTexture shapes the HyperVoxel much like a combination displacement map and Bump map. Combinations of Hyper-Texture, Texture Effect (the way the texture moves), and Texture Speed determine the way the HyperVoxel is shaped, and if and how fast it changes. The Texture Speed setting is not a movement of the HyperTexture as much as it is how quickly the texture evolves. The coordinates settings at the bottom of the HyperTexture panel allow for normal texture scaling and movement.

HyperVoxels and Viper

HyperVoxels has a rather unique relationship with the Viper window. In most cases it is necessary to activate Viper, render a frame, then observe any changes made to the surface of the objects in the last rendered frame. Things are a little different with HyperVoxels and Viper.

When Viper is used with HyperVoxels, Viper is aware of the motion of the points in Layout. Even though no other geometry gets updated in the Viper window, any motion of points effected by HyperVoxels will be seen in the Viper window. If particles are used with HyperVoxels, the motion of the particles (as HyperVoxels) will be rendered as a preview.

TUTORIAL

PARTICLES AND HYPERVOXELS

When a Particle Emitter is created as a HyperVoxel Emitter, it emits null objects with no visible polygons or points to render. It is assumed that HyperVoxels will be attached to the Emitter. This is not done automatically. It needs to be added manually.

STEP 1: SETTING UP A SCENE USING AN HV EMITTER

To add HyperVoxels to an Emitter, a Particle Emitter of course needs to be present in the scene. Use one of the scenes created in the previous tutorials that featured particles with a good amount of movement, or start from scratch and build a scene of your own. The Wind scene will be used in this example.

Keyframe the camera so that the Camera view is well positioned to see the action of the particles. Activate Viper in preparation for the HyperVoxels.

STEP 2: LOADING THE HYPERVOXEL FILTER

Click the Volumetrics button to open the Effects panel. Click on the Add Volumetric button and select HyperVoxel Filter. Double-click on the listing for HyperVoxels to open the HyperVoxel panel.

STEP 3: ACTIVATING HYPERVOXELS

On the left side of the HyperVoxels panel is a list of items in Layout. Find the Particle Emitter and double-click on it to activate it as a HyperVoxel item. As soon as the Emitter has been activated as a HyperVoxel object, HyperVoxels should appear in the Viper window. The default setting is a white lumpy surface (see Figure 10.9).

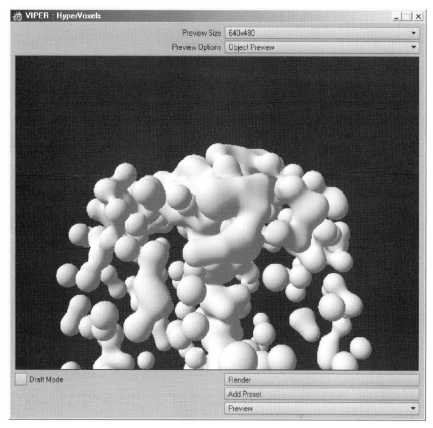

FIGURE 10.9 The default HV settings with particles.

The default object type for HyperVoxels is Surface, which is usually used for liquids and solids.

STEP 4: ADJUSTING THE SETTINGS

You can step through the different object types, Surface, Volume, and Sprite, and see the effects that they have on the particles. You can see the HyperVoxel particles in motion by rendering a preview in the Viper window.

You can also load Preset HyperVoxel textures into the scene. Be aware that most of those textures were built on a single null with a scale of 1m, not a group of points that encompass a 1m area.

Partigons as HV Particles

A Partigon Emitter differs from an HV Emitter in that the Partigons are single-point polygons and the HV Emitters are nulls to be used with the HyperVoxel filter. This does not mean that a Partigon Emitter cannot be used with HyperVoxels. The only difference is that the single-point Partigons will be rendered inside the HyperVoxel area. To get rid of the single-point Partigon in the HyperVoxel render, select the Partigon Emitter in Layout and go to the Item Properties panel. In the Render tab of the Object Properties panel, set the Polygon size to 0. This reduces the surface of the Partigon to nothing, and will not be seen in a render. This can also be done to other objects when you want to use just the points of the object but not the object's polygon surfaces (see Figure 10.10).

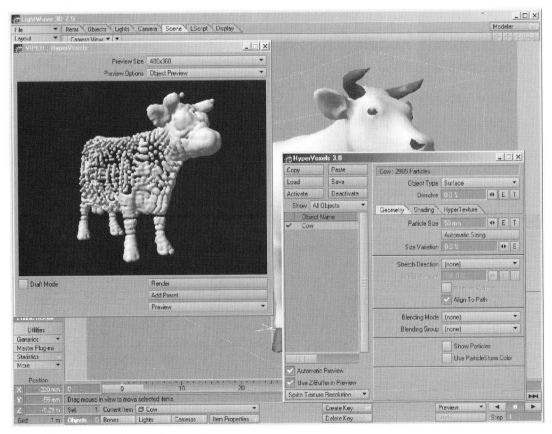

FIGURE 10.10 The HV Cow object with no polygons.

SASQUATCH LITE

There are certain real world elements that are problematic for 3D animation. If the entire world was made up of shiny mirrored balls and checkerboard planes we would be pretty well set, but luckily we have a world made up of endless complexity and limitless detail. The downside of this beautiful world is that the complex interactions of matter and light are not easily broken down into elements small enough for our computers to calculate. Something as simple as a strand of hair is a complex problem. A single strand of hair may be a fairly simple object to model, animate, and texture. Multiply that by a few thousand or million duplicates all slightly different and interacting with each other and you can see the problem. Though we do our best to simulate real-world interaction of the physical properties of light and space, sometimes it is more effective to do a little cheating.

Sasquatch Lite is a hair and fur plug-in for LightWave. Sasquatch renders volumes of hair using a post-production render process that involves both object geometry and a pixel filter, much the same way that Lens Flares are rendered in a scene. Sasquatch Lite is a scaled down version of the full version of Sasquatch, a third party plug-in from Worley Labs. Even though the Lite version has limited functionality, it still can do about 50 percent of the things you would want to do with hair and fur (see Figure 10.11).

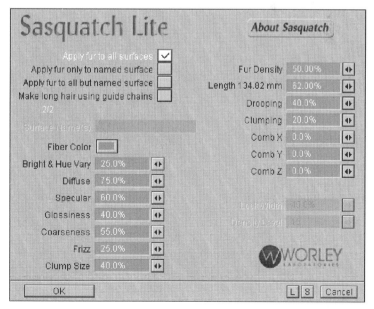

FIGURE 10.11 The Sasquatch Lite menu.

The Process for Sasquatch Lite

When Sasquatch Lite is used in a scene, it needs to be applied in two places: to the object that will be made hairy in the Deform tab of the Object Properties panel, and to the Pixel Filter in the Image Processing tab of the Effects menu.

Hair or fur can be attached in one of three ways: it can be applied to the entire object equally, it can be applied only to specific surfaces, or it can use a string of two-point polygons to use as a guide chain. Sasquatch Lite can be applied several times in a single scene with different values, even to the same object.

T U T O R I A L ## MAKING A HAIR BALL

In this tutorial we will use Sasquatch Lite to apply hair to one side of a ball.

STEP 1: CREATING THE BALL OBJECT

In Modeler, create a ball that has two different surfaces. Select the Make Ball tool and open the Numeric Requester. Click on the Reset button if necessary, and create a Ball object using the default values to create a 1m sphere.

After the ball is created, select one half of the object and give those polygons the surface name Hair. For the purposes of this tutorial, which half you select is not important.

Save the ball object as Hairball.lwo and load it into Layout.

STEP 2: SETTING UP LAYOUT

Start with a cleared Layout scene that contains only the Hairball object. Sasquatch Lite needs to be applied as a pixel filter to the scene and as a Deformation plug-in to the object.

Under the Scene tab in Layout click the Image Process button to bring up the Effects panel. In the Effects panel under the Processing tab, click the Add Pixel Filter button and select SasLite. The SasLite Pixel Filter does have some important settings, but for now the defaults will be used.

With the Hairball object selected, click the Item Properties button to open the Object Properties panel. In the Object Properties panel under the Deform tab, click the Add Displacement button and select SasLite.

Render a single frame with the default settings. The default setting for Sasquatch Lite will render short brown fur over the entire object (see Figure 10.12).

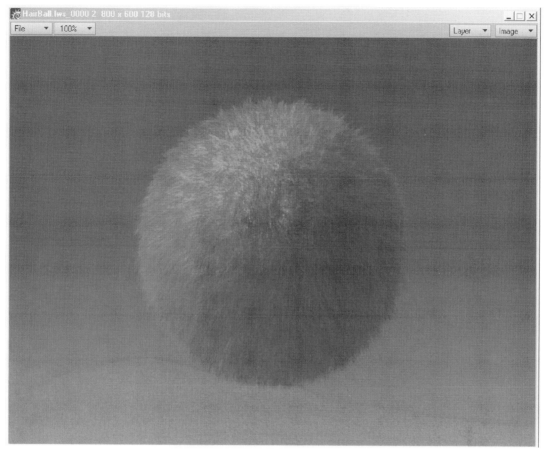

FIGURE 10.12 Hairball object with the default Sasquatch Lite settings.

STEP 3: LIMITING THE HAIR GROWTH

In the Object Properties panel for the Hairball object, double-click the SasLite listing to open the Sasquatch Lite menu. There are quite a few parameters to adjust here, some more obvious than others. (A minor annoyance when adjusting the fur values is that you must close the Sasquatch Lite panel before you can render a frame to see the result.)

At the top left of the menu are the options for applying fur. The default setting is "Apply fur to all surfaces." Click on the box below that setting to select "Apply fur only to named surface." This will un-ghost the Surface Name(s) box. To apply fur to a specific surface, the surface name needs to be typed into the Surface Name(s) box exactly. Type in the surface name Hair, the surface name for half the Hairball object. The surface name needs to appear exactly as

it does in the Surface Editor panel, matching case, or the surface will not be recognized.

Close the Sasquatch Lite panel and render a frame. The fur should now be rendered on only the parts of the Hairball object that have the surface name Hair. If no hair is rendered, it means either the name was not typed in correctly or the Sasquatch Lite shader was not added in the Effects panel.

STEP 4: CHANGING THE HAIR APPEARANCE

It is not necessary to master all the parameters of Sasquatch Lite; learning a few of the important settings will cover most of your basic needs.

Fortunately a number of Sasquatch Lite's controls resemble the standard surface attribute settings. The first setting is the Fiber Color. This setting simply controls the color of the fur being rendered. Below this is Bright & Hue Vary, which gives subtle variations to the color. The other attributes, Diffuse, Specular, and Glossiness, behave much the same way as their counterparts in the Surface Editor.

The remaining settings regulate the physical properties of the hair. Most of these settings have a high degree of interaction, so it is difficult to narrow down exactly how each control affects the hair. The setting for Fur Density, for example, needs to be much higher when the fibers are very short, unless the fibers have a lot of Frizz that makes them look denser, which in turn depends on the Coarseness setting.

Saving Settings

At the bottom left of the Sasquatch Lite panel are two buttons labeled L (Load) and S (Save). Because the interaction of the Sasquatch Lite attributes are so great, it is often difficult to dial in the exact look for the fur that you want. When you are close to a good fur setting, use the S button to save it. It is a good idea to create a separate folder in your LightWave directory for Sasquatch settings.

Using Guide Chains

Rather than using object surfaces to control where fur is rendered, guide chains can be used. (See the "Make long hair using guide chains" option.) A guide chain is a string of two-point polygons. The guide chain string of polygons needs the first polygon in the string to have a different surface name than the rest of the string to tell Sasquatch Lite which direction to point the hair.

When guide chains are used, hair is rendered around the guide chain geometry. The guide chain can be deformed and animated with bones or displacement and the hair will follow. This option is useful for creating long flowing hair, braids, and even rope.

TUTORIAL CREATING A RAT TAIL USING GUIDE CHAINS

STEP 1: CREATING THE GUIDE CHAIN

The first step to creating long hair is to make the guide chain in Modeler. This is accomplished by creating a single point, making it a single-point polygon, then using Extrude on several segments.

Under the Create tab in Modeler, click the Points button to activate the Make Points function. Click the mouse in the exact center of the Modeler screen to insert a point. Turn off the Make Point function to freeze the point.

The single point should still be selected. Click on the Make Pol (or press *p* on the keyboard) to convert the point into a single-point polygon.

Under the Multiply tab, select Extrude and activate its Numeric panel. We want the chain to be 1m long and have 20 segments. Enter these values:

Extent X = 0m
 Y = 1m
 Z = 0m
Sides 20

Press Enter to freeze the extruded point. The single-point polygon has now been extruded into a chain of two-point polygons.

STEP 2: NAMING THE SURFACE

For a guide chain to work with Sasquatch Lite, it must have an appropriate surface name. Switch to Polygon mode and select only the first polygon in the chain. This will be the end where the hair starts.

With only the first polygon in the chain selected, click on the Surface button under the Details tab and change the surface name to Root. (The surface name could be anything, but the name Root helps us remember what it is for.) The rest of the polygons should still be named Default, and that is fine for now.

Save the object as Chain.lwo and load it into Layout.

STEP 3: SETTING UP LAYOUT

As before, the Sasquatch Lite plug-in needs to be applied as a pixel filter in the Image Processing tab of the Effects panel and to the object itself. Apply the Sasquatch Lite Pixel Filter, and then open the item properties for the chain object. Under the Deform tab select SasLite.

STEP 4: SETTING UP THE LONG HAIR

The hair needs to be told which direction to render. Double-click on the SasLite listing to open the Sasquatch Lite panel. Select the "Make long hair using guide chains options." This will un-ghost the Surface Name(s) box; the surface name entered here is the surface that will receive the hair. In the Surface Name(s) box, type "Default."

Close the Sasquatch Lite panel and render a frame. The default settings for the guide chains produce a cone-shaped group of hair strands (see Figure 10.13).

FIGURE 10.13 Guide chain hair.

Notice that there is no hair on the segment that has the surface named Root. Also notice that the guide chain itself is visible, looking not very hair-like.

STEP 5: REMOVING THE CHAIN FROM VIEW

Several things can be done to improve the look of hair created using the guide chain method. The first thing is to remove the chain itself from the Camera view. The first method is to open the Scene Editor panel and deselect the guide chain in the active/inactive selector (the row with the checkmark just before the row with the eye) (see Figure 10.14).

FIGURE 10.14 The active/inactive row in the Scene Editor.

This effectively removes the geometry of the chain object from any rendering consideration. It will not show up as a render, in a reflection, or cast a shadow. This is a quick way to temporarily remove an item from the scene. The important thing is that Sasquatch Lite still sees it and uses it to guide the hair render.

The second way to remove the guide chain from view is to go to the Rendering section of Object Properties and select Unseen by Camera. Also turn off all the shadow options. Sasquatch Lite will still be aware of the object, but it will not be seen.

STEP 6: IMPROVING THE LOOK OF THE HAIR

Currently the hair looks like a few scraggly bits in a cone shape. You will notice that some of the settings in the Sasquatch Lite panel have become ghosted and others have become active while you are using guide chains.

The Lock Width setting controls the taper of the hair; a lower setting will render straighter groups of strands. The Density setting controls the thickness of the hair. The settings for Coarseness and Frizz also affect the apparent

thickness of the hair. (Increasing the Density setting will increase rendering time, although Sasquatch Lite renders very quickly to begin with.)

STEP 7: MAKING THE LONG HAIR MOVE

Any deformation that causes the guide chain to move will make the hair move. Bones, morphing, even motion designer can be used. As a quick example we will use a displacement map.

In the Deform tab of the Object Properties for the guide chain object, click on the T button for the Displacement map. We will use a procedural texture that displaces in all three dimensions. In the Texture Editor for the Displacement map, enter these values:

Layer Type	Procedural
Blending Mode	Normal
Layer Opacity	100%
Procedural Type	Ripples
Texture Value	0.1
Wave Sources	3
Wave Length	0.3
Wave Speed	0.005

All the dimensional data should stay at their defaults.

The chain object should now be bent into several curves. Use the scrub bar to preview the rippling motion. Use the Perspective view to see that the displacement occurs on the X, Y, and Z axes. The curves of the rippling object do not look very smooth, because the guide chain object consists of only 20 segments. This is not important because we do not actually see the guide chain in the final render, only the hair (see Figure 10.15).

Reflection and Shadows

Because Sasquatch Lite renders the fibers after the scene is rendered, it has some important limitations. In a sense, the hair and fur do not really exist in the scene. They are rendered separately and inserted later. For this reason, there are certain things that cannot be done.

Sasquatch Lite will not show up in any reflective surface. The hair fibers do not exist in the scene while the ray tracing is calculated, so they cannot show up in reflections or be properly refracted through transparent material with refractive properties.

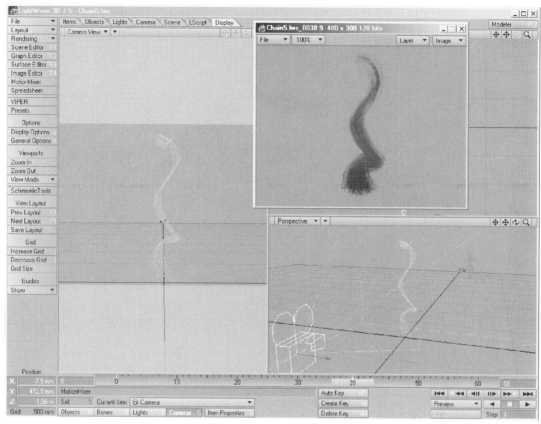

FIGURE 10.15 Five strands of two-point polygons being rippled with a displacement texture.

Sasquatch Lite also has limited shadow options. The hair fibers will not cast shadows onto other geometry. They can in some cases use shadows from a Spot light to self-shadow and to receive shadows from other objects (see Figure 10.16).

In the image you can see a Ball object casting a shadow on to a furry ball. Both the small ball and the fur ball cast shadows on the plane, but the fur only casts a shadow on itself. Notice the reflection in the floor only reflects the naked ball and not the fur that covers it.

The settings to enable Sasquatch Lite to receive shadows and self-shadow are in the Sasquatch Lite Pixel Filter in the Processing tab of the Effects panel. Double-clicking on the Sasquatch Lite Pixel Filter brings up the pixel filter option menu (see Figure 10.17).

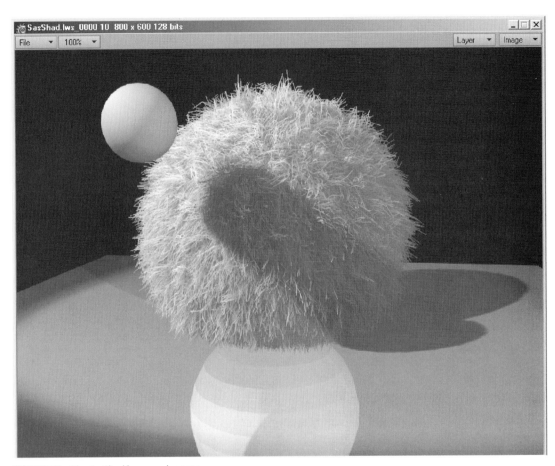

FIGURE 10.16 The SasShad.lws sample scene.

FIGURE 10.17 The Sasquatch Lite Pixel Filter menu.

Here we find the checkboxes for the shadowing options. Be aware that enabling shadows will increase render times. Notice also that Sasquatch Lite can use only Spot lights, which can have ray traced shadows or Shadow Map shadows. Sasquatch Lite uses its own method of shadow mapping to create shadows on the fur.

Antialiasing and Motion Blur

You will see in the Pixel Filter menu some settings for antialiasing. When "One-pass antialiasing mode" is checked, Sasquatch Lite will do its own antialiasing of the hair fibers as it renders, regardless of the antialiasing setting in the camera settings. Rendering the frame with antialiasing, however, will make the hair appear a bit smoother, even with "One-pass antialiasing mode" turned on.

To get hair with motion blur, you must use standard LightWave antialiasing. Antialiasing is where the separate passes render the motion that takes place in between the frames. To get Sasquatch Lite fibers to render with motion blur, "One-pass antialiasing mode" must be turned off so fibers get re-rendered with every antialiasing pass of the rendering frame.

Hair Management

There is a limit to the quantity of hair fibers that Sasquatch Lite will render. Often times the settings in the Sasquatch Lite panel do not allow for hair that is sufficiently thick or dense. A few things can be done to improve this.

Sasquatch Lite may be applied to the same object more than once. To quickly double the amount of hair that is rendered on the object, copy the current Sasquatch Lite listing in the Object Properties Deform tab by clicking it with the RMB and selecting Copy. Paste the listing, creating two listings. The values for the two settings will be exactly the same, which means the fibers will render in exactly the same place. Enter the menu for the second listing and change a setting or two very slightly. It only takes a small amount of change for the second pass to render differently enough to distinguish itself.

The above tutorial on guide chains used only a single string of two-point polygons. The original chain can be cloned in Layout and slightly offset to create a curtain of hair. The guide chain can also be duplicated in Modeler. The chain does not need to be a single straight line; it can consist of several strings, as long as they all start with a single polygon at the base that has a unique name that specifies it as the root.

Conclusion

Sasquatch Lite's primary purpose is for fur and hair, but it has found uses in other places as well. It can be used to create grass in a meadow, rope, wires, and even shag carpet. The full version of Sasquatch is much easier to use and does not have many of the limitations of the Lite version. However, as you can see in this chapter, Sasquatch Lite has more than a little functionality built into it.

ABOUT THE CD-ROM

The CD-ROM that accompanies *The LightWave 7.5 Primer* includes all the material necessary to complete the projects covered in the book. It also includes fully constructed scenes.

To use the content from the CD-ROM, you have three options: 1) You can use them directly from the CD-ROM by directing the Content directory from within LightWave to the Content directory on the CD-ROM. 2) You can copy the Content off the CD-ROM onto you hard drive as a group, and once again directing the Content Directory from within Light-Wave to the directory on the hard drive. (This will allow you to save any changes you may make to the example scenes or the objects.) 3) Or you can copy the Images, Objects, and Scenes directories from the CD-ROM to the corresponding folders within the currently existing LightWave installation. Proper use of the Content Directory is covered in Chapter 1 of the Lightwave Primer.

The Content Directory contains three standard subdirectories used for LightWave:

- Scenes
- Objects
- Images

Additionally there are a variety of fully rendered animations in these formats:

- MPEG
- QuickTime (Qtime folder)

All of the full color versions of the images from the book are also included. This folder is set up by chapter.

- Bookpics

SYSTEM REQUIREMENTS

To use the files on the CD-ROM, you must have LightWave 6.0 or higher and a movie file viewer such as QuickTime 5 or Windows Media Player.

Windows 98, Windows Me, Windows 2000 (Service Pack 2), or Windows NT 4 (Service Pack 6a), TCP/IP Network Protocol Installed and 128 MB of available RAM.

Power Macintosh Processor (G3 or higher recommended). Mac OS 9, Mac OS X *, 384 MB of available RAM for Mac OS 9, 128 MB of available RAM for Mac OS X. Mac OS X is recommended

All systems require 32 MB Available hard drive space and a minimum screen resolution of 800 x 600 pixels.

Index

multi-layered texture tutorial, 232–233
numerical coordinates, 219–220
Numerical Values for, 222
Position coordinate, 219–220
Procedural textures, 114–117, 209–214
rotating texture tutorial, 227–229
rotation, 219–220, 225, 227–229
Rotation coordinate, 219–220
Scale coordinate, 219–220
self-motivating textures, 229–230
Texture Editor, accessing, 200
Texture Editor panel, 114–115
Texture Lab, 120
see also Image Maps; Surfaces and surfacing
Tile function, 202
Tiling
Image Maps and, 202
Trace Refractions, 111
Translation, 23–24
Translucency, 133–134
settings of Surface Editor, 111
Transparency
color and, 131–132
refraction index and, 131
shadows and, 176
transparency masks, 56–58
Transparency setting in Surface Editor, 110
tutorial, 131–132
Transport Controls, 39

Triple, 170–172
Troubleshooting
distorted background or foreground, 285
missing polygons in OpenGL, 37–38
SubPlane object disappears, 248
T (texture) button, 111–114, 123
'Tweeners, 25
Twist tool, 153–155

U
Undo
in Layout, 31–32
in Modeler, 17
Move function and, 152–153
Un-Weld, 170

V
Vampire effect (lack of reflection), 130
Vertices, 12
View Centering tool, 36
Viewport bar, 10–12
Viewport Controls
navigation and, 79–80
Viewport Layout options, 32–36
Camera view option, 34, 35
Light view option, 35
Viper, 108–109
accessing, 45, 108
Enable Viper, 45
HyperVoxels and, 332
length of previews, 229
Smoothing function and, 137
textures and, 121–122
Volume HyperVoxels, 330